The Sienese Shredder

Edited by Brice Brown and Mark Shortliffe

© 2010 Sienese Shredder Editions
ISBN: 978-09787108-3-5

Sienese Shredder Editions
344 West 23rd Street #4D
New York, NY 10011
www.sienese-shredder.com
www.sienese-shredder-editions.com

This is the fourth issue.
Issues 1, 2, and 3 are still available.

Printed in Verona, Italy, at Graphicom S.r.l.
Designed by Specimen
www.quitethespecimen.com

Cover collage by Don Joint
Waldameer (2009)

Submissions by invitation only.

CONTENTS

Rochelle Gurstein

ON THE *VENUS DE' MEDICI*

Just how much does one have to know about something—a work of art, a sensibility, a way of being in the world—in order to be able to recognize what one doesn't know? An awkward and poorly put question, but one that haunts me whenever I am faced with a fragment from the past that has lingered into our own time, something that still manages to speak to me, yet in an accent and diction so foreign and sometimes so startling that I can barely discern its meaning. A number of years ago, I came upon a passage in Kenneth Cmiel's excellent study *Democratic Eloquence* that unsettled me in this way. It comes from a series entitled "Afoot," describing an Englishman's travels through Europe, published in *Blackwood's Magazine* (1857). In the installment from which Cmiel quoted, the narrator tells of meeting "a Yankee," who had just come from "Florence the beautiful." His friend addresses him enthusiastically:

> "Of course, you were in raptures with the *Venus de' Medici*"—expecting an answer such as he would himself have given. "Well, sir, to tell you the truth, I don't care much about those stone gals," was the answer he received. Our friend collapsed. Had anyone in his presence denied the orthodoxy of St. Augustine or abjured the Thirty-Nine Articles, there would have been more sorrow in his anger, but scarcely more indignation. The *Venus de' Medici*—a classic chef d'oeuvre—a thing which Praxiteles might have touched with his chisel, or Pericles have looked upon, to be called a "stone gal"! Had he doubted its genuineness, or spoken of it as a specimen of secondary art, he might have been deemed critical, hypercritical; but this was a classic impiety, an irreverence, a profanity.

What is more, the Yankee's words also betrayed "uncivism" and "egoism." He was undoubtedly among that type who "under their home influences, and the shadow of their own nationalities ... have no aptitude for general civism."

There is much, of course, that is familiar in this vignette, not least the conflict between Old World sophistication and New World simplicity, which was destined to become a popular theme in novels depicting Americans abroad. But I was struck by what was unfamiliar in it. The Englishman's willingness to judge a total stranger as well as the terms of his judgment—that the Yankee was "uncivic" and "egoistic"—could not have been in starker contrast to today's nonjudgmental attitudes: that everyone is

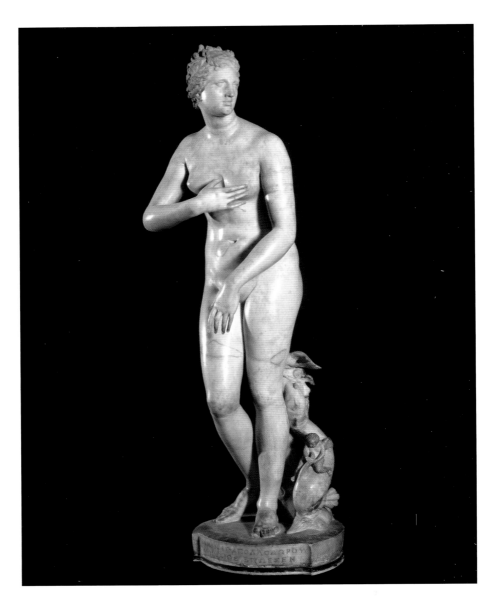

Venus de' Medici
circa first century BCE
Marble
Height: 60 1/4 inches
Uffizi, Florence

Photo Credit: Alinari /
Art Resource, New York

entitled to his or her taste; that all tastes are equal; that diversity of tastes is a measure of democracy and personal freedom. But even more alien to me, more mysterious, was the sculpture in question. Like most people, I could easily conjure the exquisitely draped, armless *Venus de Milo* at the Louvre, but I had no picture in mind of this other, once-beloved *Venus de' Medici*. My familiarity with ancient sculpture was so slight that I began to wonder if the *Venus de Milo*'s name had undergone some change over the centuries. I turned to the standard art textbooks I had at home but found nothing to support this, and, even more disconcertingly, I could find no trace of this "classic chef d'oeuvre—a thing which Praxiteles might have touched with his chisel, or Pericles have looked upon." Could the *Venus de' Medici* simply have vanished? Was the piece in *Blackwood's* fiction? Satire?

A month or so later, my husband and I were in Florence "the beautiful," with Henry James' *Italian Hours* in hand. I turned to the index to see whether James, the passionate art pilgrim, had anything to say of the missing Venus. I found but one entry: "*Venus de' Medici*, statue of, Hawthorne's estimate." James, in a review of *Passages from the French and Italian Note-Books of Nathaniel Hawthorne* (1872), noted in passing, "When he gets to Florence, [Hawthorne] gallantly loses his heart to the *Venus de' Medici*." The *Venus de' Medici*, then, was not a figment of some long-forgotten writer's imagination, for Hawthorne, too, had fallen under its spell. But to my surprise, in James' own chapters on Florence, even when he is describing his visits to art galleries, the *Venus* again is missing.

Luckily, I had also packed a modern guidebook to Tuscany. Its index proved more helpful, directing us to the sculpture's location at the Uffizi, specifically a gallery called the Tribuna, an octagonal room luxuriously decorated with a mother-of-pearl dome and a *pietra dura* floor that once displayed the treasures of the Medicis (hence the *Venus*'s name). "For centuries," the guidebook instructed us with impeccable authority, "the best-known of these [treasures] was the *Venus de' Medici*, a second-century BCE Greek sculpture, farcically claimed as a copy of Praxiteles's celebrated *Aphrodite of Cnidos*, the most erotic statue in antiquity." The usual condescension toward the past, I thought, but still I was ill prepared for our guide's final word on the subject: "In the eighteenth century, this rather ordinary girl was considered the greatest sculpture in Florence; today most visitors walk by without a second glance." "Rather ordinary girl"—was this not our contemporary equivalent of "stone gal?" Had the entire modern world somehow turned into narrow, insensible, nineteenth-century Yankees?

When we arrived at the Tribuna, we found that our *cicerone* was right: visitors did walk right by what had once been regarded as a masterpiece from the chisel of the legendary Praxiteles. Hoping to see what Hawthorne and the Englishman in the *Blackwood's* story had seen, my husband and I gave ourselves over to the *Venus*. But it (she?) was nothing like the monumental, weather-beaten, broken, yet divine, forms that we call the Elgin Marbles and that are from the time of Praxiteles but from the chisel of Phidias or, even more likely, from those sculptors who worked under his supervision. Nothing about this rather diminutive Venus accorded with our preconceived image of antiquity. The glowing white, highly polished marble seemed strangely untouched by age or the elements. Even more jarring, the *Venus de' Medici* was completely intact and without drapery, though we could clearly see the lines where restorers had attached new limbs—legs, feet, and arms with delicate, lifelike hands modestly shielding her nudity, giving the *Venus de' Medici* her characteristic pose. But it had none of the precise anatomical details, none of the suppleness of flesh, none of the breathtaking contrast between movement and repose that are the hallmark and glory of the Elgin Marbles. We dutifully took in her form for

close to an hour, and the force of our attention caused some tourists, who no doubt would have otherwise walked right by, to pay court to this long-neglected deity, if only for a brief moment or two. Yet neither of us could honestly say we were in raptures. To our modern eyes—eyes shaped as much by the vision of the Elgin Marbles and the *Venus de Milo* as the *Delphic Charioteer* and the *Poseidon*—the *Venus de' Medici* appeared stranded in another world, hopelessly frozen in time.

Upon our return, I asked a friend in Renaissance art history and another who is a classical archaeologist whether either had a mental picture of the sculpture. Both were at a loss, as were friends who move in the contemporary art world. And so the mystery of the *Venus de' Medici*, the poignancy of its disappearance from the modern imagination, began to haunt me. What, I wondered, had past art lovers seen that we no longer see? The beginnings of an answer came from a rather pretentious acquaintance who recommended a book called *Taste and the Antique*, by Francis Haskell and Nicholas Penny. Reading page after page of appreciation and seeing for the first time pictures of ancient statues that were completely unknown to me, a lost world suddenly opened up.

From the Renaissance, when ancient statues were discovered in Rome during the great building projects of the day and restored to their former perfection, through the close of the nineteenth century, artists, art lovers, men of letters, and the cultivated public saw in sculptures such as the *Venus de' Medici*, the *Apollo Belvedere*, the *Laocoön*—to name only a few of the most famous—the embodiment of all that they admired in antiquity. The classical inheritance was alive for such people, since they knew not only ancient art but ancient languages, history, geography, oratory, poetry, and architecture with as much intimacy as they knew their own world. Indeed, intimate knowledge of antiquity was the very substance of humanism. The *Venus de' Medici* was among the most revered and reproduced of these sculptures; its fame certainly exceeded that of the *Mona Lisa* today. It provided the standard of perfection for sculptors and painters, was acquired by art schools and academies in plaster casts, was avidly pursued by collectors in marble, bronze, and lead copies as well as in porcelain figurines and cameos, was widely disseminated through countless drawings and popular engravings, and was a favorite subject of conversation. Poems proclaimed the *Venus* "the statue that enchants the world," guidebooks declared it "the best of all the statues," travelers made pilgrimages to the Tribuna to see if their own experience could live up to their expectations, and when they tried to put down their impressions in writing, they typically confessed that words simply failed them. Such was its renown that when Napoleon's armies looted the great art treasures of Italy, the *Venus* was his most sought-after prize. To comfort the Florentines upon its removal, Canova, "the modern Praxiteles," sculpted a new Venus, which occupied its honored place in the Uffizi until the *Venus de' Medici* was returned in 1815 with the defeat of

Napoleon. In 1821 its empty, forlorn pedestal in the Louvre was filled by another Venus recently excavated on the island of Melos—the unrestored, draped *Venus de Milo*, which many French art lovers quickly came to believe surpassed the beauty of the *Venus de' Medici*.

It would be a long time before I would fully grasp what my not knowing the *Venus de' Medici* meant. Yet, from the moment I came across the "stone gal" passage in Cmiel's book and was unable to find any mention or image of it in my standard art textbooks, the absence of the *Venus de' Medici* perplexed and haunted me. How could works of art that were once so celebrated that their admirers imagined they would last forever vanish without a trace? But this was not quite the case with the *Venus de' Medici*. Once I was aware of her (its) existence, I began to find traces of her not only in the expected places, such as classic texts on art like Vasari's *Lives of the Painters*, Winckelmann's *History of Ancient Art*, or Reynolds's *Discourses*, in treatises on aesthetics from Hogarth to Bosanquet, and in the journals and letters of cultivated Englishmen like Gibbon; but also in places where enthusiasm for a classical statue might not have been expected, for example, in the journal of such an independent-minded Yankee as Emerson, who, after seeing the *Venus* in the Tribuna in 1833, wrote that he "saw and felt that mankind have had good reason for their preference of this excellent work, and I gladly gave one testimony more to the surpassing genius of the artist;" and, even more astounding, in an American newspaper report of a murdered prostitute. In *The Murder of Helen Jewett*, Patricia Cline Cohen reprinted an eyewitness account of the crime scene that appeared in the *New York Herald* (1836):

> It was the most remarkable sight I ever beheld—I never have, and never expect to see such another. . . . The perfect figure—the exquisite limbs—the fine face—the full arms—the beautiful bust—all—all surpassing in every respect the *Venus de' Medici*'s. . . . For a few moments I was lost in admiration at this extraordinary sight—a beautiful female corpse—that surpassed the finest statue of antiquity.

That the image of the *Venus de' Medici* reverberated with the readers of the new penny press can only begin to suggest how deeply engrained classical antiquity once was in the popular imagination, making its disappearance from the modern imagination all the more stunning. Our estrangement from the classical past turns out to be even more radical than our estrangement from the Christian past, for it is now so complete that few of us are even aware of what we no longer know. Tourists typically walk right by classical statues displayed on lawns and in hallways of country estates, and almost no one has any idea why aspiring artists once were required to draw from plaster casts. Today even cultivated art lovers are largely

unfamiliar with the classical imagery and allusions, quotations, and borrowings that are everywhere in painting and sculpture before the twentieth century, from the refiguring of the *Venus de' Medici* into the tormented Eve in Masaccio's *Expulsion from the Garden of Eden* to the miraculous reappearance of the *Crouching Venus* as one of Cézanne's primitive bathers. (Yes, even Cézanne.) In consequence, they do not recognize half of what they are seeing, and the many literary associations and beautiful renderings of those associations that delighted generations of art lovers for close to four hundred years no longer resonate with them.

As for the art establishment, it seems to be in no better position. Largely as a consequence of the Romantic cult of originality on the one hand and an increasingly scientific, archaeological approach to the remains of antiquity on the other, a new understanding of the *Venus de' Medici* and virtually all the other most revered sculptures slowly and fatefully emerged during the nineteenth century: they were actually Roman copies of missing Greek bronze originals, a distinction that had occurred to no one before then. And so these once-treasured statues have effectively ceased to exist as works of art in their own right. They now languish in an art-historical netherworld, their restored arms and legs removed in the name of authenticity, as curators typically relegate them to the ancient Greek section of the museum (and the same is true of art-history books), their only claim to attention being as a stand-in for lost statues from an earlier and allegedly superior time: *Venus de' Medici*, first century BCE, copy from a bronze original derived from the type of the *Cnidian Venus* of Praxiteles; *Apollo Belvedere*, copy of the early Hadrianic period of a bronze original by Leochares.

During the twentieth century, the anthropological understanding of culture as a way of life displaced the humanist understanding of culture as a tradition of learning and artistic appreciation that begins with classical antiquity. It is my melancholic disposition that tempts me to feel this change as a loss. Yet, for at least some members of the last generation of classically educated people, classical antiquity felt like an unbearable burden, in truth a dead weight. It is not for nothing that in his 1909 futurist manifesto, F. T. Marinetti exuberantly proclaimed "a racing car whose hood is adorned with great pipes, like serpents of explosive breath … is more beautiful than the *Victory of Samothrace*" (a Greek original, unearthed in 1863 and installed at the Louvre in 1884, making it a late addition to the classical canon). The futurists would "free" Italy "from its smelly gangrene of professors, archaeologists, ciceroni, and antiquarians." With great bravado, Marinetti declared that museums were graveyards and that the new generation wanted none of that:

> Come on! Set fire to the library shelves! Turn aside the canals to flood the museums! Oh, the joy of seeing the glorious old canvases bobbing adrift on those waters, discolored and shredded! Take up

your pickaxes, your axes and hammers and wreck, wreck the venerable cities, pitilessly!

It has been a long time since anyone sounded like Marinetti. What separates our present moment from that of the first moderns is their intimacy with the classical tradition, even as they set out to wreck it, and our almost complete obliviousness to it—an obliviousness that is, in part, a tribute to the success of the spirit of Marinetti's manifesto. With a speed that would have astonished even Marinetti, after the first decades of the twentieth century, reproductions, let alone any mention, of the *Venus de' Medici* became increasingly rare. One of the last I have found appears in John Crowe Ransom's "Criticism as Pure Speculation" (1941). He quotes from an article by Dr. Hans Sachs, a successor to Freud, who provided the following story from a French author:

> He tells that one evening strolling along the streets of Paris he noticed a row of slot machines which for a small coin showed pictures of women in full or partial undress. He observed the leering interest with which men of all kind and description, well dressed and shabby, boys and old men, enjoyed the peep show. He remarked that they all avoided one of these machines, and wondering what uninteresting pictures it might show, he put his penny in the slot. To his great astonishment the generally shunned picture turned out to be the *Venus de' Medici.*

It is hard to imagine a more pathetic end to the *Venus de' Medici*, except of course my own blankness when it came to conjuring her image. That we have managed to live without classical antiquity for close to a century, however, suggests that the humanist tradition must have already been moribund by the time moderns like Marinetti attacked it. Still, her sorry fate continues to haunt me and brings to mind a warning of John Ruskin's that now reads like prophecy:

> The whole system and discipline of art, the collected results of the experience of ages, might, but for the fixed authority of antiquity, be swept away by the rage of fashion, or lost in the glare of novelty; and the knowledge which has taken centuries to accumulate, the principles which mighty minds had arrived at only in dying, might be overthrown by the frenzy of a faction, and abandoned in the insolence of an hour.

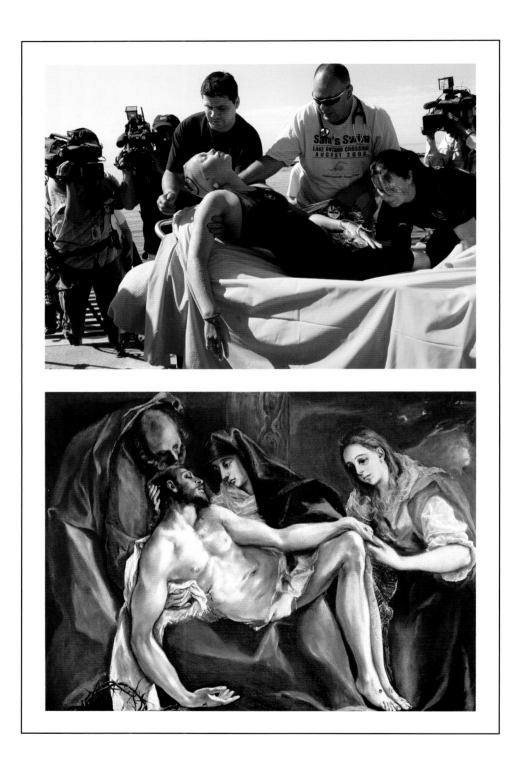

1. Réne Johnston, Press photo of Samantha Whiteside after 52 km swim across Lake Ontario, 2006
2. El Greco, *Pietà*, 1587–97, Collection of Stavros Niarchos

14

Lawrence Weschler

On the Rampancy of Christological Convergences Across the Western Pictorial Tradition

Over the past several years, I have been generating a series of convergence pieces, which is to say essays (originally published in a variety of venues, then gathered together in a 2007 book, *Everything That Rises*, published by McSweeney's, which in turn generated an online contest on the McSweeney's website in which readers were invited to contribute their own instances, which I in turn was invited to comment upon) built around the uncanny similarity of, say, one painting with another, or else a poem and a painting, a pair of magazine covers, or a news snap and a sculpture. You get the idea. Not simply instances of Separated at Birth: I mean, no one can deny that the visages of Mick Jagger and Don Knotts are spitting images of each other, but after noticing the resemblance (and then, granted, never being able to forget it), there's not terribly much you can say beyond that—unlike the case, for instance, of Newt Gingrich and Slobodan Milosevic, whose doughy high-coifed facial resemblances open out onto all sorts of other parallels with regard to opportunistic tendencies, rhetorical strategies, career trajectory, and so forth (see my essay on same, "Pillsbury Doughboy Messiahs," in the *Everything That Rises* book). There needs to be this rhyme, true, but

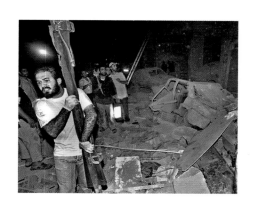 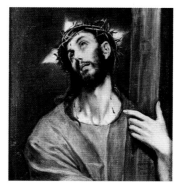

3. Press photo of Israeli incursion in Lebanon
4. El Greco, *Christ Holding the Cross*, 1602–07, Museo Thyssen-Bornesmisza, Madrid

that isn't enough: for such a pairing to become a convergence, one needs to be able to build a sort of prose poem around it.

Anyway, over the past several months, with the website contest well into its second year, I've been struck by a sort of metaconvergence, or rather a pattern of patterns, an uncannily recurrent rhyme scheme percolating through much of the contest as a whole. Which is to say, the overwhelming pervasiveness of Christian imagery.

Thus, for example, Clint Roenisch of Toronto, Ontario, notices this recent news photo of an exhausted Samantha Whiteside, her swim goggles in hand, being lowered onto a stretcher moments after completing her 52 km marathon swim across Lake Ontario [fig. 1] and can't help but recall El Greco's *Pietà* (1587–97) [fig. 2]. Which in turn gets Daniel Herman to thinking about this news shot from the Israeli incursion into Lebanon [fig. 3], convinced that it too is rhyming off some El Greco, which indeed it seems to be (specifically this one, from 1602–07) [fig. 4]. Note the strange halo burst of light hovering above the Lebanese gentleman. Which in turn got Domenikos Theotokopoulos' fellow Greek, Matt Mikalatos, to offer up The Passion of Peter Parker [fig. 5].

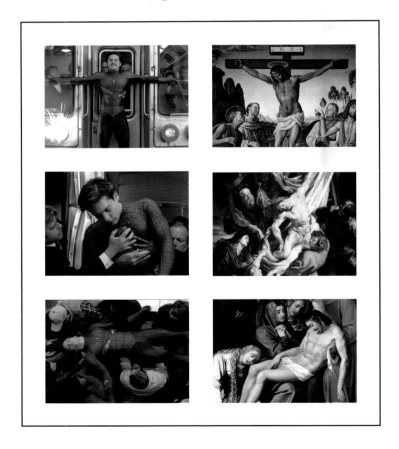

5. The Passion of Peter Parker, stills from *Spiderman*, 2002, with Renaissance Passion paintings

On another occasion, Jonathan Shipley couldn't help but notice, in this image of Skylab floating in space [fig. 6], shades of Dalí's vision [fig. 7]. (In this context, it's interesting to think about the cross, with its perpendicular axis representing the vertical slicing of the transcendental into the horizontal sway of the everyday—the divine, in other words, into the human—as also providing the template for the subsequent x-y axis of Cartesian mathematics, the sort of mathematics that in turn made the whole space program possible. And to wonder, in turn, whether that sort of mathematics could only have occurred to a secularizing Christian like Descartes.)

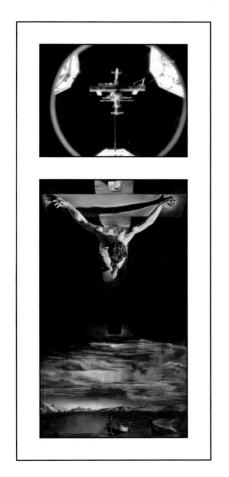
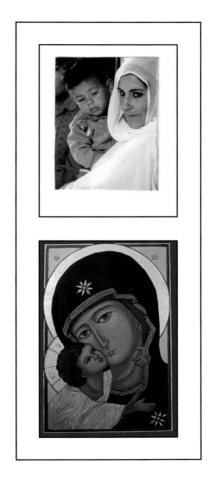

Margit Christ(!)ensen noted the convergence above between two postcards she came upon the gift shop the Dormition Abbey in Jerusalem, a church dedicated to the eternal sleep of the Blessed Virgin, one portraying a Muslim mother and child [fig. 8], the other the Virgin of Vladimir [fig. 9], an oft-emulated Russian icon.

6. View of Skylab from space 7. Salvador Dalí, *Christ of St. John of the Cross*, 1951, Kelvingrove Art Gallery and Museum 8. Postcard of a Muslim mother and child 9. Postcard of the Virgin of Vladimir, twelfth century

When Charlie Hopper submitted this snapshot of his uncles, who were World War II veterans, joined by his boom-baby cousin installing a clothesline at his grandma's house sometime in the '50s or early '60s [fig. 10], he of course couldn't help but think of Joe Rosenthal's iconic image of the flag-raising over Iwo Jima [fig. 11]. But that in turn got me to thinking. For a question arises as to why that specific image, of all the hundreds of thousands shot during the war, proved so uniquely resonant for those millions who immediately prized it back home at the time and for so many of the generations thereafter. And here I think our friend Mr. Hopper, or maybe his uncles, are onto something.

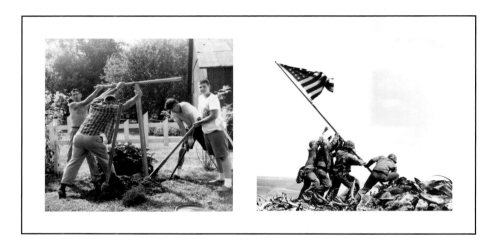

For the entire island-hopping campaign that came to characterize the Pacific War must have come to seem, both to those back home and to the thousands of ravaged, bone-weary Marines who actually undertook it, like so many Stations of the Cross, and that terrible mountain like some species of Calvary.

Whether or not that specific association was in the minds of the five Marines who posed for Rosenthal's photo, or even in Rosenthal's own mind as he shaped and snapped it, I can't help but suspect it was at the back of the minds of the photo editors back home who, all around the country, were drawn to that specific image (out of all the others that were also sent back from that roll) and featured it on their front pages the next day.

For, of course, that pose has a history, from early medieval manuscripts [fig. 12], through sixteenth century paintings [fig. 13], Rembrandt [fig. 14], and Rubens [fig. 15].

10. Uncles raising a clothesline, circa 1955–60
11. Joe Rosenthal, *Raising the Flag on Iwo Jima*, 1945

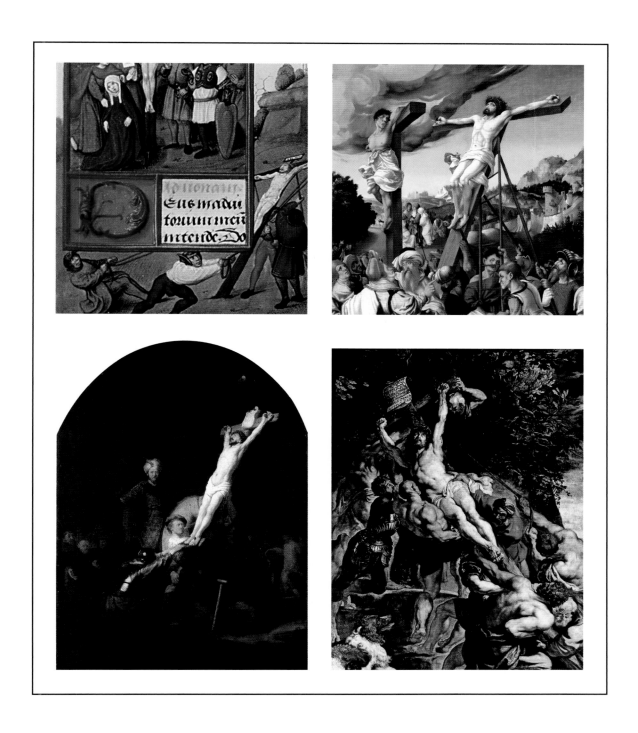

12. *The Raising of the Cross*, early medieval 13. *The Elevation of the Cross*, circa 1500 14. Rembrandt van Rijn, *The Raising of the Cross*, circa 1633 15. Pieter Paul Rubens, *The Raising of the Cross* (central panel), 1610–11

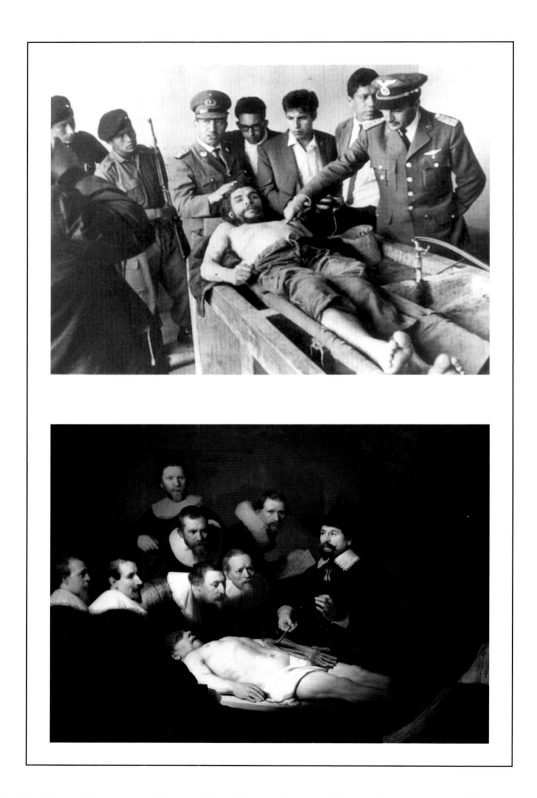

16. Freddy Alborta, The display of Ernesto "Che" Guevara's corpse, following his execution, 1967

17. Rembrandt van Rijn, *The Anatomy Lesson of Dr. Nicolaes Tulp*, 1632, Mauritshuis, The Hague

That's the way images work (this has been one of the main themes of this whole convergence exercise): images prepare a seedbed for other images, a context for receptivity. What we see is rooted in what we have already seen. That was the foundation of John Berger's marvelous insight, years ago, to the effect that the image which Che Guevara's Bolivian captors must have had subliminally in mind, as if hardwired into their minds, the image that taught the strutting generals where to stand in relation to their quarry and the photographer, Freddy Alborta, how to frame his shot [fig. 16], must surely have been this image [fig. 17] Rembrandt's *Anatomy Lesson of Dr. Nicolaes Tulp* (1632). But no less surely, the image that Rembrandt must have had in mind (or anyway an image quite like it), was this:

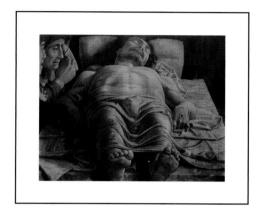

Mantegna's *Lamentation over the Dead Christ* [fig. 18]. Note the similarity of the faces of the corpses in both images (for that matter in all three images). Which is one of the reasons (another being the way that the trio of central onlookers are portrayed as gazing, dumbfounded, not at the corpse's splayed arm but rather at the professor's upraised hand, as he explains the sorts of gestures those muscles nothing short of miraculously make possible) why Rembrandt's painting ends up being so much about life rather than death. And which in turn is one of the reasons that Che in death (by way of Alborta by way of Rembrandt by way of Mantegna) ends up becoming transfigured into the iconic t-shirt figure we know today. Had Che, for example, happened to have been clean-shaven on the day he died, had he, for example, looked like this guy [fig. 19], none of that transmutive charge would have pertained, and there would have been no Che logo t-shirts. (That guy, incidentally, is Che Guevara, disguised as an Argentinean businessman in the photo of the passport he wielded on his clandestine trip to Africa, a few years earlier, in 1965).

18. Andrea Mantegna, *Lamentation over the Dead Christ*, circa 1480, Pinacoteca di Brera, Milan
19. Passport photo of Ernesto "Che" Guevara, 1965

Artists are doing this sort of thing all the time (and were doing so, I assure you, long before the contest). Thus Goya's *The Third of May 1808* [fig. 20], with that white-shirted central figure, his arms cast wide in a conspicuous allusion to the Crucifixion (and implicitly, to the Resurrection and the Life), and Manet, in turn, riffing off Goya a half-century later (granted, with the nationalities of the protagonists reversed) in his *The Execution of Maximilian* of 1868-69, the emperor christlike in his sombrero-halo, flanked in death (again like Christ) by two confederates [fig. 21].

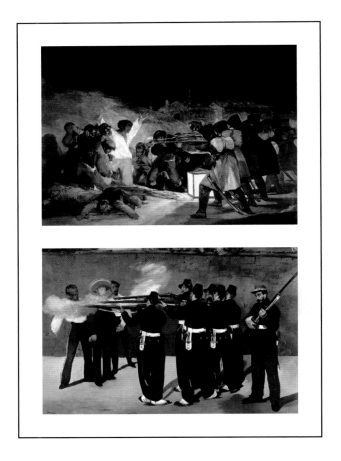

And Picasso, in turn, riffing off Goya and Manet for his *Massacre in Korea* of 1951 [fig. 22]. Though leave it to contest entrant Michele Siegal to have recognized the rhyme off Goya and Manet in Oded Balilty's Pulitzer Prize-winning photograph of a lone Jewish matron shoving back Israeli soldiers as they endeavor to remove her from her illegal settlement on the West Bank (right down to the onlooking crowd, out of Manet) [fig. 23].

20. Francisco Goya, *The Third of May 1808*, 1814, Museo del Prado, Madrid
21. Édouard Manet, *The Execution of Maximilian*, 1868–69, Kunsthalle Mannheim

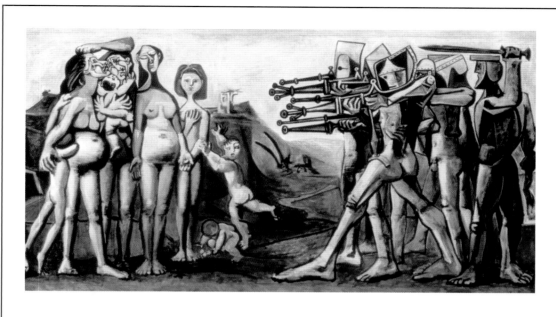

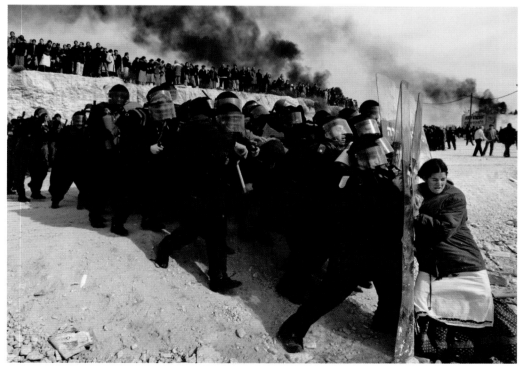

22. Pablo Picasso, *Massacre in Korea*, 1951, Musée National Picasso, Paris
23. Oded Balilty, AMONA, West Bank/Feb. 2006 (AP Photo/Oded Balilty)

Or to take just one further example, Duchamp. Yes! Even Duchamp: specifically, his notoriously inspired *Fountain* of 1917, the ready-made sculpture the ur-Dadaist attempted to enter, pseudonymously (under the name R. Mutt), into that spring's follow-on exhibition to the Armory Show of a few years earlier, where his *Nude Descending a Staircase* had caused such a howling critical ruckus ("an explosion in a shingles factory"). This time, though, the show's scandalized organizers didn't even let the piece— after all, simply a urinal set on its side—into the exhibition.

Simply a urinal set on its side, yes, and yet much, much more. "A lovely form has been revealed, freed from its functional purposes," Duchamp's sidekick and collector Walter Arensberg insisted, appealing the board's decision, "—therefore a man has clearly made an aesthetic contribution." (An estimation resoundingly reaffirmed, almost a century later, when, in a poll as part of the run-up to the 2004 Turner Prize, over 500 international art experts voted it "the most influential modern art work of all time.") Arensberg's protest was to no avail, however. So he and Duchamp lugged the forlorn thing over to Alfred Stieglitz's 291 Gallery (as Rachel Cohen relates in the sixteenth chapter of her luminous *A Chance Meeting* braid of interweaving essays), where Stieglitz in turn photographed it in a glow of profound reverence [fig. 24]. Carl Van Vechten subsequently enthused to Gertrude Stein, by letter, that "the photographs make it look like anything from a Madonna to a Buddha."

Or, as I myself always thought, and, interestingly, found myself thinking all over again just recently, a pietà [fig. 25].

Early last year, a 77-year-old "art activist pensioner" named Pierre Pinoncelli, from Saint-Rémy-de-Provence (site, as it happens, of Van Gogh's famous asylum), attacked Duchamp's icon with a hammer, slightly chipping it, as it lay in state as the centerpiece to the Centre Pompidou's massive Dada retrospective. Many shocked newspaper readers the next morning (I am sure, at any rate, that I was not alone) were put in mind of that infamous moment, back in May 1972, when a 33-year-old Hungarian-born Australian geologist named Laszlo Toth, ecstatically keening "I am Jesus Christ!," took a hammer to Michelangelo's sublime *Pietà* in the Vatican, causing considerably more damage. While Toth was almost universally decried as a cultural terrorist, a small band of radicals hailed his "gentle hammer" under the distinctly more Dadaist slogan, "No more masterpieces!" Toth was eventually committed to an Italian asylum and then expelled from the country, and even though the sculpture was presently repaired, the attack left quite an impression. (A few months later, *National Lampoon* ran a photo of the attack itself, Toth's hammer-wielding arm raised in ecstasy, under the memorable caption, "Oh my God, Pietà? I thought it said Piñata!" And some years after that, perhaps similarly liberated—or, alternatively, deranged—by the incident and its Duchampian precursor, Andres Serrano perpetrated his own *Piss Christ*.)

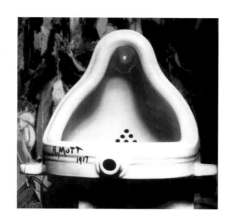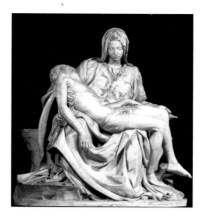

As it turned out, this most recent was not Pinoncelli's first attack on Duchamp's masterpiece. Back in 1993, in what to my own mind may count as the single most inspired feat of performance art of all time, Pinoncelli urinated into the sculpture as it lay on display in Nîmes, France. At the time, he defended his action, explaining how he'd simply been trying to "give dignity back to the object, a victim of distortion of its use, even its personality." This time around, he amplified that exegesis by explaining to reporters how, "having been transformed back into a simple object for pissing into after having been the most famous object in the history of art, its existence was broken, it was going to have a miserable existence."

"Better to put an end to it with a few blows of the hammer," he went on modestly, esteeming his own gesture "not at all the act of a vandal, more a charitable act."

Ah, the Resurrection and the Life of Art!

———•—•—•———

Now, friends of mine who've been following this whole convergence passion of mine, and especially my responses to some of these recent contest entries, have taken to asking what a good little Jewish boy like me is doing getting so caught up in Christian iconography. I suppose I could answer, glibly, by sputtering, along the lines of that classic old joke, "Hey, you're the ones showing me all these dirty pictures!" But that would merely be begging the question. Or, rather, the question might be better answered with a counterquestion: how can anyone who chooses to engage the Western pictorial tradition help but quickly become entrammeled in Christian

24. Alfred Stieglitz, *Photograph of Marcel Duchamp's Fountain*, 1917
25. Michelangelo Buonarroti, *La Pietà*, 1499, St. Peter's Basilica, Vatican State

iconography, both overt and (more recently) sublimated, sometimes even unconsciously, into more secularized renditions?

Which in turn opens out onto a more intriguing line of speculation. For back in the first few centuries of the modern epoch (the late Hellenistic/early Roman era, once characterized by T. S. Eliot for its "too rapid and great expansion and mixture of races canceling each other's beliefs" —especially there in Palestine, at the very nexus of three continents—a period supersaturated with a surfeit of stray transcendences, when somebody—I forget, was it Petronius?—noted that, and I am paraphrasing, "Nowadays, walking about, one is as like to come upon a god as another person"), what was it about Christianity that so fitted it (and it alone, among all those other proliferating cults and heresies) for eventual success and triumph? Wasn't it after all something about its story, its narrative, the overwhelming richness of that narrative and the way it so readily leant itself to illustration (especially across the many ensuing centuries, in which most people couldn't read)?

You don't have to be a Carl Jung or a Joseph Campbell to notice that the Jesus story manages to swallow up virtually all the great themes of human life (or, anyway, of human storytelling)—birth and death, poverty and wealth, virgins and whores, mothers and sons, fathers and sons, solitude and bustle, hope and despair, loyalty and betrayal, wakefulness and sleep, sin and sacrifice, great faith and great doubt, suffering and redemption, grief and rapture—and, for that matter, more specifically, many of the foremost motifs of classical Greek and Roman mythology: the virgin impregnated by a god who then gives birth to a hero, half man and half god, who in turn gets tested by a harrowing season in the wilderness and eventually, in dying, finds himself utterly transubstantiated. And what a death! Near naked like that, stretched supine, an object of pity and sorrow and horror and awe, but one through whose subsequent representations entire traditions of classical rendering of the Olympian gods were going to be funneled.

It is as if, in the vastness of time, that specific story (more so than any of the others circulating across those years) had been virtually precision engineered, lens-like, to gather in all the great themes from the ages that had preceded it, to concentrate and infuse those motifs with yet greater urgency and significance, and then, hourglass-like, spray them out on the far side into all the ages that were to follow. (And please: I'm not saying that it was thus engineered, I'm saying it is as if it were, and that it couldn't have been more expertly suited toward its eventual triumphant purpose if it had been.)

Such that you can walk through the medieval sections of any of the world's great museums, and all you will see are images of Christ's story (along with those of his subsequent martyred saints)—it can even get a bit trying; "Enough already!" you may find yourself exasperating—and yet you may in turn also notice that, even self-limited, the artists were able

to portray virtually all of life's enduring themes. Sometimes you will even catch them casting such motifs in contemporary dress—Jesus, say, as a Flemish burgher, Peter as a Venetian fisherman. (And this might not even have been a case of affect or artifice: how would anyone in those days have been given to realize that people didn't always dress the way they do at present?) Annunciation (which is to say, receiving surprising news), birth, nursing and showing off a baby, the baby growing to young manhood, walking about, speaking in parables (the parables themselves), engaging the world, confronting his elders, being betrayed, tormented and humiliated, paraded about, tortured and killed, his corpse brought down and spread out and cleansed, surrounded by mourners, and finally, on the far side, lifted up to majesty and regal splendor. What of contemporary reality, back in that age of abiding belief, couldn't have been subsumed and represented through such a tale?

True, this tale monopolized virtually all Western representation for centuries upon centuries, but it also allowed for the visualization of virtually all of Western life throughout those centuries. And then, when belief started falling away, the tropes through which those life stages had been visualized persisted in secularized form: that (and that virtually alone) being what surprise, admiration, or betrayal quite simply had come to look like.

And continues to look like to this day.

———•◦•———

Which, in turn, brings me back to that first image, the girl on the far side of her epic swim, and its paired El Greco:

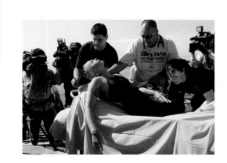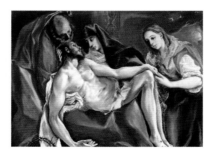

Uncannily similar. Though, one finds oneself thinking, at least Christ never had to deal with those craning paparazzi. Though, then again, come to think of it, Christ, too, over time came to suffer his own throng of jostling flashbulb rubberneckers. Such, at any rate, is another way of thinking

about the hundreds of painters and sculptors who took up the subject of his Deposition from the Cross—the Old Masters reconceived, in this sense, as Paparazzi of the Passion: [fig. 26–32]

(For that matter, flipping the polarities of our analogy, contemporary paparazzi, all agog over this Paris or that Diana, this Brad or the other Jen, this Madonna—for God's sake! this Madonna—might well themselves be thought of as latter-day versions of their Old Master predecessors, likewise in thrall to the transcendental incarnate. Star power, indeed.)

Flash! Pop! Snap!

26. Giotto di Bondone, *Lamentation (The Mourning of Christ)*, 1304–1306, Capella degli Scrovegni, Padua, Italy
27. Antonio Ciseri, *The Deposition of Christ*, circa 1883, Santuario della Madonna del Sasso, Orselina, Italy
28. Rosso Fiorentino, *Deposition*, 1521, Pinacoteca Comunale di Volterra, Italy
29. Angolo Bronzino, *The Deposition of Christ*, 1542–45, Musée des Beaux-Arts, Besançon, France
30. Filippino Lippi and Pietro Perugino, *The Deposition*, circa 1506, Gallerie dell'Accademia, Florence
31. Master of the Saint Bartholomew Altarpiece, *The Deposition*, circa 1500–05, The National Gallery, London
32. Michelangelo Merisi da Caravaggio, *The Entombment of Christ*, circa 1602–03, Pinacoteca Vaticana, Vatican

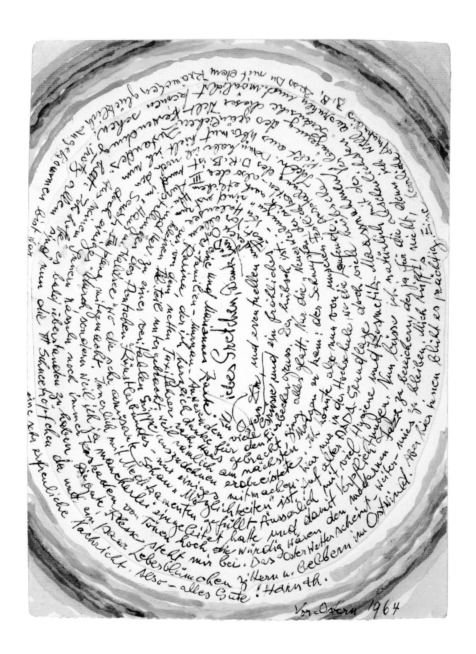

Untitled (Postcard), 1964
Ink and watercolor on paper
6 x 4 inches

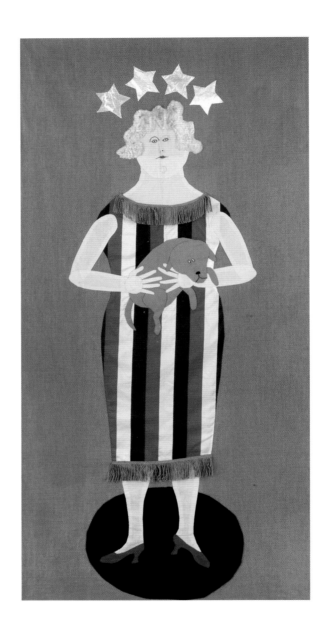

Untitled (Lady with Puppy), circa 1965–1969
Embroidered fabric
82 x 41 inches
All works courtesy Lori Bookstein Fine Art, New York

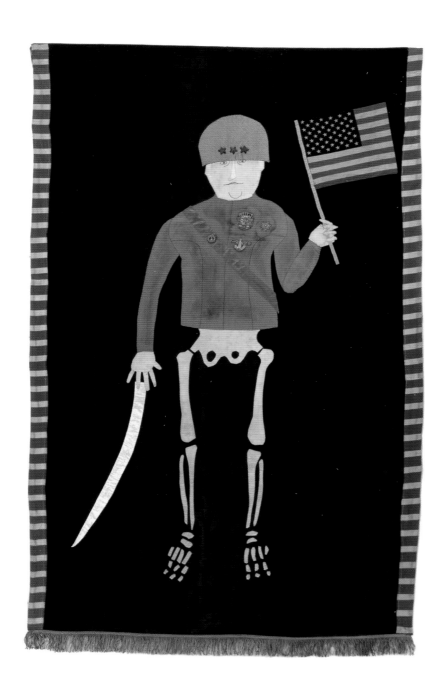

Untitled (Soldier), circa 1965–1969
Embroidered fabric
89 x 52 inches

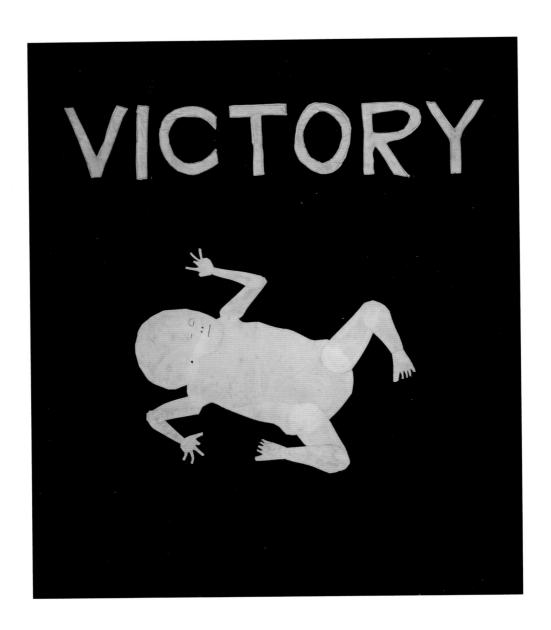

Untitled (Victory), circa 1973
Embroidered fabric
64 x 53 inches

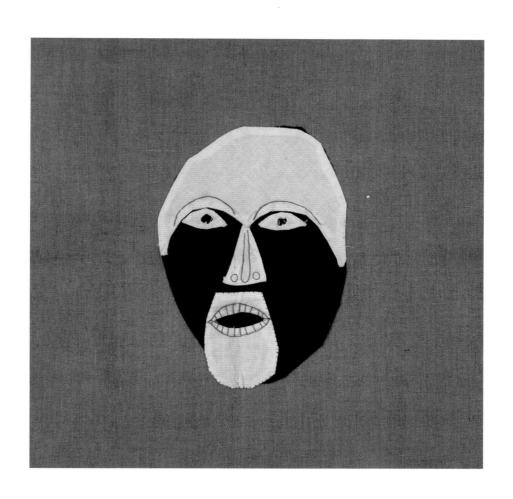

Untitled (Face), circa 1965–1969
Embroidered fabric
20 x 20 inches

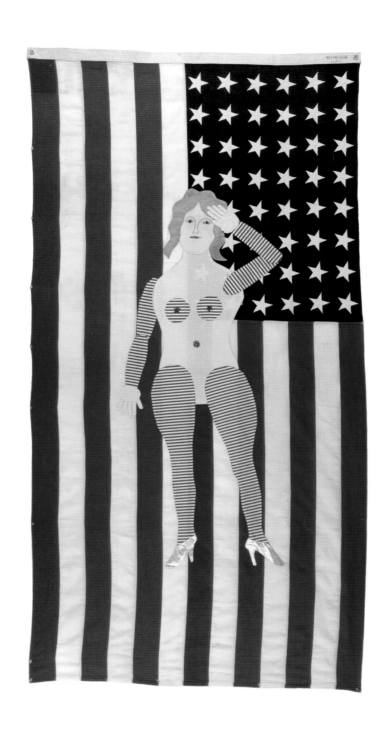

Untitled (Flag), circa 1965–1969
Embroidered fabric
115 x 58 inches

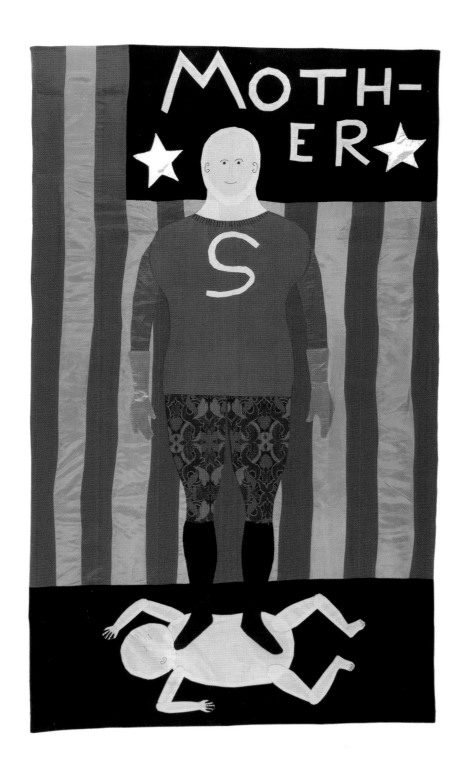

Untitled (Mother), circa 1973
Embroidered fabric
91 x 54 inches

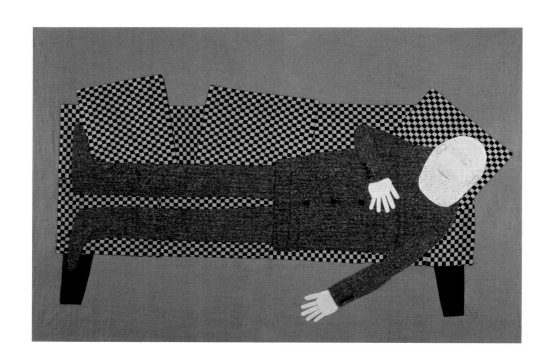

Man on Couch, circa 1973
Embroidered fabric
52 x 78 inches

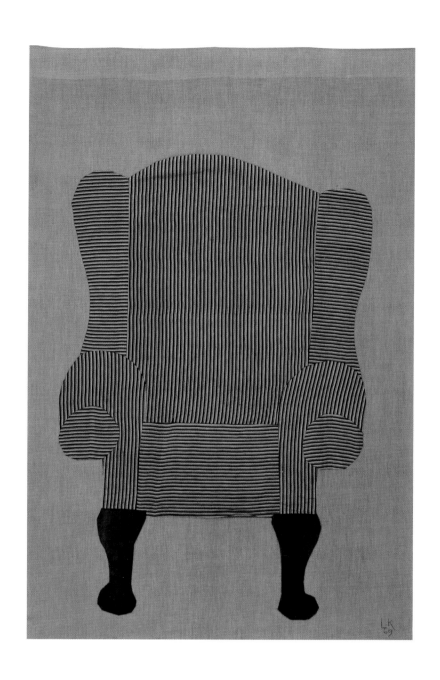

Chair, 1969
Embroidered fabric
85 x 54 inches

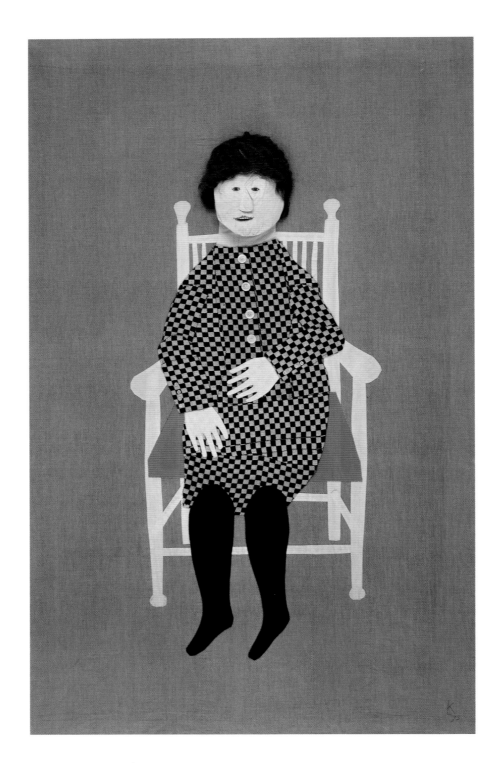

Untitled (Woman in White Chair), 1973
Embroidered fabric
88 x 55 inches

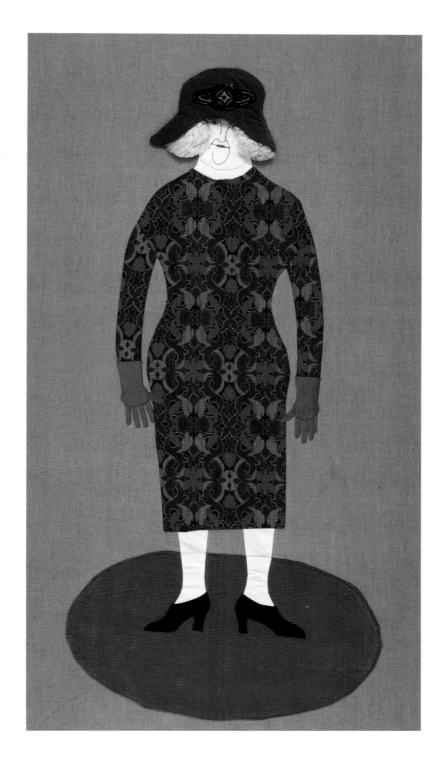

Untitled (Red Lady), circa 1965–1969
Embroidered fabric
99 x 54 inches

I wanted to go back to Walt Whitman's house in Camden this summer, to renew my memory of those rooms. I'd checked the house's open days on the web, but I hadn't thought to call ahead, and when we pulled up to the cluster of wood-frame and brick houses—among the last such stalwarts standing, on the wide boulevard the street's become—there was a sign on the door. Summer vacation. What startled Paul and me both, as we stood on the sidewalk in front of Whitman's stoop, was that we almost had the place to ourselves. In 1996 Martin Luther King Boulevard—once Mickle Street, then Mickle Boulevard—was bristling with life, even though a large state prison glowered across the street, like some anonymous 1960s high school stripped of windows and inflated several stories high. Ramshackle row houses, shouting boys playing with tire rims and basketballs, people hanging out on the corners. Today, all but empty: a couple with the look of lovers talking quietly on the stoop next door with their knees drawn up to their chests. A young man splayed on a stairway, nodding to the beat buzzing out into the air from his headphones, who dropped his iPod when we walked by, and said, "Oh, that hurts," when Paul said he'd done just the same thing. Hot Saturday afternoon, some locusts buzzing, barely a car going by. The majority of the houses have given way to open grassy lots with an occasional shade tree. MLK Boulevard seems intended to funnel drivers through a neutralized inner city toward waterfront attractions: band shell, an aquarium with jellyfish and sharks, and—near the spot where Whitman used to ride the ferry across the Delaware to Philadelphia, and in his later years ride back and forth for the open air and the company of the ferrymen—there's a sort of toy version, an old ferryboat that will take you out into the river for an hour.

I could remember, behind the locked wooden door, the daylight all honey-amber through the drawn shades, and the old man's bed upstairs, display cases and framed images: many invitations to dinners, framed menus, testimonials. His leather backpack, wonderfully crumpled. But we wouldn't be seeing any of that today. We pace a little on the street, take some pictures, pace a little more. It would be absurd to head back home. What to do? A pilgrimage to the tomb, where we've never been. The houses of writers (of which there aren't all that many in the U.S. to visit, when you think of it) fascinate me; their graves, a bit less. But we've come a long way, and it's only a mile or two.

You wouldn't know that Harleigh Cemetery is built on hilly land when you turn in the gates from Haddon Road. Drive in a little and you discover

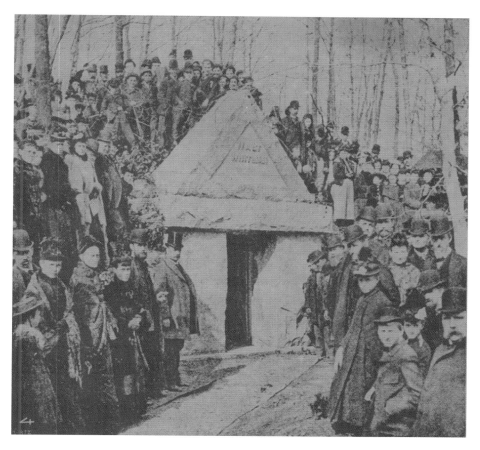

Walt Whitman's Harleigh Cemetery tomb, Camden, New Jersey, 1892

a small valley below, the view obscured by trees and the bulk of old tombs. Many graveled roads curve off from the main stem, inviting confusion. "Shouldn't there be a sign?" Just as I ask the question, a placard mounted on a stake by the road appears, with directions to the grave of Nick Virgilio. "Oh," says Paul, "Nick Virgilio!" Paul not only grew up nearby, in Cherry Hill, New Jersey, but he was born in the 1930s hospital that overlooks Harleigh. Did his mother's room, I catch myself wondering, look out over Walt's tomb?

Virgilio, Paul explains, was a local poet who specialized in haiku. The aficionados of haiku form a counterculture in American poetry; they're an enclosed garden. They argue about whether it's necessary or useful to import Japanese syllable counts into English, and whether the inclusion of a seasonal word is required in each sparse poem. Virgilio was, in these disagreements, an aesthetic liberal. His headstone, apparently, is in the form of a podium, a place for poetry readings.

If you want to find the tomb of Walt Whitman, you're on your own. Does Camden feel that somebody from the twentieth century now deserves his share of the attention? Are they worried that the poet's tomb might be a hangout for unruly bohemians? Most likely Camden has other things to

worry about. Maybe there used to be signs, but they've been snatched away by avid disciples of *Leaves of Grass?*

We wander into a newer part of the cemetery, turn back, wind past a mausoleum, down into the valley we've been glimpsing along the way, and there it is, recognizable from the photos I've seen in Whitman's biographies. And though maybe my mood is a bit dampened by the locked doors of the house back on MLK, it's hard to deny that the tomb is a buggy, somber, and rather disconsolate place. Was it so deeply shaded when it was new? The crowns of thick maples tower overhead, and above those the terraced levels of the hospital. The monument was scooped into the side of the slope and assembled of large pieces of a brooding, bluish granite; the open door feels like the entrance to a cave. Between two large upright stones, there's a padlocked wrought-iron gate. Someone's tied some artificial blue flowers to it, how long ago? They've faded in the weather. Behind them, the unimaginably heavy stone door, ajar. Through this opening you can look into the shallow space of the crypt. On a wall of granite, six flat marble rectangles mark the spaces where the six Whitmans lie, in this order:

| Louisa | George | Edward |
| Louisa Sr. | Walt | Walter |

Thus Walt himself lies beneath his sister-in-law and her husband, George, who fought in nearly every major battle of the Civil War, and beneath his mentally disabled brother, Eddie, with whom he shared a bed at the time Bronson Alcott made his famous visit to Whitman's attic bedroom in the family's Brooklyn house in 1856. The bed was unmade and still dented with the forms of the men who'd been sleeping there. Alcott described Whitman, who'd pasted pictures of Hercules, Bacchus, and a satyr on the walls, as "broad-shouldered, rouge-fleshed, Bacchus-browed, bearded like a satyr, and rank." Whitman left a good deal of the proceeds of his estate for Eddie's continuing care, though Walt's youngest brother died later the same year. The poet is placed between his parents, Louisa and Walter, whose bodies he had moved here from their original resting places on Long Island.

Whitman was offered a free plot in the cemetery in 1889, the year it opened, in exchange for a poem on the place. He accepted the gift, picked out the spot himself, but never wrote the poem. In 1891 the tomb cost $4,000, a sum which, Whitman's biographer Jerome Loving points out, was nearly twice what the poet had paid for the Mickle Street house. If you stand back to take in the triangular granite top piece, it's easy to see why. The capstone is huge, and it makes the whole structure vaguely Greek and mildly gothic.

Its blunt, centered lettering reads WALT WHITMAN—unsettling when you consider that there are five other Whitmans buried here. The poet has subsumed them, or perhaps it's more generous to say that he has surrounded himself, for the voyage, with chosen company.

Did Whitman himself dislike the tomb? His housekeeper Mary Davis writes that he visited the site to view the work in progress, and that "Mr. Whitman won't be paler when he is dead than he was when had alighted from the carriage and down into the tomb." The funeral, in March of 1892, was a ceremonious affair. Spectators lined Haddon Road; a large tent was erected near the grave. (Where did they put it? Perhaps the ornamental pond with its Florida golf course jet of water was a later addition to the scene). There were speeches. A strand of boosterism, with its optimistic fellowship of developers and opportunists, is the external side of Whitman's embrace of expansive American energies. At its highest form, it's the love of comrades, the affectionate company of fellow spirits making home and love in the wilderness; at its basest, it's the Camden Rotary.

Peter Doyle, the streetcar conductor from D. C. whom Whitman called his "tenderest lover," stood at a distance from the scene, up on the hill away from everyone (rather in the way the tomb stands away from almost all the other graves. Look closely and you can find a name carved on a small stone beside it, but that headstone toppled over quite a while ago, and another smallish but still upright stone is hard to spot. The monument broods alone). Pete said he never really liked Walt's literary friends. In one of the most beautiful of the many photographs of Whitman—he was perpetually interested in how the man he'd made of himself was to be represented, in both word and image—Pete and Walt sit in three-quarter profile, each turned toward the other, each with a wry half-smile. It's the pose of a married couple, of two who form a unit. This is one of the very few photographs of the poet in which he isn't looking at the camera, composing himself for the viewer; the two men only have eyes for each other. It says more, to my mind, than outpourings of writing by cultural historians and social theorists who've parsed the affectional lives of pre-twentieth-century men at some length. The best of Whitman's biographers practically turn somersaults trying to tell us about "passionate friendship" and insist that contemporary points of view cannot be

Walt Whitman
Burial vault design (detail),
circa 1891
Graphite and ink on paper

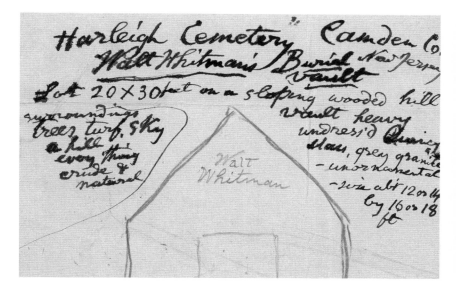

exported to the past, so that we shouldn't take the evident homoeroticism of Whitman's work as evidence of any sense of identity on the poet's part. There is a point there, but these defenses tend to come across not as intellectual caveats but something more like the protection of turf, a refusal to allow a beloved poet to be claimed. The photograph makes such discussion feel like so much spilled ink; there's a kind of energy field in the two men's attention directed toward one another that says—well, what? How did they describe themselves, to themselves or others? Irrecoverable, almost, though the glints and hints gleam out of letters and bits of prose and most of all from the poems themselves. There is something incontestable about the photograph, though as soon as I try to put language to it this ceases to be so; any description of a picture can be argued with, but a gaze cannot.

Paul and I study the slope leading back up toward the entryway and try to picture Doyle there. His presence haunts descriptions of the event; perhaps he shades the tomb itself. John Burroughs, a friend and admirer of Whitman, described Doyle "up the hill, twirling a switch in his hand, his tall figure and big soft hat impressively set against the white-blue sky." What would you do, if you were nervous, if you felt unwelcome, wanted to look on and yet set yourself apart from the external hoopla, the public realm? Twirl a stick.

A modern stone installed a few feet in front of the tomb seems a permanent, contemporary version of the act of twirling a switch. The slick black granite's inscribed with a passage from the end of "Song of Myself":

> I depart as air, I shake my white locks at the runaway sun,
> I effuse my flesh in eddies, and drift it in lacy jags.
>
> I bequeath myself to the dirt to grow from the grass I love,
> If you want me again look for me under your boot-soles.

Whoever commissioned those etched letters—now partly worn away, after only thirty or forty years—must have had some commentary in mind. Whitman's flesh has not been bequeathed to soil; it is crypted where no grass takes root. Of his bodily organs, only the brain isn't interred here; being "abnormally large" and of obvious interest, it was removed for study at the American Anthropometric Society, an institution the phrenologically minded Whitman would have been intrigued by. There it's said to have been dropped and destroyed by a clumsy lab assistant.

If you want me again, look for me under your boot-soles. Should we not even bother to look here? Is the door of the tomb closed, as well as the doors to the poet's house? Many others, of course, have made this pilgrimage too, and evidence of their passing is the only cheering thing in sight: bits of graffiti knifed onto the bark of birches: "MAE + LOUISE" and "I LOVE YOU WALT."

The Whitman who dismisses mortality is the famous one. "Even the smallest sprout shows there really is no death," he announces in the great outpouring of a poem that marked his unforgettable entrance onto the stage. "And if ever there was," he continues, aware that this risky assertion requires immediate qualification, "it led forward life, and did not wait at the end to erase it. . . ." If the self is porous and multiple, and the "I" isn't contained "between my hat and my boot-soles," then what difference could individual death make, when the teeming and various whole goes on?

But that great current of fresh air is countered by another strain in Whitman's poetry, as American as those sad urns carved in shallow bas relief on early headstones, the weeping willows and winged death's heads of old burial grounds. In the glorious poem that first appeared in the 1860 edition of his book, under the title "A Word Out of the Sea," and that he'd later call "Out of the Cradle Endlessly Rocking," the speaker "translates" the song of a widowed bird, and speculates that it was his childhood encounter with that grief-melody that made him a poet.

> The word final, superior to all,
> Subtle sent up—what is it?—I listen;
> Are you whispering it, and have been all the time,
> you sea-waves?
> Is that it from our liquid rims and wet sands?
>
> Answering, the sea,
> Delaying not, hurrying not,
> Whispered me through the night, and very plainly
> before daybreak,
> Lisped to me constantly the low and delicious word
> DEATH,
> And again Death, ever Death, Death, Death,
> Hissing melodious, neither like the bird, nor like my
> aroused child's heart,
> But edging near, as privately for me, rustling at
> my feet,
> And creeping thence steadily up to my ears,
> Death, Death, Death, Death, Death.

That is an extraordinary passage in its own right, but even more so because it comes after the ecstatic affirmations of poems written just a few years before. "Song of Myself" (1855) refused to identify the self with the limited ego, bound in its sack of skin, and thus the unbounded consciousness of the speaker ranges from one body to the next, moves across time and space, experiencing itself as part of an endless cycle of redistributed energies: buried mouths become speaking tongues. Bodies become grass become text.

At the pinnacle of his visionary intensity, Whitman's speaker sees the

world as one vast recirculant stream, a position that makes the lamentation of individual loss absurd. But just as Whitman's contemporary and fellow outsider Emily Dickinson would continually change her mind about the nature of our mortal condition, so Whitman's ecstatic point of view never seems to erase its opposite, a kind of dark romance attached to the fate of the individual body. This streak of—morbidity?—remains a constant in Whitman's work. Perhaps there's no poem that serves as a greater contrast to the bravura dismissal of death in section six of "Song of Myself" than the second poem in the Calamus sequence of 1860, the odd and elusive "Scented Herbage of My Breast." In it, Whitman proposes that leaves—the sheaf of poems we're reading—rise up out of his chest: "tomb leaves, body leaves, growing up above me, above death." The dark and swaying plant that has emerged from the speaker's chest, he tells us, produces leaf/poems that are beautiful and bitter, and this "chant of lovers" must be directed toward death. Where the poem has so far been an apostrophe to this mysterious, bodily efflorescence, the speaker shifts, in the final lines, to address Death directly.

> Give me your tone, therefore, O Death, that I may
> accord with it,
> Give me yourself—for I see that you belong to me
> now above all, and are folded to-
> gether above all—you Love and Death are;
> Nor will I allow you to balk me any more with what I
> was calling life,
> For now it is conveyed to me that you are the pur-
> ports essential,
> That you hide in these shifting forms of life, for reasons
> —and that they are mainly for you,
> That you, beyond them, come forth, to remain, the
> real reality,
> That behind the mask of materials you patiently wait,
> no matter how long,
> That you will one day, perhaps, take control of all,
> That you will perhaps dissipate this entire show of
> appearance,
> That may be you are what it is all for—but it does not
> last so very long,
> But you will last very long.

"That may be you are what it is all for"—what an odd affirmation of death. If before, death "led forward life," now Whitman proposes that life exists solely to serve emptiness, that everything moves toward the stasis and silence beneath the "show of appearances." The "mask of materials" is brief, considered in the perspective of death-time; beneath it lies the long sweet void of oblivion.

This is rather more than half in love with easeful death. Perhaps rest holds a deep allure, for a spirit so restlessly roaming, so interested in entering into all the teeming life around it. If you are everything and everywhere, what can provide balance except the restful prospect of being no one and nowhere?

———•·•———

There's one clear emblem of rest and respite in Whitman's life at the Camden house, or at least there used to be. I like thinking back to it, after standing face to face with the melancholy blank of the massive doorway to Whitman's crypt. Now the clutch of houses on MLK Boulevard stand apart from the open space around them with a little of that set-apartness his tomb has, but unlike the cool monument they are lively, particular, and friendly with human detail.

And they were even more so in 1996. We'd been to the Rosenbach Library across the Delaware in Philadelphia, a marvelous literary collection where you can see the letters Elizabeth Bishop decorated for Marianne Moore, and Moore's elegantly wry postcards sent in return. I held in my hands Isadora Duncan's copy of *Leaves of Grass*, and felt the sturdy vine of a tradition pushing forward in time, pushing still, a current of freedom and liberality moving from the soul-opening visions of the 1850s into the twentieth century, into Duncan's unfettered performance, and from her bodily abandon into the mind of the young man who watched, enthralled, in a Cleveland theater in 1922, the young Hart Crane set afire by the wildness of her art.

But in the Whitman house it was a little hard to feel any of that: too many emblems of the public life, stuff that might have gone into the scrapbook or archives of an old poet wanting to be reminded who he was. I was 43 when we made that visit; I am 56 now, and I feel rather more sympathy for the man who wanted to make sure his name was written in the world somewhere, and moved by the old man's uncertainty that anyone would remember him. In 1856, aflame with the radiant certainty that became "Crossing Brooklyn Ferry," he understood that he was both addressing his audience in the future and simultaneously creating them. There was not a doubt in his mind that he was there, a hundred years hence, enjoying the attention of his readers, fused with those who looked now or anytime at the late sunlight on the East River. But decades had passed. He'd suffered strokes, lost his physical vitality, seen his hopes for a democracy founded on the love of comrades shattered in the makeshift hospital beds of D.C. He'd lost his job for publishing scandalous verse. And he'd gained a deeper wariness about self-disclosure, as a medical model of the normative (ironically prefigured by the phrenology that fascinated him) took hold, and Whitman's assertions of comradely passion grew suspect.

No wonder he wanted a tomb, and it's petty of me to be annoyed with him for desiring one. What irks me, of course, isn't the melancholy site itself, but something closer to home, which has to do with the performance of the private man as the public poet. Whitman's great poems are idiosyncratic, deeply peculiar, and so radical in their perspectives that, one hundred and fifty years later, they feel like frontal assaults on conventional ontology. I cheer those poems on with every dimension of myself as a reader, and yet there are aspects of Whitman's performance that seem false and disheartening: Whitman the nativist and nationalist, the Whitman who cheers on the War (before it begins), the fake heterosexual claiming a batch of illegitimate children and attempting to write erotic poems that inevitably degenerate into eugenics. A bracingly radical reconstruction of "I" that shades into posing and an uncomfortable self-consciousness. A dilution of the power of his own project though the obsessive padding and reordering of his book, so that what begins as a new gospel ends as a large Victorian album.

But there is more than one paradox on the table here. Whitman's genius seems to have been dependent upon the creation of a speaking character; he replaced Walter Whitman, journalist, failed schoolteacher, temperance novelist, sometime dandy, with Walt Whitman, radiant camerado, singer of the most deeply American of songs. The poems cannot be written until the poet who will speak them is invented, a notion that has been informing American poetry ever since. As one who's been busy for decades making a version of my own life heard, how could Whitman's tomb not make me squirm?

But thirteen years ago, inside the honey-colored rooms, I came upon a wooden box windowed with glass, like a lost Cornell suddenly showing up on an upper shelf where you'd least expect it, and inside it, small, green, and permanently cheerful, was Walt's parrot. I hear it's no longer on display; a friend told me it had been moved to storage or sent off for restoration. Maybe it was moldering a little, after all these years. But that day he was as alert and poised as a stuffed bird could be, the windows and the room given back upside down and in miniature on the curve of his glass eye. Firmly dead as he was, maybe all the more so for being immortal now, he was nonetheless the first sign of the actual life lived here, the breathing air. He was the opposite of the tomb. And as I stood staring into the window of his box I found myself seeing him on the poet's arm, or climbing up a wool sleeve toward Walt's shoulder, where he could sit there above the famous open collar. And I slipped for a moment, as we do far more often than is usually acknowledged, out of myself, and I was looking through the eyes of that little green fellow when those eyes were not fixed replacements. I saw the pinkish, wrinkled skin of a robust old man's neck, right beside me, warm, and suddenly I could smell it, that skin, the talc from his bath.

Mitchell Algus

Sometimes the artists to whom we are strongly drawn appear to be the most reactionary. That is their charm, and Valentine Hugo is one of these artists: her style is anti-modern and illustrational, evoking Symbolism, the Pre-Raphaelites, and William Blake; her subjects Romantic and feminine in a way that seems at odds with the avant-garde circles in which she traveled, at first in the world of theater and music with the Ballet Russes, Jean Cocteau, Antonin Artaud, and Eric Satie, then beside André Breton, Paul Éluard and the Surrealists.

Born Valentine Gross in Boulonge-sur-Mer, France, in 1887, Hugo studied at the École des Beaux-Arts in Paris, graduating with high honors in 1910. Her first exhibition, in 1913, was of drawings from the premiere of Stravinsky's *Rites of Spring*, documenting Nijinsky's performance. Graciously social, Hugo's apartment became an informal salon, where Picasso, Satie, and Cocteau conceived *Parade* for the Ballets Russes in 1917. In 1919 Valentine married Jean Hugo, Victor Hugo's great-grandson and a collaborator of Cocteau's. By the late 1920s, as her relationship with Jean deteriorated, she fell in with the Surrealists, particularly Breton, with whom she had an eighteen-month affair, and Éluard, for whose poems she became the premier illustrator. Under Breton's influence, Hugo's art was transformed, flowering into a lapidarian haze. It is this confluence of inverted romance and somnambulant violence that makes her art so compelling. Illustrating de Sade, Lautréamont, and the German Romantic Achim von Arnim, Hugo's work is significant in bringing a unique and female perspective to the outrè psychosexual literature championed by the Surrealists.

In 1963, sixty artists, writers and composers—including Picasso, Poulenc, Michaux, Dalí, Miró and Giacometti—came together for a show at the Palais Galliera, the proceeds of which went to the support of Hugo. She died in Paris in 1968.

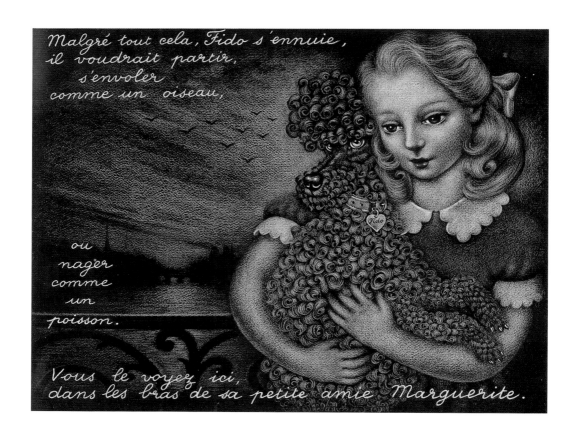

Malgré tout cela, Fido s'ennuie,
il voudrait partir,
s'envoler
comme un oiseau,

ou
nager
comme
un
poisson.

Vous le voyez ici,
dans les bras de sa petite amie Marguerite.

All images from *Les aventures de Fido caniche*, 1947
Guy Le Prat, Éditeur, Paris
9 x 12 inches

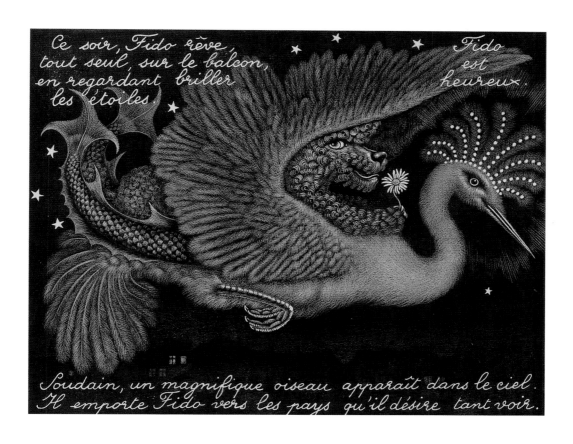

Ce soir, Fido rêve, tout seul, sur le balcon, en regardant briller les étoiles. Fido est heureux.

Soudain, un magnifique oiseau apparaît dans le ciel. Il emporte Fido vers les pays qu'il désire tant voir.

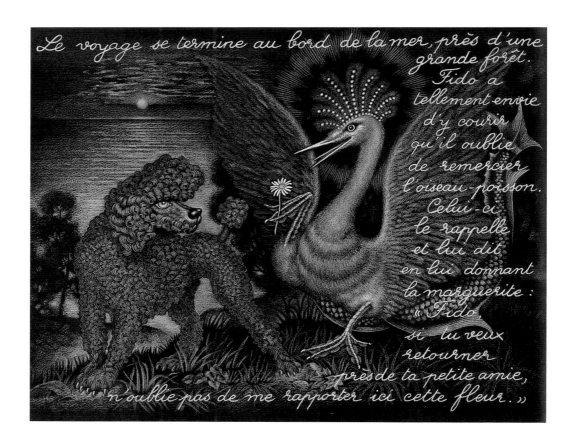

Le voyage se termine au bord de la mer, près d'une grande forêt. Fido a tellement envie d'y courir qu'il oublie de remercier l'oiseau-poisson. Celui-ci le rappelle et lui dit en lui donnant la marguerite : « Fido, si tu veux retourner près de ta petite amie, n'oublie pas de me rapporter ici cette fleur. »

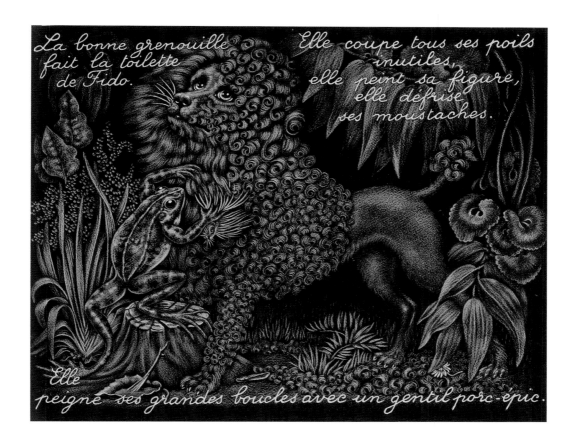

La bonne grenouille fait la toilette de Fido.

Elle coupe tous ses poils inutiles, elle peint sa figure, elle défrise ses moustaches.

Elle peigne ses grandes boucles avec un gentil porc-épic.

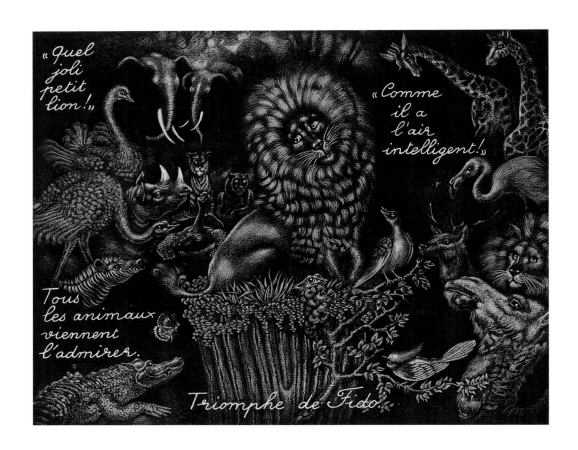

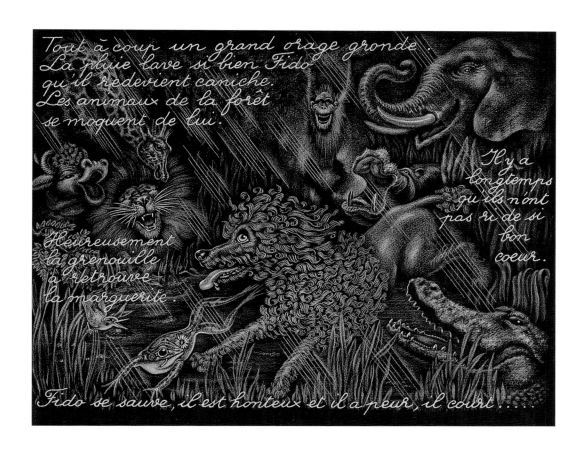

Tout à coup un grand orage gronde.
La pluie lave si bien Fido
qu'il redevient caniche.
Les animaux de la forêt
se moquent de lui.

Il y a
longtemps
qu'ils n'ont
pas ri de si
bon
cœur.

Heureusement
la grenouille
a retrouvé
la marguerite.

Fido se sauve, il est honteux et il a peur, il court.....

55

Gary Cardot
Susanna Coffey
Jon Gregg
Carl Plansky

Gary Cardot
Drag Queen as Marie-Antoinette, 2008
C-print
30 x 40 inches

Gary Cardot
Marie-Antoinette in My Garden, 2008
C-print
30 x 40 inches

Gary Cardot
Profile of Marie-Antoinette, 2008
C-print
30 x 40 inches

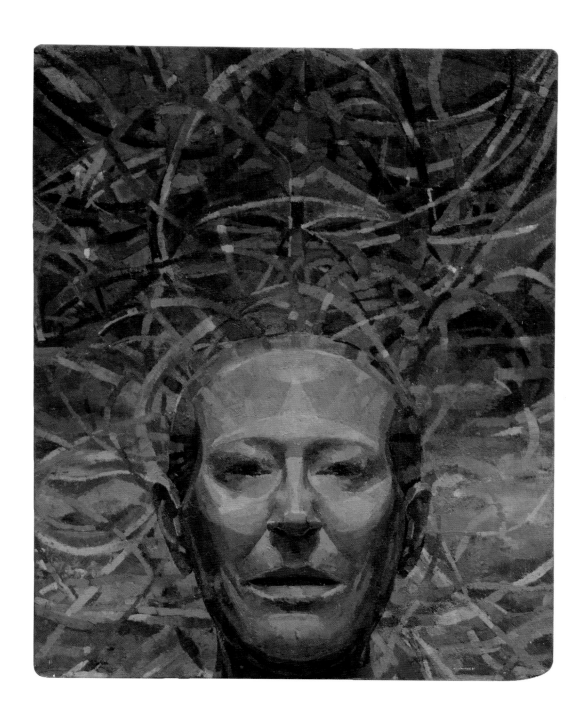

Susanna Coffey
Oxossi, Moss Glen Falls, 2008
Oil on panel
15 x 12 inches

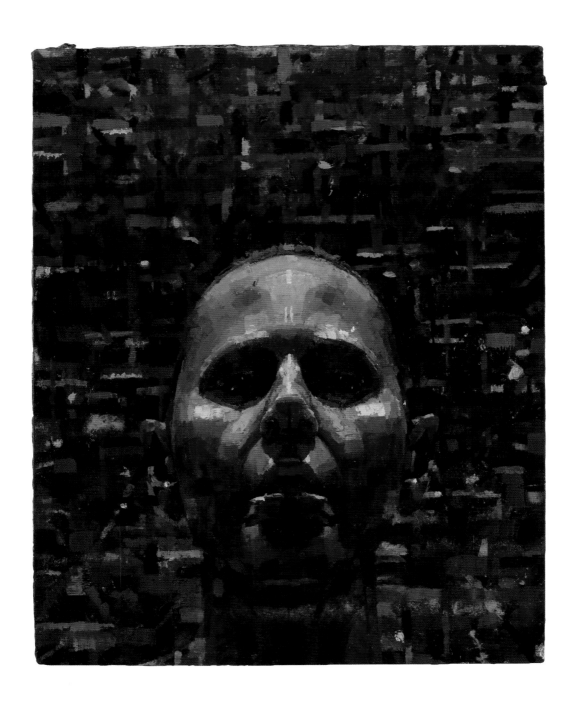

Susanna Coffey
Intake, 2008
Oil on panel
15 x 12 inches

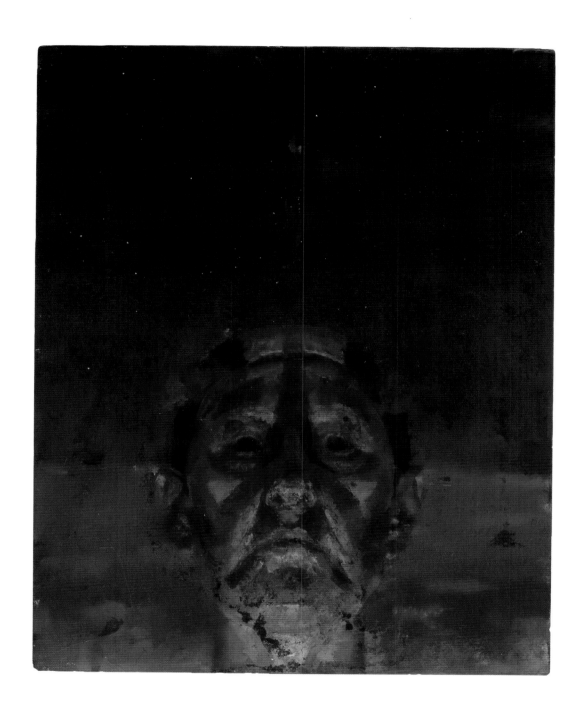

Susanna Coffey
Fall's End, 2008
Oil on panel
15 x 12 inches

Jon Gregg
Black and Blue, 2008
Oilstick and oil pastel on paper
22 x 30 inches

Jon Gregg
Red Bodhi Tree, 2009
Oilstick and oil pastel on paper
22 x 30 inches

Jon Gregg
Wagon Blues, 2009
Oilstick and oil pastel on paper
22 x 30 inches

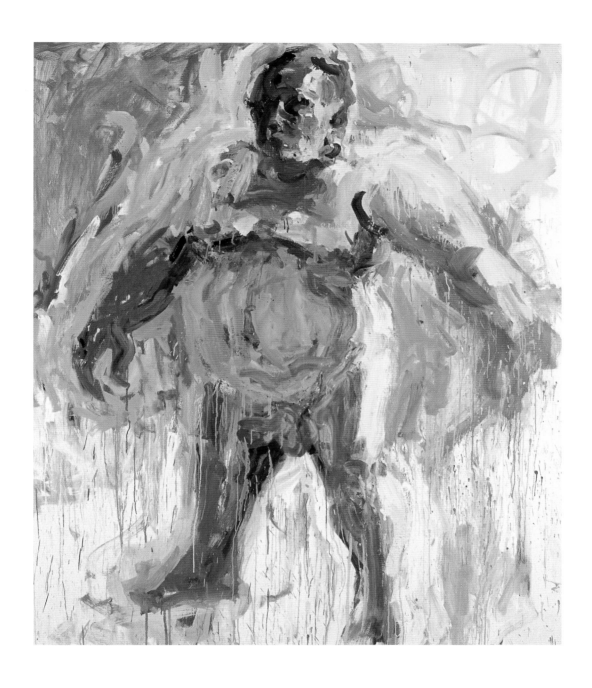

Carl Plansky
Prague Encounters, 2007
Oil on linen
84 x 66 inches

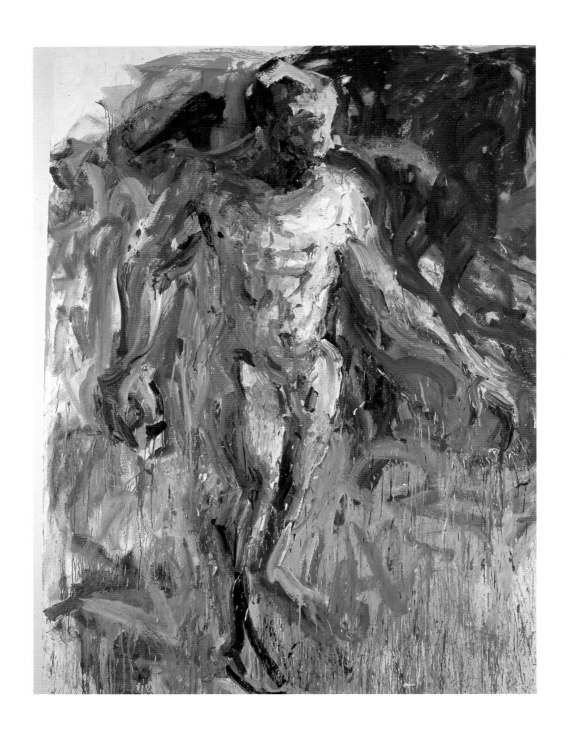

Carl Plansky
On the Duna Corso, 2007
Oil on linen
96 x 72 inches

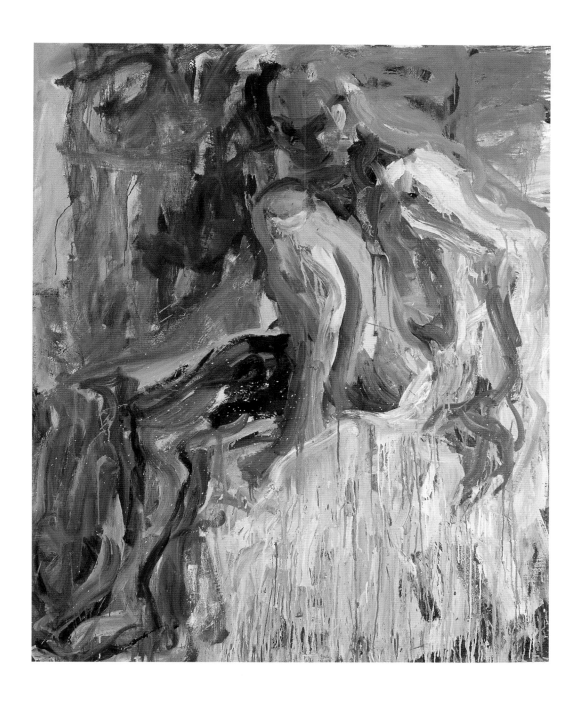

Carl Plansky
Paolo, 2007
Oil on linen
72 x 60 inches

GIORGIO MORANDI

Morandi's name almost disappears among the concrete chicanes,
the weathervanes nervous and grieving
the whispering elms with their ghostly demeanor, their tips swaying
or the hand without trumps or the brush that goes with it

and then suddenly it doesn't. Or off in the distance
surf pounding the shore along the Costa Leuca
not the view from his 4 storey window,
not your 5 o'clock shadow, not the dog days of August
but almost. And then the name remains hidden awhile
or the street or the tram tracks go sleeping,
or as if several blue jays were pretending a rout
then turned around causing much mischief.
The petals the stamens the meager corollas tangled and drooping.
The table askew. A thick gloom descending.

JOHN FREDERICK KENSETT

You find none of the electrical sparking the mini-tornadoes
cracked windows.
You don't see the flutes of smoke in the distance, farmers
toiling their fields in the lower righthand corner
or snug in the middle ground,
or a hint of the drowning that caused the pneumonia,
the mending, then sudden death on a Saturday.
It's been said his world never darkened nor chafed at the edges.
You don't see the sledders, the wet snow falling, the voids
or the scumbling. Couples moving about or taking the waters.
Not your once in a while rainy day.
Not your elm branches sighing. Not the bravura the chomping
of axes the oohs and ahs and the echoes.

No anecdotal figures. No anecdotal anything.

AZURE CHAMPOT

It wasn't the Normandie coast, per se. But more inland.
It wasn't stinky cheese or osprey
clamouring on the one last available rock
before the tide seethes, churning up toys bottle-tops
a starfish or two, according to what,
except for moonlit serenades, but no moon and who's serenading?
Wasn't anything you can pinpoint exactly—unrelated plots
the turn of the century before last or the day before yesterday
or the prelude before the maelstrom.
Still no sign of the mailman or the laundry delivery.
Still no hints and clues along the rue de Vosges
as to what he'd been doing out of the limelight or those
twenty-odd years marked by reclusion before taking the plunge.
Was he pencilling in a few notes before winter not to forget?
Was he dipping a week-old baguette
into coffee? Was there anything left
to discuss—the mimeo cobwebbed
and tarped in a barn at the town's edge
sheafs of hand-stencilled affiche peeling maquettes
a note or two to a comrade in Paris. Les Halles long gone.
Still no word as to what happened next.
Any number of maybes.

for Guy Debord

Mark Shortliffe

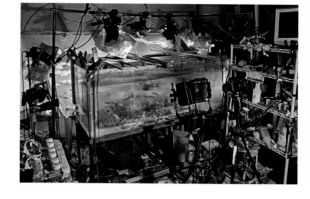

Kim Keever's studio, New York

I was not sure what to expect visiting Kim Keever's New York studio. I had known his photographs for some time, and enjoyed them well before having a full understanding of his process. Monumental in size (see the full-scale detail to the left!) and saturated in color, they are endlessly intriguing in their sublime, almost frightening, beauty. Although something is surely odd in their making—painterly while photographic, artificial while true, foreign while strangely familiar—questions of their technical process were not what grabbed me. Yet at the same time, I wanted badly to know their origin: How were such worlds possible? What obsessive mind did they come from? And where on our earth were they created?

Perhaps an unknowable origin is enough, even desirable. No amount of investigation can really answer these questions nor are they necessary to validate beauty and meaning in art. Certainly, the photograph is the thing—I normally feel art should not be dependant on a background narrative or explanatory text (such as this one!)—but, my goodness, standing face-to-face with Keever's spectacular sets was a unique experience on par with viewing his photographs. I immediately realized the importance of this studio as a living, breathing laboratory, essential in the genesis of the photos (biblical pun intended) and an artwork in its own right. Keever has managed to create two parallel bodies of work, one public and one private. Because for Keever, the studio is as real as the photographs.

Forfeiting the bedroom in his one-bedroom prewar apartment, Keever has constructed an elaborate diorama inside and surrounding a two hundred gallon fish tank. To create each unique moment in the time of his photographic world, Keever uses plaster to construct mountain ranges, found twigs and leaves as foliage, bags of pulled cotton as spectacular clouds, and drops of paint dispersed in the tank's water as atmosphere. The entire room is given over to shelves of paint, the enormous tank, gelled lights on tripods, colored tubes, circuit breakers, plaster dust, cameras, and the other endless supplies that build and capture his mythical realms. As with the photographs, this room is like nothing else, but it is also tangible and real, accessible. I know these items—this place—immediately, even if I could never have imagined their packed wonder behind the apartment door. Imagine what the neighbors must think—if they even know!

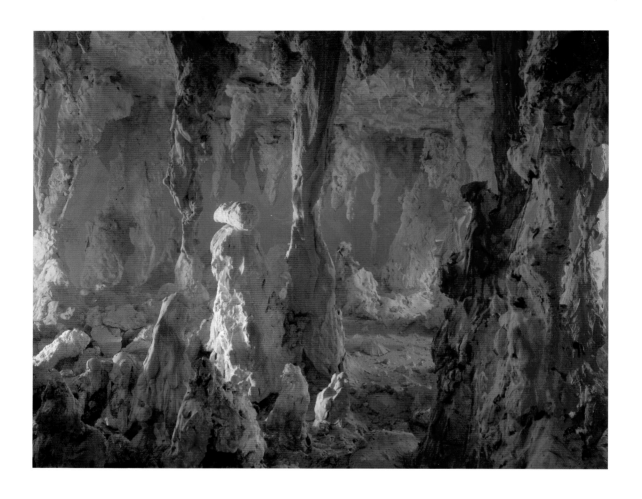

Buried Dreams, 1993
C-print
34 x 44 inches
All images courtesy Kinz + Tillou Fine Art, New York

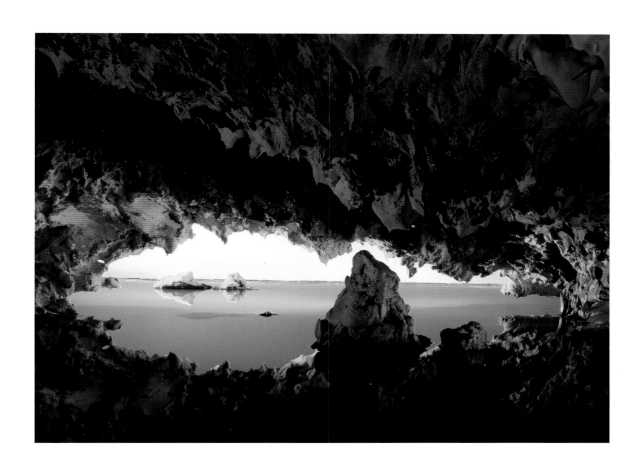

Out from In, 1996
C-print
34 x 44 inches

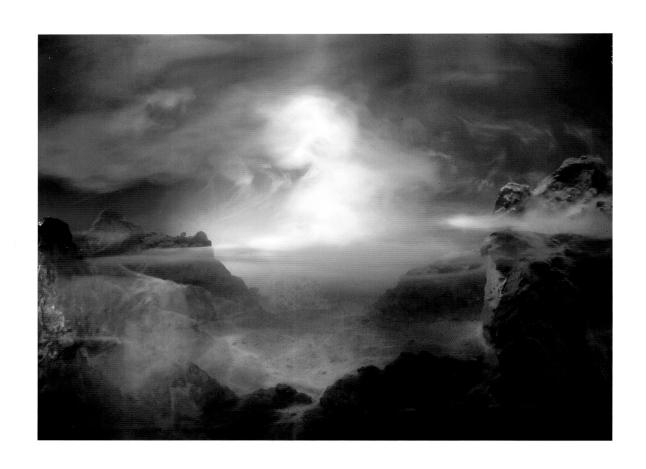

Girl on a Road, 1998
C-print
34 x 44 inches

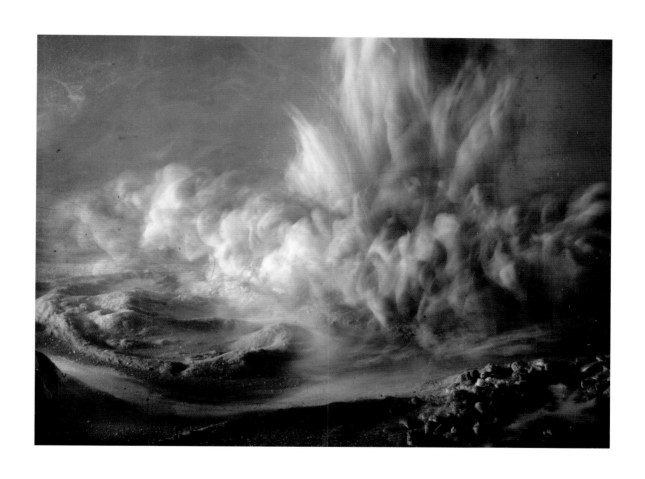

You Were Mine Once, 2000
C-print
48 x 60 inches

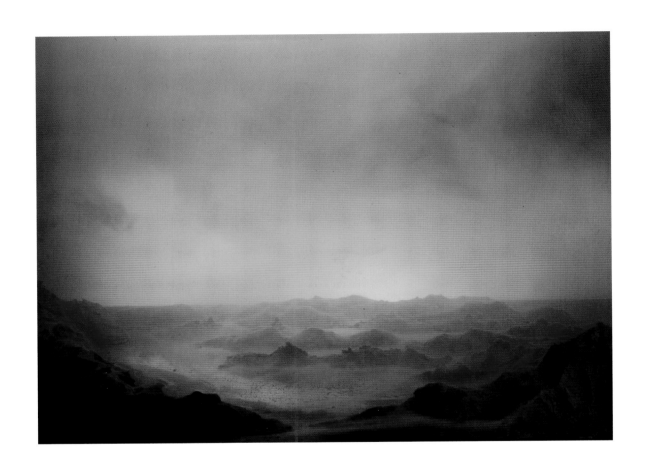

Heartlight, 1998
C-print
34 x 44 inches

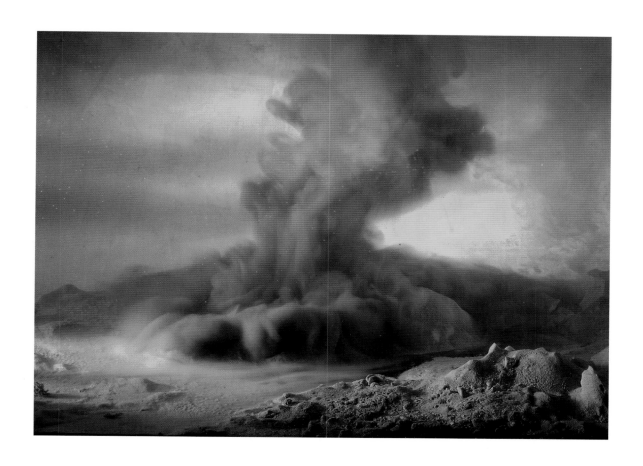

All Away, 2000
C-print
48 x 60 inches

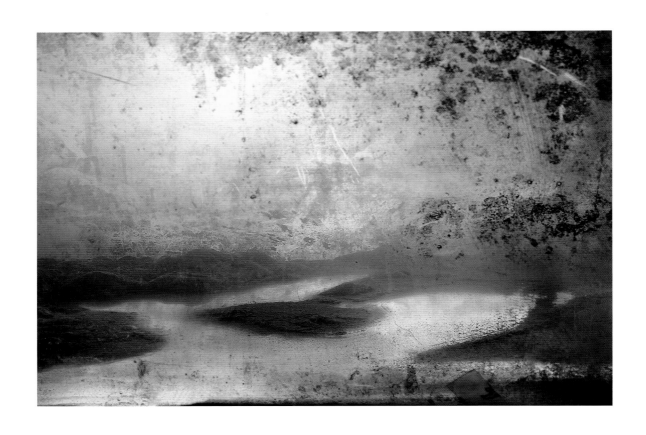

Eastern Shore, 2002
C-print
44 x 64 inches

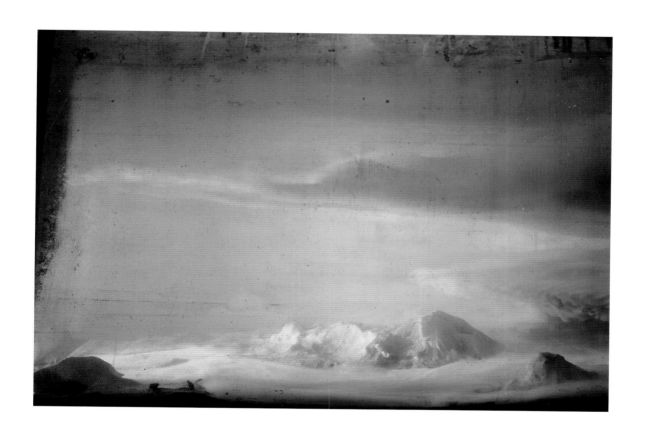

All to Ever, 2003
C-print
44 x 64 inches

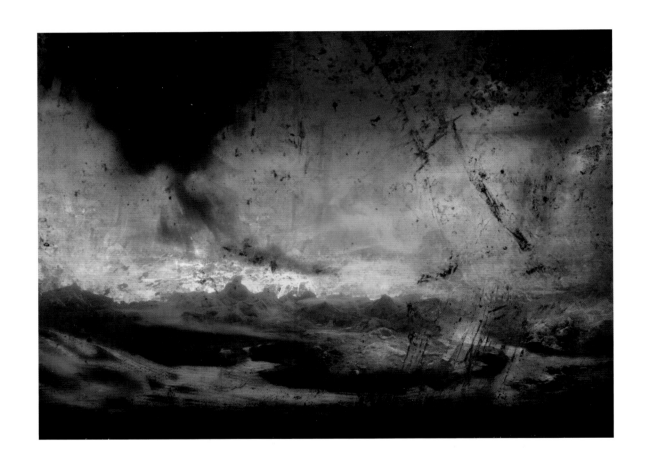

River Keeper, 2003
C-print
50 x 65 inches

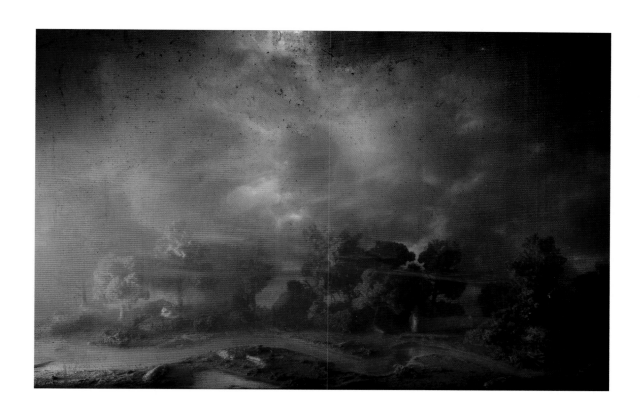

Palm 64, 2005
C-print
47 x 71 inches

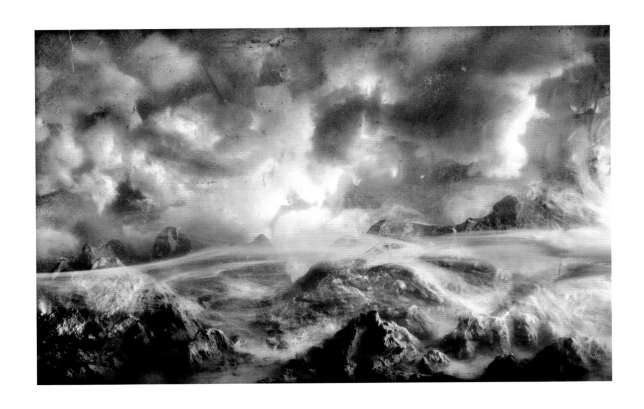

Winter 18, 2006
C-print
47 x 73 inches

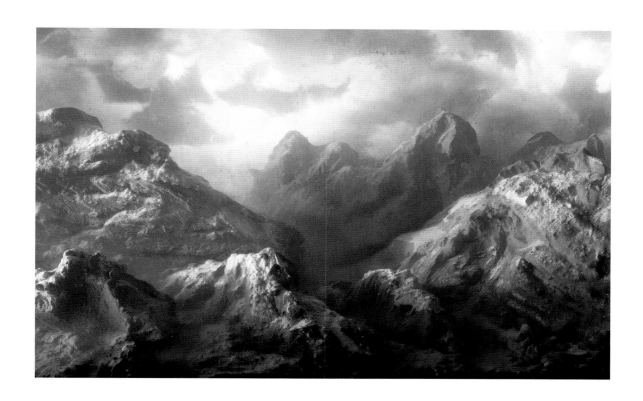

Winter 17, 2006
C-print
47 x 71 inches

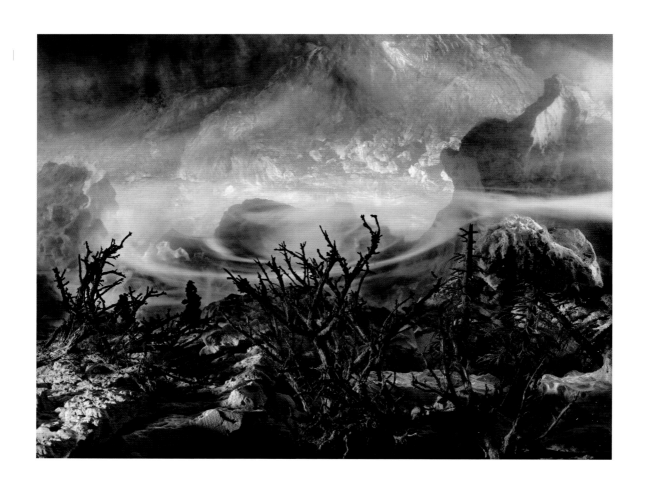

West 120j, 2009
C-print
44 x 57 inches

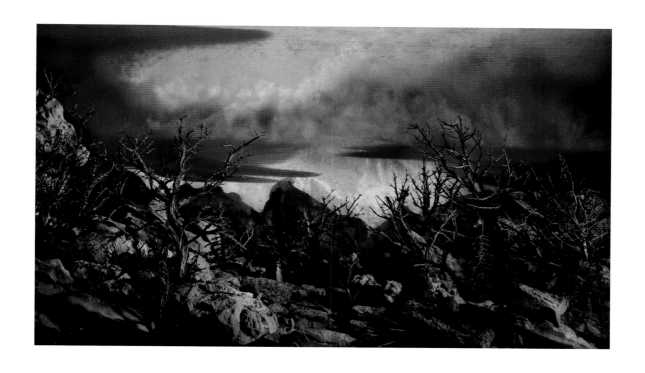

West 125m, 2009
C-print
46 x 77 inches

heimtyp

heimtyp a. g. celle, erste deutsche aktiengesellschaft für die errichtung typisierter eigenheime

| absender: **heimtyp a. g.** celle, allenhägener straße 34 | drahtwort: **heimtyp celle** | ruf: **celle 21 91** | bank: **deutsche bank und disconto-gesellschaft, filiale celle** | postcheck: **hannover 180 22** |

ihre zeichen ihre nachricht vom unsere zeichen tag

betrifft:

Stationery, 1930

NWG

ring „neue werbegestalter"

ring „neue werbegestalter" vorsitzender: k. schwitters, hannover, waldhausenstr. 5

postscheckkonto: verlag des merz. hannover 34201

ihre zeichen

ihre nachricht vom

unsere zeichen

tag

betreff

Stationery, circa 1928

MERZ WERBE
HANNOVER, WALDHAUSENSTR. 5
TELEFON 3504, NEBENANSCHL. FISCHER
POSTSCHECK-KONTO HANNOVER 34201
(VERLAG DES MERZ)
KURT SCHWITTERS
MITGLIED DES BUNDES DEUTSCHER
GEBRAUCHSGRAPHIKER

HANNOVER, DEN 12.12.27. 192

Lieber Zwart!

Weshalb antworten Sie nicht auf meine freundliche
Einladung zum Beitritt zu der Gruppe radikaler Reklamegestalter in Deutsc
land? Wir haben uns jetzt mit 9 Mitgliedern fest gegründet, das sind
Vordemberge, ich, Trump, Burchartz, Michel, Baumeister, Tschichold,
Dexel, Domela. Wir haben schon 2 Zeitschriften und 5 Ausstellungen. Das
ist viel für den Anfang. Wollen Sie nicht als ausländisches Mitglied bei-
treten? Dann sende ich Ihnen die nötigen Unterlagen. Und wollen Sie an ei
ner Ausstellung teilnehmen, in Köln, dann muss ich Arbeiten und für die
Ausstellung 10Mk zum Ersatz der entstehenden Unkosten haben. Wir möchten
auch gern Ihre Mitwirkung bei einem Artikel in der Zeitschrift Stuca, Pa-
ris, auch dazu muss ich Arbeiten haben. Ich habe zwar etwas von Ihnen hie
aber das betrachte ich als persönliches Eigebtum und ich bitte um andere
Arbeiten zum Verwenden für Propaganda. Das Mitgliedsgeld für die Vereini-
gung beträgt 18Mk jährlich. Also bitte senden Sie und treten Sie bei.
Herr A F del Marle in Paris, 20 rue poissonnière, bittet auch um einige
Arbeiten von Ihnen.
Mit besten Grüssen Ihr

[signature: Kurt Schwitters]

[handwritten notes]
14 XII 27.

MERZ
WERBEZENTRALE

Letter to Piet Zwart, December 12, 1927, on stationery circa 1927

Dear Gabo, my dear friend!

3 St Stephens Crescent, London W2

the 17.3.1941

Since about 2 years I am fortunately in England and am very glad about it. I tried where I could to get your addres, but didn't succeed. Today my friend the sculptor Hermann visited me and gave me your addres.

I have to see you as soon as possible. When do you come once to London, or where may I meet you. My son is too in England and has a good job as a photographer. He is married with a Norwegian girl, and both of them are working with the Norwegian government in London. I am painting abstrakt paintings, and besides portraits for earning my living. Hermann told me that you are known to Nicholson, I would be very pleased, to meet him too.

Please, write me soon. Remember Hannover, Berlin, Paris, my wife, Anneliese Eg, Madelene Hampmeau etc, etc.

With all my best wishes your

dada
Kurt Schwitters
MERZ

Letter to Naum Gabo, March 17, 1941

From *Sturm Bilderbücher IV*, 1920
Photolithography from rubber-stamp drawings
11 3/8 x 8 3/4 inches

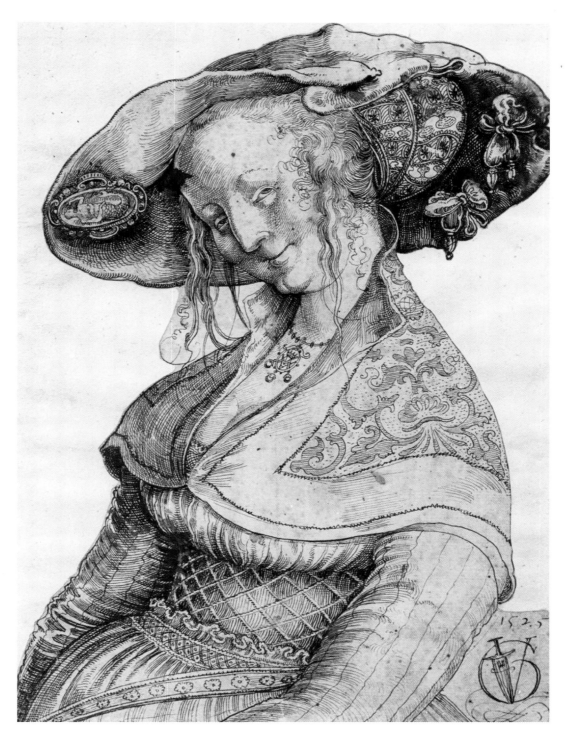

1. Urs Graf
Simpering Harlot, 1525
Ink on paper
10 5/8 x 7 7/8 inches
Anhaltische Gemäldegalerie, Dessau, Germany

böwörötääzääböpö
böwörötääzääböpö
böwörötääzääböpö
böwörötääböpö
böwörötääböpö
böwörötääböpö
böwörötääböpö
böwörötääböpö
böwörötääböpö
böwöböpö
böwöböpö
böwöböpö
böwöböpö
böwöböpö
böwöböpö
böwörö
böwörö
böwörö
böwörö
böwörö
böwörö
böwö
böwö
böwö
böwö
böwö
böwö
bö
bö
bö
bö
bö

böwörötääzääböpö
böwörötääzääböpö
böwörötääzääUu böpö
böwörötääzääUu böpö
böwörötääzääUu böpö
böwörötääzääUu böpö
böwörötääzääUu böpö
böwörötääzääUu böpö
böwörötääzääUu böpö
böwörötääzääUu pögö
böwörötääzääUu pögö
böwörötääzääUu pögö
böwörötääzääUu pögö
böwörötääzääUu pögö
böwörötääzääUu pögö
böwörötääzääUu pögiff
böwörötääzääUu pögiff
böwörötääzääUu pögiff
böwörötääzääUu pögiff
böwörötääzääUu pögiff
böwörötääzääUu pögiff
böwörötääzääUu pögiff
flumsböwötääzääUu pögiff
flumsböwötääzääUu pögiff
flumsböwötääzääUu pögiff
flumsböwötääzääUu pögiff
flumsböwötääzääUu pögiff
flumms bö wö tää zää Uu,
pögiff,
kwiiee
kwiiee
kwiiee
kwiiee
kwiiee
kwiiee.

Sound Poem
from *URSONATE*
circa 1922–23
Ink on paper
Artist proof
13 1/2 x 5 5/8 inches

From *Sturm Bilderbücher IV*, 1920
Photolithography from rubber-stamp drawings
11 3/8 x 8 3/4 inches

Christiane Andersson

<div align="right">

URS GRAF'S
EROTIC DRAWINGS

</div>

Urs Graf is one of the few exceptional Renaissance artists who has yet to be discovered by American audiences. The most gifted and innovative artist active in German-speaking Switzerland around 1520, he spent most of his life in Basel during the same years that Erasmus consulted there with his publishers and Hans Holbein began his career in that city. Graf's most important body of work, about 150 drawings, was created in pen and ink or in watercolor. Drawings created in such fugitive materials are kept away from daylight for their own preservation, stacked in large, air-tight Solander boxes and accessible only by appointment in print study rooms, where few seek them out. Unlike two other exceptional draftsmen of this period, his almost-contemporary Albrecht Dürer or his artistic soulmate, Hans Baldung Grien, Graf's work cannot be admired in museum galleries alongside the paintings of other early sixteenth-century artists because he seems to have only very rarely taken up the paintbrush. Active primarily as a goldsmith, a lucrative business at that time, Graf made a very comfortable living. When not away from Basel participating in military campaigns as a Swiss mercenary, he resided with his family in a four-story residence-cum-workshop, located in the center of Basel very near the town hall. He added to his goldsmith's income by designing book illustrations, stained glass, and jewelry. He also created engravings and a few etchings.

His preferred medium of drawing is the one to which he made the most important and lasting artistic contribution and to which he owes his place in Western art history. He used drawings in two very different ways: some are preparatory studies for works of art in other media, such as designs for daggers or for stained glass, while others are entirely independent of such ulterior purposes. These latter works are his most fascinating drawings, made as independent works of art in their own right. Free from the constraints of traditional imagery, Graf fully exploited the potential of his medium for personal expression. In so doing he provided us with unparalleled insights into his life and times and into his own psyche.

In his drawings he addressed both public and personal issues: his drawings are trenchant commentaries on the world around him but also extremely personal statements of his most intimate fascinations and fears. Some are quickly sketched, whimsical records of a sudden insight, passing mood, or witty observation, while others appear to be the carefully considered products of intense contemplation.

Women, especially his wishful-thinking constructions of the ideal

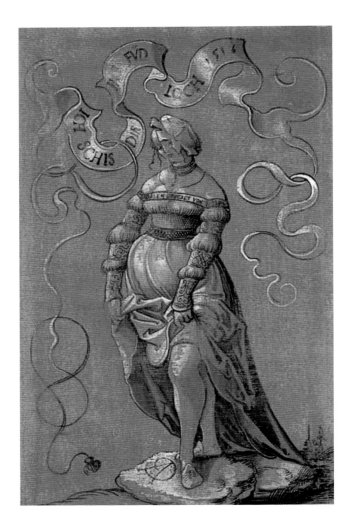

2. Urs Graf
Whore Lifting Her Dress, 1516
Ink and colored pencil over
red ground on paper
8 3/4 x 5 3/4 inches
Kunstmuseum Basel

woman, sexually available and compliant at any moment, are a central theme in his work. A large pen-and-ink sketch of a simpering young woman, signed and dated 1525 at the lower right [fig. 1], may at first appear to be a portrait of someone he knew. But more likely Graf has captured on paper his private fantasy of an attractive and available female, with ample breasts, glancing coquettishly from under her hat, and signaling her sexual interest in the artist. In 1525 no "proper" woman would have dared gaze at a man in such a direct and provocative way. Graf probably meant to create the image of a successful, well-dressed harlot. Her wealth is suggested by her elaborately stitched dress and carefully embroidered fichu, by her lavish hairnet, the floppy leather hat adorned with silk bows, and the jewelry she wears. The hat ornament and the necklace with a broach containing the crowned initials MA are the kind of objects Graf himself made as a goldsmith.

Graf's drawings depicting his fantasies of attractive, sexually available women were calculated to elicit a specific response. The well-dressed harlot was obviously intended to incite the viewer's lust, the primary viewer surely having been the artist himself. He made other drawings to insult the viewer, as the inscriptions reveal. In the drawing of a young woman lifting her skirt to display her nude legs, the artist perversely combined a "come-on" with a turn-off [fig. 2]. Her gesture conveys an erotic invitation to the viewer, presumably male, and her beret, placed at a rakish angle, and the come-hither glance again suggest the nature of her profession. But her body language of erotic invitation is contradicted by her message to the viewer, inscribed on the artfully curlicued banderole hovering above her, comparable to the bubble in a comic strip: *ICH.SCHIS.DIR.INS FVD.LOCH*, or "I defecate in your anus." This expression was a common insult used by street toughs in Basel. Though she entices men by displaying her sexual wares, Graf puts words in her mouth to express her loathing for the "johns" who fall for her offer. One wonders whom she is addressing. Unlike the previous drawing, the artist certainly did not create this drawing for himself. Its technique, using pen and black ink, with grey, yellow, and white body color applied with a fine brush on a reddish prepared ground, is particularly elaborate and is of a type often used during this period for drawings given as gifts or created as collector's

items. The subject of this drawing makes for a most unusual gift, perhaps intended in a spirit of raucous banter for a close male friend.

According to court records, Graf was notorious for consorting openly with prostitutes in the streets of Basel, so one must assume that aspects of his drawings are based on his personal experiences with sex workers. Indeed, they are a major theme in his work. He clearly took great pleasure in lifting their skirts, even if only on paper. In his drawings he often paired them with a fool, the comic character who in northern Renaissance art personified both folly and unfettered lechery. In Graf's drawing of about 1514 [fig. 3], the fool wears a traditional short tunic and fool's cap with donkey's ears and bells. The artist shows him to be old, infirm, and nearsighted; he is mocked by a bird perched on his head. He peers lasciviously at a nude young woman, holding up a pair of large eyeglasses, instrument of the voyeur and symbol of lust, the better to inspect her. The voluptuous nude, wearing only slippers, a beret, and some jewelry, holds a curry comb. In Graf's time this instrument was a symbol of sexual intercourse, derived from the way it was used to brush down a horse. This instrument and her nudity reduce her to a wholly sexual being. The old fool's excessively large money bag is a reference to the mercenary nature of such "unequal" couples, characterized by a great disparity in age. As expressed in a popular proverb of the period, "He who hopes to capture a beautiful woman must carry a heavy purse," meaning heavy with coins. The conspicuous position of the fool's

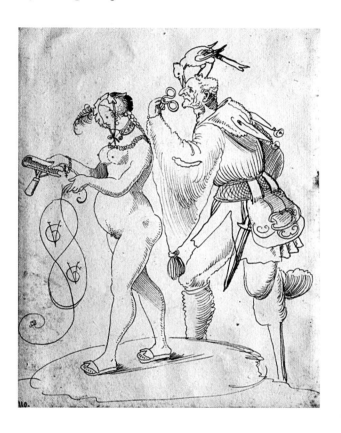

3. Urs Graf
Old Fool Inspecting a Nude Girl, circa 1514
Ink on paper
7 1/2 x 5 5/8 inches
Kunstmuseum Basel

dagger, a well-known phallic symbol, between the legs also emphasizes his lechery. The eyeglasses, the large purse, the dagger, and even the wooden leg, which adds to his unattractiveness, display the ludicrous nature of his foolish courting. The nude woman ignores him completely and expresses her boredom by the laconic sigh inscribed on her neck band: *OCH.MI*, meaning, "Oh, my!" Having inscribed his monogram VG twice into the loops of the rope forming a love knot that she dangles in the air, the artist demonstrates with malicious pleasure that he, not the old fool, is the object of her fancy.

In the graphic art of this period, the lecherous fool is often shown expressing his lust more aggressively than does Graf's lovelorn old fool. In an engraving created around 1460 by the Upper Rhenish artist Master ES [fig. 4], the fool again wears the short tunic, fool's cap with bells, purse, and dagger but here he fondles the breast of a young woman at his side and

4. Master ES
*Woman Holding a Crest
and a Fool*, circa 1460
Engraving on paper
5 1/2 x 4 inches
Musée du Louvre, Paris

raises her skirt to display her genitals. Typical for his period, the artist gives her an expression of bemused tolerance of such conduct. The engraving purports to show a coat of arms in the center but its heraldry of flower motifs is sheer fantasy. Surely no aristocratic family would want to have its arms displayed by a woman showing off her pubic hair. The engraving may have been a kind of visual joke, which in the cultural context of the period around 1460 was probably intended as pornography.

Unlike *Woman Holding A Crest*, Graf's pen and ink design for stained glass dated 1515 [fig. 5] is a bona fide heraldic composition, commissioned by the Basel textile merchant Hieronymus Stehelin and his wife Ottilia Bischoff. Their family's coats of arms appear on the left and right crests, respectively. Standing before a distant landscape, the female heraldic figure, completely nude but for a long veil, is not much use in holding up the shields bearing coats of arms, her usual function in such heraldic images, because

5. Urs Graf
*Design for Stained Glass with
the Arms of Stehelhin and
Bischoff*, 1515
Ink on paper
15 1/8 x 16 1/4 inches
Kunstmuseum Basel

she does not actually support them. Her long veil is the mark of a so-called "fallen" woman. In Graf's era only virgins were seen in public with loose, uncovered hair, while all other women were required to cover and hide their hair due to the sexual powers that superstitious beliefs attributed to it. Married women wore bonnets and "dishonored" girls and harlots wore veils. In some cities unmarried girls whose loss of virginity became known were sent a veil to wear by the municipal authorities, who also required prostitutes to wear veils of specified colors as a means of easy recognition. In Augsburg they were yellow, the color of shame. In his design, Graf shows the seated fool gazing up enraptured at the nude woman while pulling down her veil to display fully her nakedness. Stehelin, for whom a stained glass panel was to be made from this drawing, must have been a patron with a bawdy sense of humor, akin to the artist's own.

In these works the fool acts as a voyeur. He surely functions as a sur-

rogate for the voyeurism performed by each viewer of the drawing, beginning with the artist himself. Voyeurism seems to have been a popular outlet for sexual fantasies in Basel. A description of activities at the brothel on Malzgasse in Basel, published in that city by the pamphleteer Pamphilus Gengenbach in his *Gouchmat* of about 1520, recounts how couples in the brothel were routinely observed by others through small windows.

Voyeurism seems to have been an obsession of the artist as well. The eroticized gaze of a male figure looking up at a woman's genitals from a reclining position below her became a recurrent theme in his drawings. No previous examples of this motif in the art of this period are known before 1515, when Graf used it in his stained glass design. Rather the theme seems to have arisen from the artist's own sexual fantasies. It became a popular theme in stained glass panels only much later, perhaps due to the popularity of the panel made from Graf's design of 1515, about which, unfortunately, nothing is known. In a glass panel dated 1563 with the coats of arms of the Zender and Chassignole families [fig. 6], the reclining fool gazing up at the nude heraldic figure recalls Graf's design of almost fifty years earlier. In the panel the inscription on the banderole (*EY JA ES LYT ALS AM GUNST*) says "Oh, yes, everything depends on a woman's whims." A related work by the Nuremberg printmaker Peter Flötner [fig. 7] casts the fool even more overtly in the role of a voyeur, one who today would surely be a fan of the artist Karen Finley. He watches intently through eyeglasses, the symbol of lust, holding up a lighted candle for better viewing, as a nude woman shaves her pubic hair.

Not content to merely have the fools strip bare the women who fall into their hands, Graf attributes exhibitionist tendencies to the fools themselves. In Graf's drawing of 1525 [fig. 8], an old, goitered fool dances alongside a young mother holding her infant. Their relationship remains mysterious. Clad in his customary tunic and fool's cap, he is being mocked by the same type of bird seen in Graf's earlier sketch of an old fool. While dancing, he intentionally raises his tunic, displaying his genitals, while she, too, displays a nude leg, signifying that she is a harlot.

In Graf's last drawings of the 1520s he returned to his voyeurist obsession, sketching again a man's erotic gaze at a woman's genitals, showing him looking at her from below. In a pen drawing of 1523, the reclining fool gazes upon a voluptuous nude fiddle player [fig. 9]. Her activity portends more than an Orphic gesture of musical enchantment: in the sixteenth century it was an erotic metaphor signifying sexual intercourse, based on the suggestive movement of the bow. But the nude musician, fiddling as a come on, looks coquettishly directly at the viewer and ignores the dazzled old fool. The placement of the armorial symbol of the city of Basel, a simplified bishop's crozier, sketched on the shoulder of the fool's tunic, suggests that the artist may have intended this figure of folly to represent the entire male population of the city, all of whom are accused of being lecherous old voyeurs.

Two years later Graf used the eroticized gaze in a parody of Pyramus and Thisbe [fig. 11] to characterize the nature of Pyramus' fascination with Thisbe. Graf's version strays far from its literary source in Ovid's *Metamorphoses*.

8. Urs Graf
Old Fool Dancing Along Side a Young Mother, 1525
Ink on paper
7 3/8 x 5 3/4 inches
Kunstmuseum Basel

9. Urs Graf
Nude Fiddler, 1523
Ink on paper
12 1/8 x 8 1/8 inches
Hessisches Landesmuseum, Darmstadt, Germany

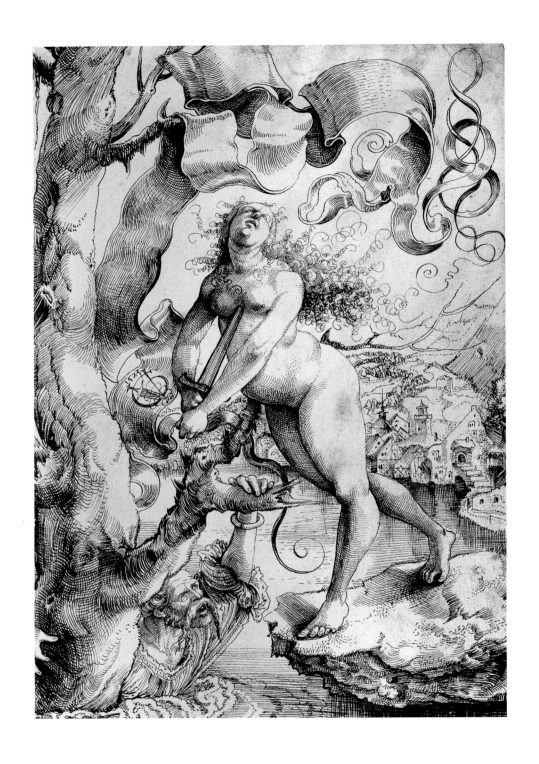

10. Urs Graf
Nude Committing Suicide Observed by a Man Drowning, 1523
Ink on paper
13 x 8 7/8 inches
Kunstmuseum Basel

Thisbe is shown completely nude and Pyramus is not dead at all. On the contrary, he is grinning with delight at the sight he beholds while lying between Thisbe's legs as she is about to commit suicide. The fool shown as a fountain figure hints at the ribald silliness of this scene. Graf has created more an amusing erotic charade than the tragic end of a love affair.

Voyeurist obsession is the theme of one of Graf's most unusual and original creations [fig. 10], apparently a persiflage on the story of the Roman heroine Lucretia, who after being raped chose to end her life rather than live dishonored. Again the artist shows his protagonist entirely nude, about to drive a sword into her breast. She too is strategically placed above a man in deep water clinging to a tree. His lascivious gaze apparently puts him in danger of his life. This scene is partly based on the popular expression "drowning in lust," which is how Graf's contemporaries described a lovelorn, lustful man. The idea is taken literally in this erotic melodrama, turning a figure of speech into an unforgettable image.

In his late drawings Graf created a series of images of disparate themes all chosen to display the male gaze riveted on female genitals. Repeated and developed over the space of a decade, this motif seems to take on ever-greater importance or even urgency in his work. His humorous adaptation of Ovid's tale of the unlucky lovers Pyramus and Thisbe gives an erotic twist to a well-known classical theme. But the suicidal nude observed by a man in danger of drowning is certainly one of the most astounding works of Swiss Renaissance art. Graf created a completely original and highly personal iconography, driven by his erotic preferences and voyeurist obsession. These drawings offer the viewer an unusually intimate psychic barometer of the artist. Herein lies one reason for the great fascination with his work. In his drawings Urs Graf reveals more about his hopes, dreams, fears, and obsessions than any other artist of this era. His astonishing body of work constitutes the most revealing visual commentary on an artist and his times that has survived from the Renaissance in northern Europe.

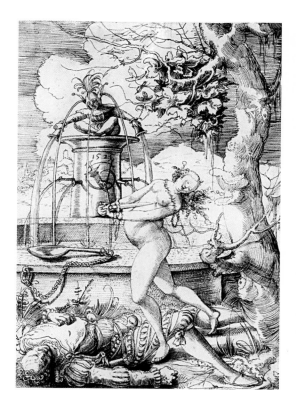

11. Urs Graf
Pyramus and Thisbe, 1525
Ink on paper
11 1/2 x 8 inches
Kunstmuseum Basel

All images photomicrograph on printing-out paper with gold chloride toning from glass plate negative.
Shown actual size. Executed 1885–1919. Courtesy Davis & Langdale Company, Inc., New York

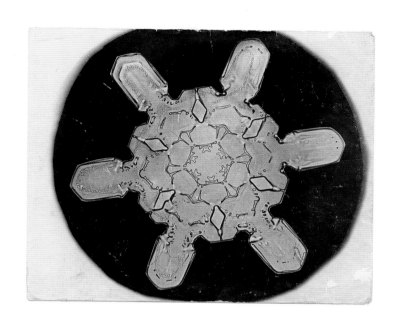

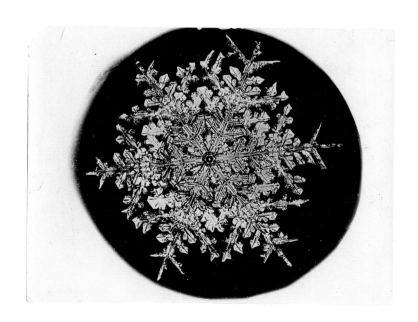

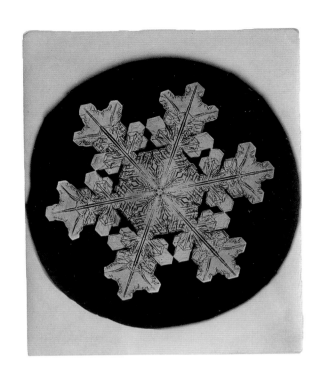

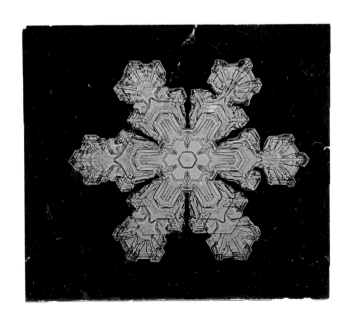

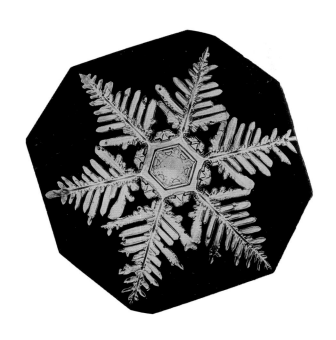

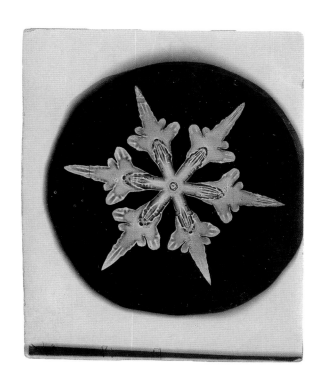

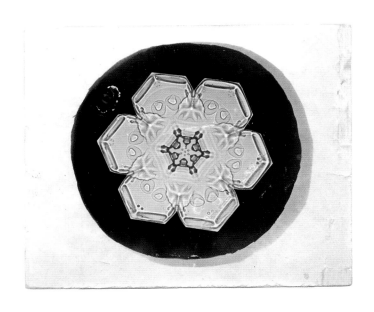

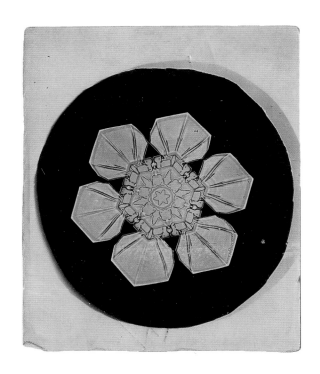

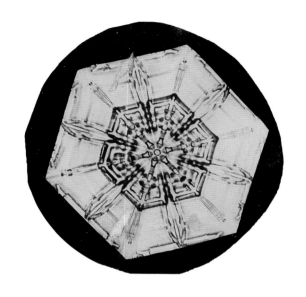

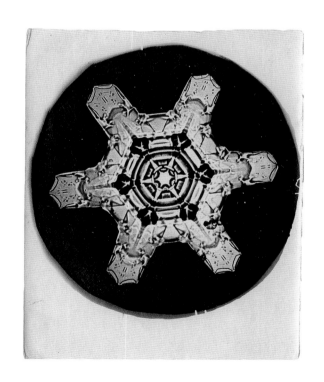

In case neither of you noticed,
We have not been elected, gents. The Company
Of Immortals disregards us, plainly.
Do we not exist? Or are we merely
Deficient in reality, difficult
To focus and adjust.
 from "Stone Soup"

Charlie was on his way to the Brattleboro Retreat in Vermont, and becoming increasingly agitated. He knew hell awaited his arrival. It was the first of four or five rehab hospitals he required and which he eventually rated like a Michelin guide, assigning stars according to the quality of service he had received in each of them. But he wasn't suffering from delusions of grandeur; he was suffering from alcoholism. "John Milton needs a drink," he told his brother Tommy. "I am John Milton!"

Charlie knew that he wasn't John Milton. That wasn't the point. Milton was merely one of the poets Charlie revered and one of the many roles he liked to play; and, owing to his prodigious memory and his irrepressible panache, he always had an inexhaustible repertoire to inspire him and entertain others. Not that the idea of John Milton entering detox would have amused everyone, but Charlie could do Milton or any number of other poets at will. He knew their poems by heart and could discuss their times, their strengths and weaknesses, their reputations, and their scholarship like a professor. There was method to his madness. And he could morph himself into them spontaneously, putting on their words and gestures like a convenient costume or disguise, as a game or diversion; or perhaps as a kind of alibi, hiding behind them to avoid identification or scrutiny.

As a child, Charlie had a rambunctious appetite for play, for impersonation, as well as a passion for history. Growing up and watching your dreams and fantasies dissipate in the face of an inglorious reality is hardly unprecedented in the annals of childhood, but for Charlie it must have been especially demoralizing. At times, it must have felt like a bad dream, the jarring and disorienting disjunction between fantasy and reality that became the substance of his poetry. Charlie's world was real, or had been: but it existed long ago, and without him, and for that reason Charlie's poetry is inevitably elegiac, the poetry of loss and exile, always infused with a sense of dispossession and displacement and the feeling of being outcast, unknown.

Charlie knows what he's doing and is always wary. He anticipates the accusations and the criticism that it is "all silver light ... cheap circuses ... cheap theatrics." Charlie has left behind childhood hero worship, and he isn't impersonating anyone anymore; his poems aren't imaginary conversations with famous men. In his poems, Charlie is Charlie, but in disguise, an actor to be sure; and in that sense alone he is, as he must have felt himself to be, still something of an impostor—someone who isn't what he appears to be or what he had always imagined himself to be. No matter, Charlie resists the inevitable morning-after reviews and keeps rolling his films, acknowledging his "stunted dreams," the "cartoons you never meant to finish," and accepts his bankruptcy while reveling in his former riches.

In his imagination, which was vast and infinitely elastic, he was free to be anyone—or himself—and be anywhere. He could be a king or a duke; but as his conscience knew, and his comic sense insisted, only a duke deposed. Charlie was not Falstaff, although there were certainly strong resemblances. He was more like Prospero—a Prospero in exile, who never got his kingdom back, for all the magic in his books. Still, it was "dukedom large enough," and as Charlie understood better than anyone, the insubstantial world he conjured was worth his exile.

The public face of poetry is suspect, an easy mark for mockery, and although Charlie was not averse to performing other people's poetry in public, or reciting his scandalous clerihews about rare booksellers, he kept his own personal poetry private, fearful of exposing it—and himself—to ridicule. It was not until the last five sober years of his life that he felt confident enough to return to it, to make of it what he might. It was a risky and audacious endeavor. Charlie was far too conscious of his antecedents and inspirations, all his anxiety-producing exemplars.

All the echoes and ghosts of earlier and contemporary poetry must have hovered over and seemed to question his every word, until finally that cacophony of voices pushed him over the top, out of the protective trenches of conventional poetic style and diction and into a defenseless no-man's-land of his own.

In the last years of his life, without succumbing to self-pity or to confessional forms of poetry, Charlie seems to have found his stage, a cast of characters, and the poetry to convey all his sardonic, self-reflexive complexity. The poetry is rich and strange, a kind of allusive, anachronistic, and phantasmagorical *Walpurgisnacht*. It is baroque, histrionic—full of dialogue and declamation, as if written for some vast Miltonic stage, the sets in plush chiaroscuro by John Martin. It is also fun, as if Charlie had returned to the boisterous child's play of his youth, and instead of pretending to be others, he took pleasure in being himself. Charlie was one of the most convivial and good humored of men, and although he did not live to see his first poem published in *Fulcrum*, any sense of regret or tragedy in his life was posthumous, and must be ours.

GALLOWAY: How long is the story, Joe? Longer than *Ossian*?
 A tumbling companion for Ms. Scudéry, exceeding
 Even the *Mahabharata*? Sightless monsoons?
GOOLKASIAN: We must cross the river while the weather holds;
 Release the fox then wade a ways downstream.
 Dogs are resolutely dumb.
GALLOWAY: They caught Euripides.
GOOLKASIAN: Oft repeated though unlikely like many oft
 Repeated things. Aristophanes never mentions
 Such an outrage. Almost certainly he would have.
 Downstream in the shade we can rest a few hours.
 Sire, above all, you must calm yourself now.
 We mustn't overheat.
GALLOWAY: Is it longer than the neck
 Of the Scottish Queen? A pathless dirge, longer
 Than the legs of spiders?
GOOLKASIAN: Your Majesty,
 We must cross the Mohawk. On the opposite shore
 We can parse the thing at leisure.
GALLOWAY: I fear
 It will be longer than the stride of leopards, longer
 Than the Chinese wall. That it will prove at last
 A fatal strain upon the trumpeters, endless
 In its ending.
GOOLKASIAN: Sire, we must staunch the flow, we
 Mustn't tarry.
GALLOWAY: If they knew how the snow
 Caked-up mine eyes. If my people understood.
 Understood how the snow filled-up the wards,
 The plaster drifting as we walked the yard.
GOOLKASIAN: Those ceilings have collapsed, your Highness.
 The corridors have long been emptied, the toilets
 Drained. We mustn't lose heart now. The mattresses
 Are stacked and dried, the springs have rusted.
 Trust me, Sire. The floral papers are peeling
 Off the walls like skin.
GALLOWAY: What shall I bring
 For Josephine? A brace of Tuscarora braves?

The strumpet, I'm sure, would be entranced.
Devour the pair of them within the hour.
But what thanks will I get? I know, I know, it
Remains in my interest to shield her pirouettes
From oafs and gawkers. The Tuscarora will serve
Quite admirably, I'm sure. They will do their duty.
What else? *Ma zasgon* requires many things.
A convex mirror? Too appropriate,
Trite. We want an idiosyncrasy—
Something unique, a Farfeluvian gift.
A Latvian sleigh made out of sandalwood?

GOOLKASIAN: Sandalwood, I imagine, would be too soft
For such a purpose. One might display it
Beneath a bell

GALLOWAY: of Venetian glass! Excellent,
Otranto! But we must garnish it. Touch it up.
Say with the head of Atta Troll, mangy brute.
A package on the seat, *un brocart rouge*. The guy
Scrubbed and *coiffed* in the daintiest of modes;
Subjected to the curling iron, liberally doused
With *eau de Cologne*, his rampaging ended.
A surprise, *mon lépou*, for *mon petit ange*.
The thought of her squeals when she opens it.
We'll need a spot of ribbon, a proper box.
Bed the chappie down in clouds of *crêpe*. A blue box
We'll pinch from Bonwit's once we get to Boston.
A deep dark blue. The color of the cloak I wore
At Marengo. Do you remember, Joe?

GOOLKASIAN: I do.
As though were yesterday. It will never leave me.

GALLOWAY: For a backdrop, the coast of Finland in a shell.

GOOLKASIAN: Sire, I suggest we pause and regroup.
We mustn't veer into gimcrack, vainglorious
Conceits, cumbrously grotesque. Flourishes,
Displays that cannot serve us well.
O'erwrought *cliché*. Let us choose, instead,
Something easier to read and to transport.
Eschew the Lautréamontian *macabre*.
Bring a whimsical souvenir, an amulet,
Forget this *tableau*.

GALLOWAY: You despise my assemblage.

GOOLKASIAN: Majesty, my objections are not aesthetic.
I know Madame will disapprove, that's all.

GALLOWAY: Tell me then: What? What shall I bring the

Spoiled brat? What? Tell me, since you know
Everything. Tell me, man. I'm listening, Joe.
GOOLKASIAN: A box of Britains.
GALLOWAY: A box of Britons?
A box of Britons would be less cumbersome?
GOOLKASIAN: Not Britons, Sire, Britains. An I not O.
Leaden soldiers. Their maker, I believe, is vital;
Though we would want an older set. Fifties, at the earliest.
A rare item secured at auction, unopened
And untouched. Confederate cavalry, avidly sought;
Arab horse and foot—these can be acquired
In stunning formations; idle gangs of redcoats;
Khaki figures traipsing across the veldt.
This last ensemble includes a caisson
Drawn by donkeys. Granted, I only saw one once,
Years ago. It was Christmas. I was walking
With my *mama* through Jordan Marsh, browsing
What was called The Rich Grandfathers Shop.
The set I should imagine is now impressively
Expensive. Fine condition would bring a premium.
GALLOWAY: An able policeman does not speak in riddles.
GOOLKASIAN: No riddle was intended, Majesty.
It seems straight-forward to my legal mind.
Not that I don't employ riddles on occasion.
Riddles have many uses. They thwart the leery
And the literal; exacerbate the toads even
As they charm the weasels. They can be had for nothing.
GALLOWAY: And enigmas? Can they be had for nothing too?
GOOLKASIAN: Enigmas? No. Enigmas are rather costly.
GALLOWAY: At Oswego, once, there was a nightingale.
Don't ask how I know. It suits me, for the present,
To conceal my sources. She was translunary.
An ineffable creature, beyond sequence
Or conclusion. A magic without precedent.
GOOLKASIAN: Why should this nightingale concern you, Sire?
GALLOWAY: She would fly alone come summertime, searching
Blue Ontario's shores. You know nothing
Of this singularity? I would have supposed your
Cabinet noir had looked into it. Frankly,
It is scarcely credible it didn't. It suggests
A lack of thoroughness thoroughly out of character.
GOOLKASIAN: There are problems with the story.
GALLOWAY: Such as?
GOOLKASIAN: The nightingale is not native to the Americas, Sire.

It is born in Africa and reaches England
In the spring. The creature you describe was,
In all likelihood, a common warbler. What name
To assign it I shouldn't care to surmise;
Ornithology falling outside my expertise.

GALLOWAY: She was a nightingale, you cod fish.
To dispute this is mere contentiousness,
Maladroit. The luxury of her notes
Confirms the matter. Birds are birds, old sport.
Things easily borne about in cages.

GOOLKASIAN: The nightingale dies in captivity, your Highness.

GALLOWAY: Some few, I'd wager, have effected their escape;
Found themselves in unfamiliar places. In rags.
They adapt, make their way about the world.
We are living in the Age of Sail, Otranto.
Things can turn up anywhere, you know that.
She alights upon a mast in Lisbon harbor.
Biarritz, La Rochelle, choose your port. She takes
A little snooze, and, in a twinkling, awakes
Upon the Main, her destiny rewritten.
Poor thing. She is left to seek her kind
At the mouth of the St. Lawrence. At Montreal,
Through the Thousand Islands. Nothing
Could be simpler or more commonplace. Hell,
You've read books. They've discovered popinjays
Fluttering about on desolated atolls,
Peacocks nesting beneath Ocean.

GOOLKASIAN: Regrettably
The disjunctures do not end with place.
The music of the nightingale is a masculine
Phenomenon. The female is mute.
The bird you speak of was phantasmal, Sire.
She could not have existed.

GALLOWAY: The ladies mute?
A preposterous canard. The lustrous
Jenny Lind! Even you, old mole, interred
In solemn law books, must've heard of her.
Fluffed, ruffled and perfumed, her warm
Thighs bedewed with precious juice. The Swedish
Nightingale, known to all Nations.

GOOLKASIAN: A coinage
Of Mr. Barnum's, Majesty. Poorly minted.
Granted, Mr. Barnum is not alone.
The error appears in a multitude of forms,

Some highly respectable, even distinguished.

Some, indeed, sublime. All are errors nonetheless.

GALLOWAY: You always have an answer, don't you, Joe?

A box of red pencils and a pink eraser?

GOOLKASIAN: Your Highness has charged me ascertain

The facts. To learn what is true, and what is not

True. To pick locks, break ciphers, listen through walls.

To read other people's mail; never failing

To record the postmarks. And more than this:

To seed the ground with lies and see what grows.

I regret if my findings at times distress you,

But I assume the charge has not been changed.

GALLOWAY: There are things you are withholding, Joseph.

Obviously you are acquainted with this business.

Tell me what you know. Tell me now. There are those

Who say I fear you. But I fear no one.

I made you what you are, *Otranto*.

I can see that you are unmade.

GOOLKASIAN: Very well.

Among the Onandaga was a squaw, Lela-Walla,

Since deceased. She was blathering in public

And we picked her up. A procedural matter.

We had a chat, tediously routine.

GALLOWAY: You personally

Conducted the interrogation?

GOOLKASIAN: I did.

GALLOWAY: Proceed.

GOOLKASIAN: She was old, Sire, ancient, a bag of bones;

And senile, unimpeachably. She claimed

To remember the Jesuit wizards,

The occult black cassocks.

GALLOWAY: Had the old darling

Been dipping into Mr. Parkman's port?

GOOLKASIAN: My first thought too. The nightingale she said

—Rumor confirms a nightingale upstate—

Arrived with them.

GALLOWAY: Ha! What did I tell you?

A frigate from Calais!

GOOLKASIAN: The fathers, she claimed,

Always called him Maurice; often followed

By mock *rodomontade*. Now. At this point

Her narrative veered into the marvelous.

GALLOWAY: Go on, my friend, continue.

GOOLKASIAN: For two

Hundred years after the missions were abandoned,
Every summer Maurice returned, skittering
Erratically along the shore, his song
Resplendent. Haunted. The local people
Regarded him with fright. A thing of ill-omen.
Now, starting in the fifties, or thereabouts,
Maurice began to stay throughout the winter.

GALLOWAY: Is that conceivable?

GOOLKASIAN: Frankly, it is not.
Then again, if you recall, the creature
We are discussing is aged two-hundred.
I prefaced my report by describing
Its transit into the Marvelous. Myself,
I would favor a less enchanted term.
Its transit into the Risible. That would be
My personal choice. I chose, however,
Not to prejudice the matter. The Marvelous
Insists upon acceptance or rejection.
The middle ground is scant. That is a property
Of the category.

GALLOWAY: Point taken, Joseph. Proceed.

GOOLKASIAN: The girls at St. Mary's would feed him
Until Spring. Now. At this point the interview
—How shall I put it?—turned alarmingly
Queer. Weird, fey, unsupportable. Unprompted,
Lela-Walla began quoting from *La Plèiade*
In a sumptuous unravelling. Not Ronsard
Alone, you understand, the whole Brigade—
Pontus de Tyard, Peletier, Jodelle.

GALLOWAY: Quoting
Jodelle? Impossible. Peletier? Go to. But
Pontus de Tyard? Queerer than cricket, pal—
Get a grip. Admittedly, it's droll. A crone
Reviving *La Brigade* in old York State—
The raggedier splendor of such an enterprise.
La Franciade well represented? Ha!

GOOLKASIAN: Books two and four in their entirety.

GALLOWAY: What? *Polloppe*. A jest, however wild,
Requires its sliver of the plausibe.

GOOLKASIAN: I am a policeman, your Majesty.
A cop, *un keuf*. I am not a *farceur*.

GALLOWAY: How long did this interrogation last?

GOOLKASIAN: She was arrested pre-dawn. I couldn't say,
Exactly, how long we talked. Well into evening.

GALLOWAY: Books two and four in their entirety?

GOOLKASIAN: Yes. Her performance was not in snippets. And,
 Although its relevance, to me, was not apparent,
 The sequence betrayed nothing of the arbitary.
 Dolorous choruses from *Cléopatra captive*.
 What amounted to a complete rehearsal
 Of *Le Brave, ou Taillebras*—a comedy after Plautus
 Your Highness may be unfamilar with.

GALLOWAY: Baïf? No, I know Baïf. A decent fellow,
 If lacking animation, without panache.
 And you say this raddled squaw, this Lela-Walla,
 Knew Jean-Antoine? Knew him by heart. Quoted
 His tedious effusions.

GOOLKASIAN: At some length.

GALLOWAY: Splendidly unlikely. A curious world
 We live in, Joe. But please continue.

GOOLKASIAN: Well, Majesty,
 I feigned a few chuckles, signifying
 I knew her game. But she wasn't watching.
 The performance was incantatory;
 Individual voices rarely intruding
 Into the Alexandrines. I was, let us say,
 Alert. Hippolyte transcribed the tapes.
 The quotations proved disturbingly accurate;
 Though none matched, exactly, the texts as we had them.
 That would have been suspicious. The divergences
 Gave her credibility. And, indeed, some of her
 Readings were distinct improvements.

GALLOWAY: You were
 Nonplussed? I would've enjoyed observing that.

GOOLKASIAN: Her accent, Majesty, was quite superb—
 Worthy of Dorval at the Odéon.
 The recitation ended, the elegance dissolved.
 Her English was a cackling, dubiously
 Plastered with Latin tags. She could juggle,
 As well, the odd ball of Greek. Absurd,
 But in the end magnificent. No need
 To be unnerved, I told myself. All this can be
 Explained. The martyred fathers had been rigorous;
 And she, no doubt, had been an eager pupil. Still?
 To argue thus was to accept her story.
 She went on. Her conceits extravagant,
 Well nigh Peruvian.

GALLOWAY: Tell me.

GOOLKASIAN: She said the one

 For whom it sang had died in labor.

 Quieted, the nightingale had waited.

 The baby, a girl, lived eleven days.

 When she died too, erratically, the bird

 Flew north-northwest, although it was already

 Late October. Lela-Walla insisted he survived.

 Adding, that though immortal he would never mate,

 Nor come again to Blue Ontario.

 An old woman at her knitting, Sire. It didn't

 Seem to merit your Majesty's attention.

GALLOWAY: I will decide what merits my attention.

GOOLKASIAN: Logistically problematic as I'm sure you grasp.

GALLOWAY: Did the witch know who this woman was?

GOOLKASIAN: Lela-Walla described her as a Mingo.

 A vague term, too Cooperesque for use, certainly

 Too Cooperesque for me. Call her what? A girl

 Of mixed-blood. A half-breed overwhelmed

 By commonplace compulsions. She'd been a student

 At St Mary's. The enigmatic Maurice

 Appears to have favored her above all others,

 Alighting upon her shoulder, allowing

 Her to stroke him, not merely eating from her hand.

 An odd strip of girl, thinner than string, claiming

 She was virgin.

GALLOWAY: Is that quotation marks I'm hearing, Joe?

 The term, of course, is liable to a Quevedian

 Inflection.

GOOLKASIAN: A sad case, your Highness,

 Common enough. Desperate, and addicted,

 Down on her knees among rotting apples.

GALLOWAY: And who was her betrayer?

GOOLKASIAN: Lela-Walla didn't know. She suspected

 A certain German, an itinerant, a tinker,

 A Dreiserian quack. Impossible to say

 With any surety, but a figure

 Without significance.

GALLOWAY: That I do not accept.

GOOLKASIAN: His Highness will, of course, accept what he wishes.

 Although such a course is perilous, pitted

 With mischance. It evinces a love of ruin, a thirst

 For death. It is like cities built of wood.

GALLOWAY: Is this some sort of lecture, Joe?

GOOLKASIAN: No, your Highness.

GALLOWAY: Good. And what became of Lela-Walla?

GOOLKASIAN: We held her overnight for observation.

GALLOWAY: You held her overnight?

GOOLKASIAN: Reasonable enough.
 The woman was neither threatened nor molested.
 We locked her in with a half-a-dozen blankets.
 We gave her food. We offered her a glass of wine,
 Which she refused. In the morning she was dead.

GALLOWAY: She died in custody and I was not informed?

GOOLKASIAN: She was a crone, your Highness, an arrant prattler
 In the market square. A gossip. A purveyor
 Of imbecilities and sordid folk tales.

GALLOWAY: *Buffone!*
 This reflects on me, dog. *Va t'an cullo!*
 All of you, *buffoni. Va t'an cullo!*
 (Epileptic jack-offs beleaguer me.
 Mountebanks, cowards, two-dollar whores. Bah!
 My Staff—so-called—beyond metaphor inept.
 Incontinence staining *l'ordre de bataille.*
 Enough!) We must turn north.

GOOLKASIAN: That is irrational.

GALLOWAY: Herr Doktor Professor, I am sick of Greek logic—
 Sick unto death, in no mood for your nostrums.
 I tire of the niceties of Roman Law.
 At Oswego, at the Council House, the shams
 Of the past will be addressed forthrightly.
 The women will understand. Anyone can see
 The thrust into Ukraine was folly. That preening
 Jack-a-napes will be chastised and replaced.
 All will be set right. This time I will be Charles.

GOOLKASIAN: Sire, we must cross the river. We must do this
 Now. The pack cannot be far behind us;
 Little time remains. Beyond the Berezina
 Lies the road to Boston; at Boston should be the sea.
 By spring we'll be in Paris, the Tuileries, the tresses,
 The Luxembourg Garden awash in fragrance,
 Boschian creatures alighting on our tongues—
 Melting wafers, dripping like snowflakes.

GALLOWAY: We could have a few drinks.

GOOLKASIAN: We could indeed.
 Kochinowski will set them up.

GALLOWAY: *That* ugly bastard!
 Good old Bruno. Is it possible he's still alive?

GOOLKASIAN: It's possible.

GALLOWAY: Stalwart at his post
 In Montparnasse, commingling Seagram's
 And Seven-Up.
GOOLKASIAN: Some things are eternal.
GALLOWAY: What will become of Attica?
 Sodus, Syracuse, Seneca Falls?
 If we foresake them now forever?
GOOLKASIAN: They will be as forests in Lithuania.
GALLOWAY: You mean ashes and ice; rusted engines
 And broken drums.
GOOLKASIAN: I mean forests in Lithuania.
GALLOWAY: What do the stars at Paris have to say?
GOOLKASIAN: They are silent, your Majesty. Illegible.
GALLOWAY: Your men descry nothing? All the heavens,
 And these agents of yours discern nothing
 Whatsoever? Do they lack for method?
 For initiative, for ingenuity? For what
 Do these excuses lack? I should have them shot.
GOOLKASIAN: Sire, the ancient systems are disarrayed.
 Surely you know this. Now but dangerous
 Contortions of chicken-wire, ageless dust.
 They glitter with bits of worthless mica:
 The shattered glass scattered on the floor,
 Bedizened with moonlight at Utica,
 Waiting for a broom and a plastic barrel.
GALLOWAY: What shall I bring the Empress?
GOOLKASIAN: The Empress,
 Your Majesty? Or Mlle. Beaumarchais?
GALLOWAY: I should bring something for *ma mére*.
GOOLKASIAN: *Ma mére* is dead.
GALLOWAY: Is she, old boy?
GOOLKASIAN: *Oui.*
GALLOWAY: Silver sleigh bells, ting-a-ling. Byzantine,
 I think. Something without precedent,
 That's what she'd like. A cabinet of fire.
 Do you suppose a wisp of Isfahan might do?
 A subtle blend, Ghelderovian. A set of flown
 Jade cups. Another chest of over-worked
 Lezamic things; studded with gemstones,
 With sticks of cinnamon.
GOOLKASIAN: A box of the King's
 Own African Rifles. A box of Boers. A box
 Of Arab horse and foot. Mongols and Prussians,
 Berserkers, lancers, riant cuirassiers—

In peerless condition, virtually untouched,
Wrapped in the original cellophane.

GALLOWAY: You know a supplier?

GOOLKASIAN: I know just the man.

GALLOWAY: In the old days we might have nicked them
From Schwarz's.

GOOLKASIAN: Those days are gone. Good-riddance.

GALLOWAY: Is that your pal Metternich's opinion
Or your own?

GOOLKASIAN: Is that an accusation, Sire?.

GALLOWAY: Will it be cold in the tomb of porphyry, Joe?
Will I leak and splutter over everything,
Dripping in ignominy as I always did, tied
To that iron bedstead? Do you remember it?

GOOLKASIAN: We are away from there now.

GALLOWAY: How I'd strain, gagged, burnt with sweat?
Will it reek of disinfectant?

GOOLKASIAN: Do you remember the eyes
Of Our Lady of Milo? What do they see?

GALLOWAY: They see my starving legions, Fouché

Last Blue Wheel, 2009
Acrylic on linen
70 x 60 inches
Courtesy DC Moore Gallery, New York

Tim Knox

THE PROXIMITY OF ART AND DEATH: DULWICH PICTURE GALLERY AND ITS MAUSOLEUM

The lugubrious collections assembled by Sir John Soane in his house in Lincoln's Inn Fields demonstrate his fascination with the funerary architecture of antiquity. The Egyptian sarcophagus and the displays of altars and cinerary urns attest to his enthusiasm for dramatic funereal scenography. Soane's obsession with the architecture of death can be traced throughout his oeuvre—especially in the cryptlike apartments of the Bank of England—but it is most forcefully expressed in the singular ensemble of the picture gallery, almshouse, and mausoleum he built at Dulwich College between 1811–14.

In 1811 Dulwich College was bequeathed a magnificent collection of old master paintings by Sir Francis Bourgeois, a wealthy painter and a friend of Soane. The collection had been assembled by the *marchand-amateur* Noel Desenfans for Stanislas Augustus, King of Poland, who abdicated in 1795, leaving his agent with the pictures on his hands. Desenfans left the collection to Bourgeois with instructions that he should bestow the pictures upon an institution that would preserve them and exhibit them to the public.

The dome area in Sir John Soane's Museum, with bust of Soane surveying his creation

Bourgeois left £2,000 to fit up a gallery in the existing buildings of the college and for the erection of a small mausoleum adjacent to the chapel. He hoped that Soane might be employed to carry out the work. The architect recommended an entirely new building and persuaded Desenfans' widow to contribute an additional £6,000 toward the cost of a gallery for the pictures and a mausoleum for the bodies of Bourgeois and Desenfans. The college agreed to match this sum but stipulated that the building should also provide accommodation for the bedeswomen it supported under the terms of its foundation.

Dulwich College was a venerable but modest institution that Soane thought could be enhanced by adopting a traditional collegiate plan. His precedent was the typical institutional quadrangle where almshouses flanked a chapel containing the tomb of its founder. At Dulwich, however, there was the novel addition of an art gallery. The traditional composition was turned inside out such that the gallery, rather than the chapel, formed the central feature of

the courtyard. Of all the disparate functions Soane was asked to accommodate in the new building, he undoubtedly found the mausoleum the most interesting. As Sir John Summerson observed, "Since the dead do not require air, light and warmth but only shelter and veneration, the mausoleum is a theme round which the imagination can freely play."

Bourgeois had prescribed that any alterations to the college buildings should be in the "Gothic" taste, and accordingly Soane's first proposals were clad in a starved Jacobean dress. Classical elements inevitably crept into the decoration of the building, but in the end Soane settled upon an astylar structure of an austere primitivist-classical character defined by strip pilasters, simple cornices, and arched recesses. This fugitive style of architecture was incomprehensible to contemporary critics such as the Rev. T. F. Dibdin, who exclaimed, "What a creature it is! A Maeso-Gothic, Semi-Arabic, Moro-Spanish, Anglico-Norman, a what-you-will production!"

The picture galleries, lying behind the mausoleum and almshouses, were originally entered by a discreet door at their southern end. The architect's proposals for a more prominent entrance fell victim to economies. Soane had designed a grand gallery for Fonthill in 1787, and knew C. H. Tatham's innovative galleries at Castle Howard and Brocklesbury, but these were comparatively expensive structures. The rooms at Dulwich were more like the purpose-built commercial galleries in London—practical top-lit barns for the display of pictures, such as in the Shakespeare Gallery in Pall Mall. Their simple arrangement of interconnecting rooms separated by bold arches, top-lit by means of glazed lanterns let into the roof, were adopted by Soane as a cheap and practical setting for the pictures.

More imposing was the mausoleum: the ornamental character of its architecture underlined the solemn and sacred nature of its employment. It was the focus of the west elevation and was the College's "show" front. Soane believed "magnificent buildings in honor of the dead inspire the soul" and made a road before the mausoleum in imitation of the ancient "practice of placing tombs and sepulchral buildings on the sides of our public roads."

The plan of the mausoleum was, at the request of Bourgeois, based upon that of the short-lived classical structure Soane built in 1807 in the stableyard of the Desenfans house in Charlotte Street, Marylebone. This mausoleum, a temporary resting place for the bodies of Desenfans and later Bourgeois, contained a top-lit catacomb and a circular oratory for viewing the sarcophagi. At Dulwich, Soane was able to give this dramatic interior a corresponding external expression.

The exterior of the mausoleum took the form of an antique Roman patrician tomb—Soane was acquainted with the spectacular remains of such structures in the Roman *campagna*. Its inspiration was possibly the

Sir John Soane
*Perspective of the Mausoleum
at 31 Charlotte Street, London,
for Sir Francis Bourgeois,* 1807
Ink and watercolor on paper
25 3/8 x 25 5/8 inches

strange sepulchral monument known as La Conocchia, a view of which had been engraved by Piranesi. The Dulwich mausoleum was by necessity a smaller and more modest structure but recalled something of the grandeur of its Roman model. The ornamentation is idiosyncratic—the three solid "doors" with tapering jambs that project from the niches may be "spirit doors" and inspired by Egyptian funerary architecture. The sarcophagi that surmount the cornice declare the purpose of the mausoleum and correspond to those inside: in early designs they were inscribed with the names of the donors. The square lantern bears a roof in the form of a capstone of a Roman altar laden with canopic urns.

The stained glass panels of the lantern cast an amber light upon three severe sarcophagi that repose on the shelves below—each painted to resemble imperial porphyry as are the massive Doric columns that describe the sunken, circular chapel beyond. Christian symbols are absent from this burial chamber, although serpents of eternity occupy the spandrels of the tomb recesses and victories decorate the vault. Soane particularly appreciated the contrast between the light-filled galleries as they opened directly from the gloom of the mausoleum. On one occasion he found the connecting door shut and vigorously remonstrated with the college authorities, complaining that by closing the mausoleum they were "destroying its relationship to the whole."

On her death Mrs. Desenfans bequeathed her best furniture to the gallery as well as a plate service to be used for an annual dinner held for Royal Academicians on St. Luke's day. These festivities, served by footmen wearing the Desenfans livery, were magnificent occasions. Soane himself, imagining one such banquet in the Picture Gallery, mused upon the startling proximity of death and art in his singular creation:

> How gratifying to the reflective mind must such a repast be, surrounded by some of the richest treasures of the pencil! To increase the enjoyment of this splendid scene we have only to fancy the Gallery brilliantly lighted for the exhibition of this unrivalled assemblage of pictorial art—whilst a dull religious light shows the Mausoleum in the full pride of funereal grandeur, displaying its sarcophagi, enriched with the mortal remains of departed worth, and calling back so powerfully the recollections of past times, that we almost believe that we are conversing with our departed friends who now sleep in their silent tombs.

All images, unless noted:
Untitled (Sketchbook), 1949–51
Graphite on paper
10 x 7 3/4 inches (sheet)

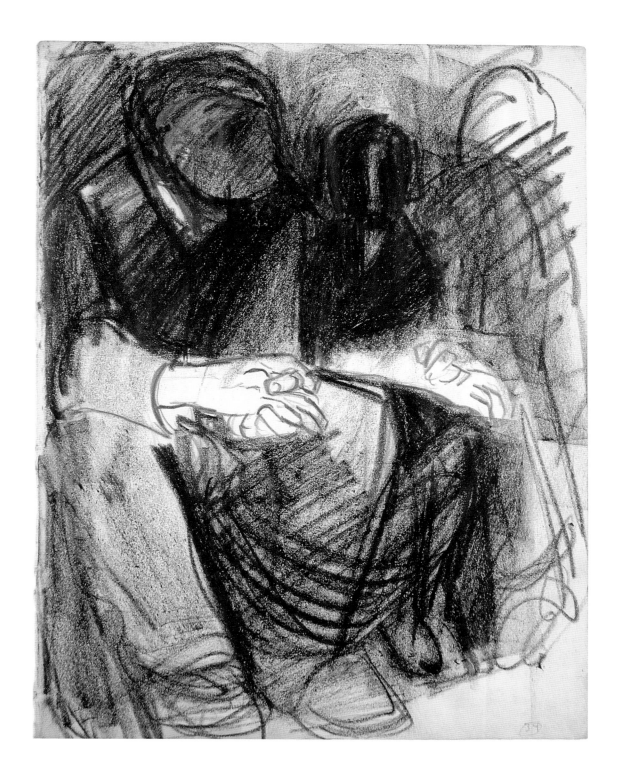

Graphite and ink on paper

BROTHER — SISTER

SISTER — BROTHER

BROTHER — BROTHER

BROTHER — SISTER

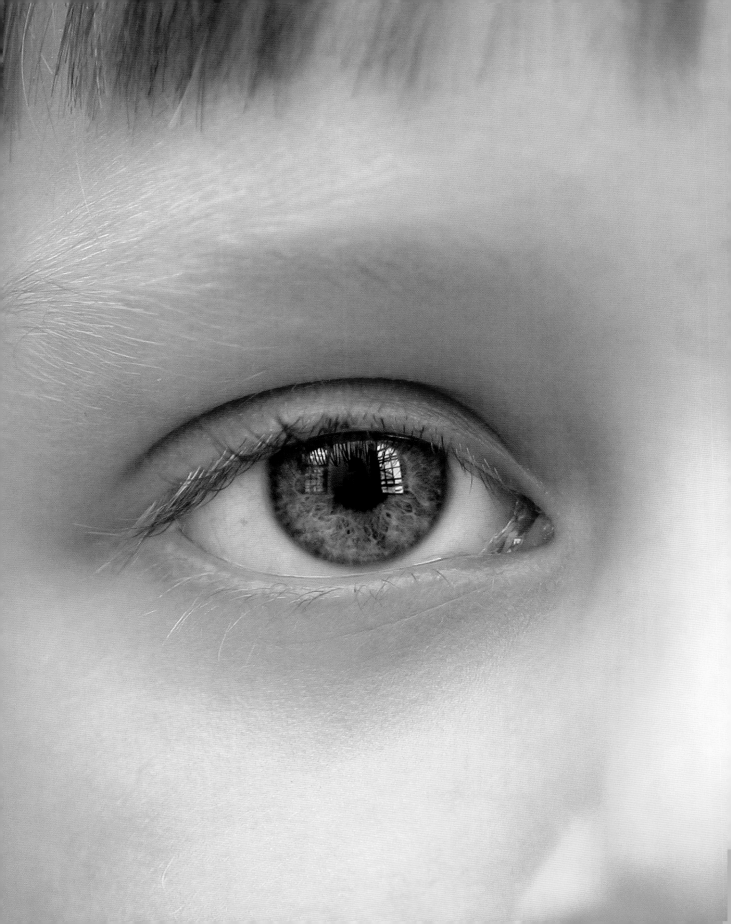

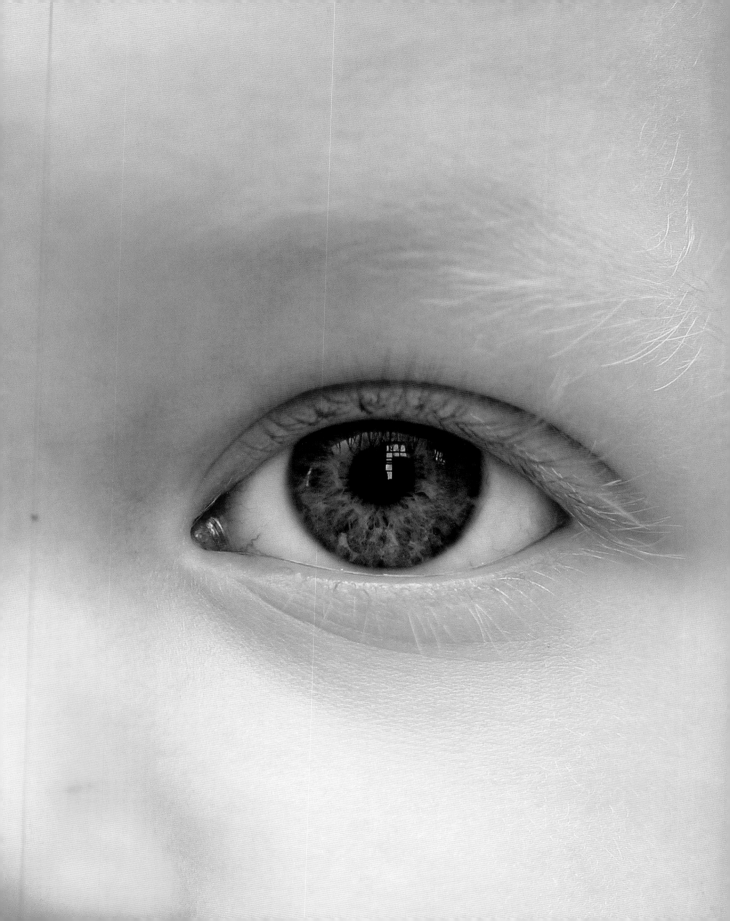

Frances Richard

A SILENT FORCE: TOWARD A COMPARISON OF GORDON MATTA-CLARK AND MARCEL DUCHAMP

Gordon Matta-Clark grew up on the periphery of the twentieth century's preeminent avant-garde circles, with Marcel Duchamp as a neighbor and family friend. This enticing fact belongs to the lore of Matta-Clark as Surrealism's child, and as such is regularly mentioned in biographical sketches that frame the critical literature on his oeuvre. It is not, however, a relationship that has been fully examined in analytic terms. When Matta-Clark's concerns and strategies are set beside those of Duchamp, what off parallels or displaced repetitions—*subsidized symmetries* or *mirrorical returns*[1]—might be discerned?

The two artists appear, of course, markedly different. One has been bookmarked by history as coolly cerebral and ironically distanced; the other as hotheaded and hands-on. Fourth-dimensional gamesmanship and *non-retinal* conceptual complexity characterize the work of one; the direct address of chainsaw or blowtorch on clapboard or metal, and the elegant visual forms that result, typify the other. One aged serenely as an *éminence* grise; the other died at thirty-five and has only posthumously been art-historically canonized.

But, *whether you're anti or for, it's two sides of the same thing.*[2] Obvious contrasts in style, scale, and materials, as well as in personality and experience, should not obscure an intriguing set of resonances through which Matta-Clark's art and Duchamp's might be compared. A full treatment of this subject would account for the complicated connections between the Surrealist painter Roberto Matta Echuarren and the American artist, model, and designer Anne Clark—Matta-Clark's parents—and their Paris and Greenwich Village comrades Marcel and Teeny Duchamp. It would ask how Matta-Clark's intense but mostly tacit dialogue with Duchamp was nuanced by engagement with the Land art and Pop or neo-Dada generations and their own responses to the *readymade* as "pure sign and pure thing."[3] It would also scrutinize certain facets of the Duchamp/Matta-Clark connection—for instance, the problem of the lost or destroyed original—that I can only glance at here. As it is, these notes first juxtapose Duchamp and Matta-Clark as artists whose overt formal interests tally in a surprising number of idiosyncratic ways. I then turn to their underlying structural affinity, which

is a shared obsession with language-play. Both Duchamp and Matta-Clark treated words as physical and performative material, while simultaneously exploiting their properties as arbitrary ciphers. As "pure signs" that also function as nonsensical "pure things," their neologisms, aliases, and puns enact a noncontradiction of opposites, by which idea and object, energy and substance are held in synergy without collapsing into one another.

Specifically, the remarks that follow spiral around three pairs of made-up terms. These are:

1) Duchamp's key conceptual designation of the *readymade*, which Matta-Clark acknowledged while insisting that his appropriated buildings ought to be called "ready-to-be-unmades." Disclaimer notwithstanding, this was the closest he came in discussion of his own work to affirming a Duchampian influence.

2) The unique connective distances that Duchamp called *inframince* and Matta-Clark named "the thin edge." In such trace relations, one surface rubs against or is revealed as phasing toward another, bearing witness to the indexical impress of matter into matter over time.

3) The words devised by Duchamp and Matta-Clark, respectively, to simultaneously name and unname their activities, i.e., *anartist* and "anarchitecture."

These sets of terms, despite their striking similarities, are not identical; they do not prove that Matta-Clark derived his practice from Duchamp's. The gap between their meanings is the glitch of *subsidized symmetry*. The lag between their moments reflects *mirrorical return*.

Left to right:
Marcel Duchamp
View of *Door, 11 rue Larrey*, 1927

Gordon Matta-Clark
View of *Bronx Floors: Threshole*, 1972

Gordon Matta-Clark
View of *Open House*, 1972

In 1927, Duchamp installed a door in his apartment at 11 rue Larrey in Paris that swung at a right angle to close either the bedroom or the bathroom, thereby canceling the proverb *Il faut qu'une porte soit ouverte ou fermée*. Dividing yet connecting domestic spaces, this double-duty door has been proposed by at least one Matta-Clark scholar as analogous to the floor-and-ceiling cuts he executed in 1972 in abandoned apartment buildings in the Bronx. Matta-Clark's *Museum* (1970) has also been read as engaging Duchamp's legacy. This was an installation at Manhattan's Bykert Gallery in which vines were strung around the room and draped with desiccated sheets of a strange sludge he had concocted in his studio[4]; the whole was lit with whale-oil lamps. With its linear segmenting of space and contrarian blend of display and mystery, *Museum* has been seen as a reply to *Sixteen Miles of String*, Duchamp's weblike installation for the 1942 *First Papers of Surrealism* exhibition in New York, which visitors navigated with flashlights.[5]

Gordon Matta-Clark
Reality Properties:
Fake Estates "Jamaica
Curb" (detail), 1973
Photograph, deed, and map
Dimensions variable

Such formal correlations are persuasive. But they hardly encompass the Duchampian echo in Matta-Clark's practice, and the missing element is language. If *Door, 11 rue Larrey* relates to *Bronx Floors*, for example, it could as well be likened to the labyrinth of doors and partitions that Matta-Clark built, also in 1972, in a Dumpster parked on Greene Street in SoHo, to make the piece now known as *Open House*. This comparison traverses the sculptural form of the swinging door to entertain the proverb of complete and simple closure. *Open House* in effect asks, does an industrial trash bin open to the sky become a house by being fitted with doors and hallways? Is it necessary that a house be either open or closed, public or private, divvied up or intact?

Or take the project variously known as *Fake Estates, Reality Properties: Fake Estates*, and *Realty Positions: Fake Estates*. This was a suite of fifteen tiny "gutter space" lots that Matta-Clark bought at New York City auction in 1973 and '74, which he speculated about selling as artworks along with corresponding photographs, maps, and deeds.[6] As nonsensical documentation of a real—though rogue—value, *Fake Estates* could be read in light of Duchamp's *3 Standard Stoppages* (1913–14), *Tzanck Check* (1919), and *Monte Carlo Bond* (1924). The latter are word-drawings that mock up financial instruments, while the former, despite its objecthood, makes little sense without the anecdote of dropped and measured strings. The *Fake Estates*, likewise, explore the conundrum of precisely measured assets that for practical purposes exist only as words and numbers on paper. Duchamp's assertion that his homemade curvy rulers are *standard* is ultimately no more farcical than city maps and other official apparatus that duly demarcate a 2.33-inch-by-355-foot property. The *Fake Estates* are institutional *canned chance*.

Duchamp told Pierre Cabanne in 1966 that, having bought *Tzanck Check* back from his dentist, Dr. Tzanck, he gave it to Matta.[7] It is difficult to imagine that Matta-Clark did not know the piece in his father's possession, though of course he may not have derived *Fake Estates* or anything else directly from it. The question of Matta's influence on his son's career is just beginning to be explored,[8] and it bears heavily on the issue of Matta-Clark's perception and reception of his father's older colleague. Duchamp seems to have been for Matta-Clark a kind of conceptual uncle, personally available but emotionally unfraught, who as an artist offered permissions and areas of interest rather than charged exhortations or rigid templates. Call it, then, a byproduct of (elective) family resemblance that both played with doors, string, and real-yet-unreal wealth—or even that each had himself photographed covered with soap: Duchamp with his hair sudsed into horns for *Monte Carlo Bond*, and Matta-Clark lathered up in a raincoat for *Clockshower*. This project, which was staged at the Clocktower Gallery in 1974, was an overt homage to Harold Lloyd in *Safety Last* (1923), though Lloyd's clock is not on a tower and he is not taking a shower. Could *Clock-*

Marcel Duchamp
3 Standard Stoppages, 1913–14
Wood box and thread on painted canvas and glass
12 1/4 x 7 1/2 inches

Marcel Duchamp
Tzanck Check, 1919
Ink on paper
12 1/4 x 7 1/2 inches

Marcel Duchamp
Monte Carlo Bond, 1924
Gelatin silver print on lithograph with letterpress
12 1/4 x 7 1/2 inches

Gordon Matta-Clark
Still from *Clockshower*, 1973

Harold Lloyd in still from
Safety Last, 1923

shower, a daringly physical performance whose punning title is arguably the most important thing about it, be flecked with Duchampian soft-soap?

Just one work makes the alliance explicit—though, in keeping with the trend toward self-doubling structures, it may in fact have been two works. This was Matta-Clark's *Memorial to Marcel Duchamp*, no photographs of which seem to have survived. Anecdote locates both versions at Cornell University in 1968, the year Matta-Clark graduated with a B. Arch. from the school's five-year professional program. It was also the year that Duchamp died.

The first *Memorial*, as discussed by the critic Briony Fer, was an installation in an Ithaca graveyard, for which Matta-Clark wrapped the tombstones in a web of string.[9] This closely parallels his contemporaneous *Rope Bridge* (1968), slung across a gorge in Ithaca; as a salute to *Sixteen Miles of String*, it is if anything more faithful than the draped vines of *Museum*. Even cannier as a comment on its subject is *Memorial*'s second iteration or parallel event, which was descibed to both Thomas Crow and Pamela L. Lee by Matta-Clark's widow, Jane Crawford, whom he met in 1976. She had heard about it from a Cornell-era friend:

> The piece began with a woman friend dressed as Duchamp's female alter ego Rrose Sélavy reading poetry from a balcony overlooking a square room with a number of entrances. While the performance above held the attention of the bemused audience, Matta-Clark began filling the space with an inflatable structure, which progressively grew in volume until it occupied the entire floor. When the last spectator had been forced from the room, the memorial was over.[10]

As Crow observes, if this second story didn't exist one would have had to invent it, since it encapsulates so many aspects of Matta-Clark's practice, while illustrating so elegantly his understanding of Duchamp's. It is not clear when the *Memorial* performance took place, but on March 19, 1969, *Cornell Daily Sun* ran a picture of an inflatable sculpture by Gordon Matta, as he was called then.[11] Blow-up forms then disappeared for nearly a decade from Matta-Clark's work, to return near the end of his life, when he began researching industrial inflatables for use in "balloon housing." Or take *Memorial*'s square and balconied room with its "number of entrances," an architectural container schematized by neat geometry yet pierced by openings on multiple levels. This, too, was Matta-Clarkian *avant la lettre*. Visitors to geometrically sliced works like *Splitting* (1974) and *Office Baroque* (1977) would later report experiencing ecstatic disorientation in those kaleidoscopic environments. One imagines a similar response in audience members as they were pushed by a giant airbag towards a confusing variety of doors.

Other features of the inflatable *Memorial* are distinct in Matta-Clark's career. Performers, especially female dancers, occupied his works on several occasions, notably *Open House* and *Circus–Caribbean Orange* (1978). But they were not in drag, and certainly not in reverse-drag as a celebrated elder's alter ego. Matta-Clark was friendly with poets—Ted Greenwald's *You Bet* (1977) is dedicated to him—and poetry reading may have featured in other of his performances; mention of it has not, however, persisted in anecdotal accounts. (It is tantalizing to imagine what *Memorial*'s text was.) Even more particular are features that relate *Memorial* to the *Large Glass* (1915–23). These include the balloonlike shape of Duchamp's Bride and the fact that, like Matta-Clark's accomplice on her balcony, the Bride is sequestered in a realm above. Her desire is imagined as a gas, and Duchamp writes in *The Green Box* of the sensual inflation and deflation of the *"piston of the draft," modeled on a window curtain that blows in and out, i.e. cloth accepted and rejected by the draft.*

This evokes not only the faintly phallic inflation of Matta-Clark's pneumatic device, but the sense of elusive presence, a kind of *fort-da* game of loss and return, intimated by the *apparition* of faux-Rrose. In Duchamp's lexicon, *appearance* names the way a thing actually looks, while *apparition* describes the event of its appearing. Thierry de Duve explains that "in French, *apparition* only occasionally has the meaning of a ghost-like

Left to right:
Gordon Matta-Clark
View of *Splitting*, 1974

Gordon Matta-Clark
View of *Office Baroque*, 1977

Man Ray
Marcel Duchamp as Rrose Sélavy, circa 1920
Gelatin silver print
8 1/2 x 6 3/4 inches

vision. It also, and more prosaically, means the simple fact of appearing, for which the English only employs *appearance* again."[12] But Matta-Clark (like Duchamp in Matta-Clark's lifetime) was bilingual, and Rrose Sélavy—who was and was not Duchamp in life, and who embodied and did not embody herself in *Memorial*—here appears indubitably ghostly. The unattainable though present Bride is not stripped bare, but re-costumed. *Eros, c'est la vie*—except when she represents death. And yet, it was Duchamp who caused to be carved on his tombstone in Rouen the quip, *D'ailleurs, c'est toujours les autres qui muerent.* So Duchamp becomes a dead "other," and Rrose lives to play another round of what her creator called *a little game between I and me.*

A last aspect of *Memorial* is worth exploring. For the 1947 Surrealist Exhibition in Paris, Duchamp designed a piece called *L'autel du Soigneur de gravité.* The altar was built to his specifications by Matta. Or, Matta made a piece called *L'autel du Soigneur de gravité* while knowing—or not—that Duchamp had described such a figure in *The Green Box.* Matta told the Duchamp scholar Jean Souquet that he had acted on Duchamp's instructions; he told a different scholar, Herbert Molderings, that he conceived it unaided.[13] Subject to delayed retelling and hearsay, the details recall the circumstances by which we have come to know about *Memorial.* In either case, as Souquet explains, the task of Duchamp's *jongleur de centre du gravité* as described in *The Green Box* is to be "an inconspicuous minstrel." While the *jongleur* deranges the downward force, Souquet says, the Bride "speaks, she murmurs, she shouts the *blossoming imagined by her, Bride desiring.*"[14] The Bachelor-gaze is lifted up.

> Thus the two energies at work in the *Large Glass* flow together: a flow of light below, a flow of words above. At the end of the journey, the gas has become a dazzled gaze, and the Bride effervescent writing. As to the *stripping bare*, Duchamp instructed us, word for word, to read it as a *poème,.* (The comma was put in by Duchamp himself.) The time has come to entrust a troubadour with the task of reading this poem on our behalf.[15]

All the parts of Matta-Clark's stunt would seem to be in place: the Bride above, the gazing group below, the poem read, the stripping bare reversed in the dressing up of the woman-who-isn't-Duchamp; and yet accomplished as the room is "stripped" of its audience and the balloon of ridiculous desire and sincere homage "blossoms." And the juggler or attendant of gravity, the "troubadour" or "inconspicuous minstrel"? Matta-Clark himself, manning the air pump. The performative *Memorial* seems to have been a little game between "I" and "s/he."

From *Door, 11 rue Larrey* to *Open House* to *3 Standard Stoppages* to *Memorial* in either of its guises, these works share a concern with space dissected into forms that are precise in their illogic. As arbitrary limits, they emphasize that which is uninterrupted, i.e., air. Trap it in an ampoule—*50 cc of Paris Air* (1919)—bottle it as an esoteric perfume—*Belle Haleine* (1921)—peddle it from oxygen tanks on the street—*Fresh Air Cart* (1972)—or force it into a room-filling balloon: air makes a mockery not only of inside versus outside, or of measurement, packaging, and commerce, but of the very concept of division. Nothing could be more given, more ready-made than air, and nothing is easier or more impossible to cut in pieces.

As Thierry de Duve has shown, the readymade demands that viewers make a choice to see a nonart thing as if it were art. At the same time, it exposes that choice as an antinomy.[16] Air, a door, or a Dumpster—or a bottle rack bought at a Paris flea market, say; or a derelict warehouse illegally commandeered on the Manhattan waterfront—are not aesthetic creations in the traditional or academic sense. If *Bottlerack* (1914) and *Day's End* (1975) are works of art, then the definition of works of art has changed. But if viewers too complacently accept that received notions of skill and beauty have been renovated, they miss the point of the appropriation. Anti-*nomos* or "against law," the *readymade* remains challenging only when it hovers in between.

This flipside-to-flipside antinomial relation asserts spatial and conceptual proximity or interdependency—a mutual friction, imbrication, or penetration of unlike things—while at the same time leaving difference undenied. Here again, the crux of comparison is a physical relationship rendered in language.

Inframince and "the thin edge" name something very like this zone of quantum contact. These spatial-yet-conceptual situations are "metaphoric voids," "places where you stop to tie your shoelaces" or "spaces between places." They are a *possible*, a real nowhere located in

> *Hollow paper (infra-thin space*
> *and yet without there being*
> *2 sheets)*

or in the

> *infrathin separation between*
> *the detonation noise of a gun (very close) and the apparition of the*
> *bullet*
> *hole in the target.*

As such, they are not abstruse or esoteric. Like the bottle rack and the warehouse, they are mundane. But, like the open closures or the packaged

Marcel Duchamp
The Bride Stripped Bare by her Bachelors, Even (The Large Glass), 1915–23
Oil, varnish, lead foil, lead wire, dust on two glass panels
109 1/4 x 69 1/4 inches

Marcel Duchamp
50 cc of Paris Air, 1919
Glass ampoule
Height: 5 1/4 inches

Marcel Duchamp
Bottlerack, 1914
Photograph by Man Ray

Gordon Matta-Clark
View of *Days End*, 1975

air, such hyper-intervals are difficult to notice, much less to analyze, until they have been sliced by an act of will from the undifferentiated continuum of daily phenomena. A directing of attention—a choice—leads to the coining of a name. Now the unlike-but-somehow-like things comprise a category. The distinctive quality of almost-not-existing can be assessed, discussed, manipulated. But then the name, with its putative authority, threatens to reify the very fugitive, undecidable quality that summoned the attention in the first place. To balance on the teeter-totter of antinomy and hold open a Janus-faced view toward place and no-place, *anti* and *for* at once, is the desideratum of noncontradiction—and so language must be made to torque and shiver, to describe a something that is a nothing, or at least, simultaneously, a something else. The *anartist* and the "anarchitect" understood at the deepest levels of their practice the special permission or affirmation that such punning denials could bestow.

What Matta-Clark terms "the space between" and Duchamp calls *a minute separative amount* can be understood as that gap in meaning, that beat just before comprehension, that divides-and-unites the mutually exclusive/mutually dependent parts of a pun. The artists' two bodies of work, of course, are not only premised on the *readymade*/"ready-to-be-unmade," but are dizzy with puns. An aggressively physical building-cut is "Non-u-mental;" Mona Lisa is a transvestite, and *L.H.O.O.Q.* A complete concordance of their *jeux de mots* would be encyclopedic. The typology of their verbal productions in general, however, is remarkably similar.

Both Duchamp and Matta-Clark used language extensively. Neither authored manifestos, polemics, or criticism. Instead each left a three-part archive that includes: 1) a series of interviews revealing their subject as a consummate raconteur and trickster; 2) a sprawling compendium of aphoristic notes—Duchamp's collected by himself in *The Green Box*, *Texticles*, etc., while Matta-Clark's verbal artifacts, in particular the suite of index-card notes dubbed "art cards" by Crawford, have only recently begun to be exhibited and published; 3) a predilection for punning titles—*Fresh Widow*, *Splitting*—that transform the reading of tangible, visible forms.

Matta-Clark's funny, absorbing interviews are quoted as devotedly by scholars as are Duchamp's, though Duchamp's conversational record is more extensive; he lived more than twice as long as Matta-Clark, after all, and was far better known. The corpus of his writings is also larger. Centered on the erotic, hydraulic, and meta-dimensional system that explains, or mystifies, *The Bride Stripped Bare by Her Bachelors, Even*, Duchamp's verbal project also includes important statements like "The Creative Act" (1957) and "Apropos of 'Readymades'" (1961). Matta-Clark's writings are less elaborate. He tended toward mischievous one-liners, though a careful reading of the art cards and notebooks shows him returning to particular areas of inquiry and working through sustained sets of ideas. As Matta-Clark's thought is set in context against Duchamp's, the two interview collections

and compendia of notes demand a depth of consideration beyond my present scope. But a few comments on punning names and titles will suggest the kinds of relationships that lurk.

It was Duchamp who wrote, in "Apropos of 'Readymades,'" that the tagline attached to a readymade *instead of describing the object like a title was meant to carry the mind of the spectator towards other regions more verbal.* This is precisely what Matta-Clark's titles do. But his logorrhea differs from Duchamp's. The *Precision Oculist* tended to foreground nonsense musicality—*Nous estimons les ecchymoses des esquimaux aux mots exquis*—and his aliases apply mostly to himself: Rrose Sélavy, R. Mutt, the shady character in *Wanted: $2000 Reward* (1922), who is known as *George W. Welch, alias Bill alias Pickens, etcetry etcetry. Operated a bucket shop in New York under name Hooke, Lyon, and Cinquer.*

Marcel Duchamp
The Bride Stripped Bare by Her Bachelors, Even (The Green Box), 1934
Felt-covered cardboard box with photograph, facsimiles, and works on paper
Box: 13 1/8 x 11 x 1 inches

Matta-Clark once mounted a show under the Richard Mutt–ish pseudonym George Smudge, and needless to say he changed his own name—either to honor his mother and distance himself from his father, or to honor his father by adopting the Spanish-language custom of using both patronymic and matronymic, as in Roberto Matta Echuarren. But he was most prolific with monikers for his works. *Fake Estates* has at least three names. *Bingo* (1974)—a frame house in Niagara, New York whose façade he sectioned into nine panels—was variously called *Bingo X Ninths, Bingone X Ninths, Bin.go.ne, Bingo.ne by Ninths and Days,* and *Been Gone by Ninth or 1/9ths.*

Conical Intersect (1975) started life as *Étant d'art pour locataire*. It is not hard to hear in this name an echo of *Étant Donnés*, and the suspicion that Matta-Clark might have had Duchamp's late tour de force (1946–66) in mind is supported by his assistant Gerry Hovagimyan, who told Joan Simon:

> Gordon had another name for the piece, a play on Duchamp, which we joked about a lot while working in the building. This other name was *Quel Con,* which he knew was a very wry play on Duchamp's *L.H.O.O.Q.* (Gordon also called it at various times "Quel Can," "Cal Can.") ... Gordon's pun says both "what a cone" and "what a —" —I don't know quite how to say this, "lady's genitals, a cunt."

Simon adds the reading "'*quel conque*' ('whatever,' or 'more or less')."[17] Hovagimyan's observation, though, is paramount if slightly misdirected. Mona Lisa may have a hot ass, but it is *Étant Donnés* that focuses on a

cunt—or something like it, more or less. As Jean-François Lyotard explains, the French pun on *con* as "cunt" and "idiot" or "jerk" determines Duchamp's joke. In the visual structure of *Étant Donnés*, Lyotard writes,

> the viewpoint and the vanishing point are symmetrical. Thus if it is true that the latter is a vulva, this is the specular image of the peeping eyes; such that: when they think they're seeing the vulva, they see themselves. *Con celui qui voit.* He who sees is a cunt.[18]

Matta-Clark conceived *Conical Intersect*, which was produced as a commission for the 1975 Paris Biennial, as a social intervention commenting on the controversial redevelopment of the Les Halles district and the construction of the Centre Pompidou adjacent on the rue Beaubourg to his twin townhouses. Pamela L. Lee has described the complex reaction of the French Communist press to the project, which Matta-Clark found distressing,[19] while Thomas Crow outlines the work's relationship to Anthony McCall's film installation *Line Describing a Cone* (1971).[20] Marc Petitjean's documentary film *Conical Intersect* (1975), shot on-site during construction, in turn highlights Matta-Clark's own sense of the piece as what he calls a "*son et lumière*," i.e., a grand public entertainment in which projections onto an architectural façade are accompanied by music. "It started with the name," he told the interviewer Elisabeth Lebovici. "So this is a *son et lumière sans son et sans lumière*." Characteristically affirming by negating, Matta-Clark emphasizes the public aspect of the work. But perhaps the *son et lumière* that is not a *son et lumière* could also be related to the uncompromisingly private situation arranged for the viewer in the installation whose full title is *Étant donnés—1° la chute d'eau, 2° le gaz d'éclairage.* Is there something of a soundless sound in the Duchampian waterfall that is only an image, or a flicker of lightless light in the illuminating gas that does not illuminate? In *Conical Intersect*, it is as if the visual cones projecting from the eyes of the viewer who stands at Duchamp's door like an awkward Bachelor, uneasily peering at the distorted Bride, have been unraveled and shot home like projectiles into the conjoined houses where M. and Mme. de

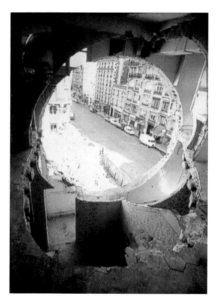

Marcel Duchamp
View of *Étant donnés: 1° la chute d'eau, 2° le gaz d'éclairage . . .* , 1946–66

Gordon Matta-Clark
View of *Conical Intersect*, 1975

Lieseville once lived together with ease or lack thereof.

If Matta-Clark was responding to *Étant donnés* in *Conical Intersect*—that is, if he was experimenting with built space as a stage on which a violently gendered voyeurism plays out; or if he meant to invoke the sense, articulated by Lyotard, that a reflexive occlusion spins vision back upon itself at the moment of revelation—then another small detail dovetails with the title *Étant d'art pour locataire*. The phrase "being art for the tenant" ties Matta-Clark's interest in housing rights and the problematic Beaubourg redevelopment to Duchamp's very different preoccupations with sexuality and interiority, and this unlikely link is affirmed by a notebook entry that Matta-Clark made circa 1974, in which the feminine city is imagined as dismembered by its inhabitants: "A BRIDE TORN APART BY HER LODGERS." Another oddly female and essentially verbal ghost marks Duchamp's presence in Matta-Clark's thought.

As with the interviews and sets of notes, much more could be said about the Duchampian/Matta-Clarkian pun than I have space for here. As this reading of *Conical Intersect* suggests, the pun provides a way in to discussions of space as gendered in Matta-Clark's work. This then points not only to the punning interpretation of masculinity and femininity in Duchamp's art, but also, more elusively, to Matta-Clark's actual collaborations with women artists—a subject that itself rebounds vertiginously toward Duchamp's auto-collaboration with Rrose Sélavy. The paradigm of the pun, furthermore, can help to disentangle the vexed question of whether, or how, Duchamp might be understood as an alchemist or master of physio-symbolic transformations. A pun, like an alchemical procedure, is a vehicle by which unlike things are made to meet and mingle, giving rise to a hermetic third entity that can be realized in no other way.[21] Thus the pun also shifts Matta-Clark's avowed interest in alchemy past the literal transmutation of substances—though he was certainly interested in that—*toward other regions more verbal.*

Matta-Clark understood "the thin edge" as a trace inscription, a kind of spatial writing. Accordingly, a fuller treatment is called for regarding the pun as a trope for spatial relations read linguistically, or what Matta-Clark called "a building's total (semiotic) system." The semiosis of a building is indexical because its symbolic vocabulary is physically inscribed in traces that, as Matta-Clark explained, reveal "the element of stratification. Not the surface, but the thin edge, the severed surface, which reveals the auto-biographical process of [a building's] making."[22] A house or office block as a coherent, pre-existing thing must be "unmade" in order for its history to be legible. Nevertheless, that history waits "ready," embedded in the thin-edge nonspace inside walls or floors. The *inframince*, too, is found or identified but not created, and is similarly indexical. Duchamp explains in his notes that *inframince* is always an adjective, never a noun. It exists only as a modifier, a qualitative extra generated as a trace or residue by certain

kinds of touch that occur in time; to cite the examples most often quoted, velvet trousers rubbing together, or a seat warmed by a recently removed sitter, produce a frisson whose dimensions are infrathin. Verbal punning, physical punning, infrathin relations, and the indexical trace could therefore be arranged as lopsided equivalents—another *subsidized symmetry* or paradoxical noncontradiction.

An extended argument would work through these equivalencies slowly, then turn to another system for fixing indexical traces, i.e., photography. How is "light writing" as used by these two artists like or unlike regular writing with words? How do their notes and photographs alike help to account for—or confuse—the uneasy status of their most famous artworks, so frequently destroyed or gone missing, left unfinished, and/or remade by others? Writing and photography, obviously, are systems of signs used to represent vanished or distant things. As Rosalind Krauss has shown in "Notes on the Index, Part I," Duchamp was preoccupied by indexical signs, from photographs to shadows to casts of body parts; in "Notes on the Index, Part II,"[23] Krauss examines ways in which Matta-Clark's generation used photography to index far-flung or temporary installations. To make explicit the comparison implied in her two-part text, how is Matta-Clark's indexicality like or unlike Duchamp's? How does this similarity or difference relate to the distinction between *readymade* and "ready-to-be-unmade"; that is, between the selection and recontextualization of mass-produced objects like a urinal or a snow shovel, and the selection and reconfiguration of buildings that are built one at a time, but nevertheless remain governed by the laws of a mass market that consigns them to obsolescence?

Et cetera. I can only repeat that this marks territory for a longer project now in progress. For now, I will content myself with one more specific comparison, and a bit of biography.

<div style="text-align:center">—•—</div>

Duchamp called himself an *anartist*. Matta-Clark called his work "anarchitecture." These aliases allowed their inventors to keep "tying different intersects together," *to make work that is not a work of art*. The two neologisms, moreover, express their *ironism of affirmation* through exactly the same etymological maneuver. The an- is a variant of a prefix called an alpha privative. With origins in ancient Greek, the alpha privative stands for negation or absence, as in "anaerobic" or "atheist." Grafted onto the names of roles or disciplines that Duchamp and Matta-Clark could embrace only by denying, this *an-* cancels art and architecture but does not cease invoking them. *Anartist* and "anarchitecture" split the difference between being and not being; instead of simply toggling between *two sides of the same thing*, alpha-privative constructions hold open a third option, a sliver-space that connects yet divides the two sides. As names for categories that undo their

own existence, *anartist* and "anarchitecture" thus offer meta-aliases for the art-and-yet-not-art that is the *readymade* or "ready-to-be-unmade." At the same, in these twinned terms we might discern a fundamental difference between Marcel Duchamp and Gordon Matta-Clark.

"Anarchitecture," for Matta-Clark, was a running conversation or collaboration with a coterie of artist and dancer friends. The word was also a protean container whose absurdity sanctioned his impulse toward "DESTRUCTURAL PUNCTUATION." The group mounted one exhibition at 112 Greene Street in 1974; in June of that year a two-page photospread appeared in *Flash Art*, which included this list in Matta-Clark's architectonic handwriting:[24]

AN ARK KIT PUNCTURE	A KNEECAP FRACTURE	ANACCUPUNCTURE
AN ARCHITECTURE	IN ARCHITECTURE	AN ASTRAL VECTOR
ANARCHY TORTURE	ON ARCHITECTURE	AN AUSTRAL UNDER
AN ARCTIC LECTURE	AN ATTIC TORTURE	A NECTOR TASTER
ATLANTIS LECTURE	AN ARTICVECTOR	A NARCO TRADER
AN ORCHID TEXTURE	AN ART KIT TORTURE	AN ASSTRAL FACTOR
ANT LEGISLATOR	ANARCHY THUNDER	A FILLIBUSTER
ANARCHY LECTURE	A LETTUCE TEXTURE	A FULLER BRUSHMAN
AN ART COLLECTOR	AN ART DEFECTOR	AN AUSTRAL BUSHMAN
AUNT ARTIC TORTURE	AN ASS REFLECTOR	AN ARCTIC TRACTOR
AN AIR KEY TALKIE	AN AIR KEY TACTILE	AN AIR KEY TICKLE

As meta-puns, his variants prise open the gap between *anti* and *for* by spiraling into delirium, and one can almost hear the laughter as a dinner-party brainstorm gets more and more far out. Duchamp's rationale for becoming an *anartist*, in contrast, establishes the third option by making a logical argument against a logical structure in which iconoclasm too neatly opposes belief. It sounds like a solitary commitment. As he told Richard Hamilton in 1959:

> I am against the word "anti" because it's a bit like atheist, as compared to the believer. And the atheist is just as much of a religious man as the believer is, and an anti-artist is just as much of an artist as the other artist. *Anartist* would be much better, if I could change it, instead of anti-artist. *Anartist*, meaning no artist at all. That would be my conception. I don't mind being an *anartist*.[25]

Duchamp as the *anartist* praises *a complete anaesthesia* (in Greek, an absence of *aisthesis* or "sensation"), which he identifies in "Apropos of 'Readymades'" as the signal factor in choosing an object to designate. Matta-Clark's "anarchitecture" instead encourages anarchy (a subversion of the Greek *arkhos*, "ruler or chief"). It fosters not a dulling of feeling but its riotous release.

To return to the issue of air: as Joan Simon observes, Duchamp once described himself as "*un homme, tout simplement un 'respirateur.'*"[26] He also proposed, with a surprising violence implied against himself as "simply a breather," that one could *establish a society in which the individual has to pay for the air he breathes (air meters: imprisonment and rarefied air, in case of non-payment simple asphyxiation if necessary (cut off the air).*[27] Matta-Clark's thoughts about life, death, inflation, and deflation might seem predicted in this note. But when he made *Fresh Air Cart*, rather than anaesthetizing or asphyxiating a disobedient receiver who stands in for the self, Matta-Clark gave "beautiful breath" away as AN AIR KEY TACTILE—a physical necessity framed by verbal wit and offered with anarchic generosity.

<center>———•—•———</center>

Marcel Duchamp is sometimes referred to as Gordon Matta-Clark's godfather. Other sources identify Teeny Duchamp as his godmother.[28] Family documents indicate that Gordon and his twin brother, John Sebastian, who was nicknamed Batan, were baptized in Chile during an extended visit in 1945; their mother, distraught and broke after Matta's sudden departure from the family, had decamped for Santiago and the shelter of the paternal grandparents. Baptismal certificates show that Matta's mother Mercedes stood as godmother to the two-year-olds, while the role of *padrino* was filled for Roberto Gordon by one Pedro Montero, and for Juan Sebastian by a relative called Roberto Matta Sagle. Teeny Duchamp wrote a fond note of condolence to Anne Clark after Gordon's death, remembering that "ever since Batan and he were little boys I have followed their lives and yours in thought and sympathy and you all had a secret place in my heart." If she assumed the role of godmother in a secondary or informal way, perhaps this stands as her acknowledgement; no definite evidence demonstrates that the skeptical Duchamp accepted such a commission.

But there is a rightness to the idea of spiritual sponsorship that helps to explain the story's persistence. "Duchamp was a silent force," wrote Carol Goodden—Matta-Clark's girlfriend and frequent collaborator in the early seventies—when she was asked, in 1992, about his influences. "Gurdjeev (spelling) was the philosopher he was enamored of … Matta (father) was his psychological drive. Batan was his guilt."[29]

Matta-Clark's own testimony is inconclusive, but this was characteristic. (He doesn't seem to have said a word, for example, about Gurdjieff).[30] Perhaps because his artistic inheritance was so Oedipally overdetermined, he rarely admitted influences of any kind. He was quick to acknowledge the importance of his own close-knit coterie—who from about 1970 frequented the cooperative gallery at 112 Greene Street, owned and benevolently operated by the artist Jeffrey Lew; or ate in the restaurant-cum-art-project FOOD, run by Matta-Clark and Goodden (who danced with Trisha Brown

when she wasn't cooking); or met as the loosely organized Anarchitecture group, which again involved Goodden, Lew, and the same core cast of characters who frequented 112 and FOOD, including Tina Girouard, Jene Highstein, and Richard Nonas. When it came to forebears, however, or even to relationships beyond his intimates, Matta-Clark was determinedly independent. Little documentation exists in his archives for any kind of aesthetic apprenticeship.

Like the note that reads "A BRIDE TORN APART BY HER LODG-ERS," Duchamp's aphorism *there are no solutions because there are no problems* appears in a Matta-Clark notebook. No attribution or comment is attached, though a determined interpreter might read a challenge into the dash that Matta-Clark inserts: "there are no solutions because there are no—problems." He mentions Duchamp just once in the interviews. It is his interlocutor, the architectural historian Donald Wall, who raises the question, and Matta-Clark is careful to distinguish his own "unrational" process from the "perfectly tutored rational being" of Duchamp.

> Donald Wall: To interject for a moment, Duchamp once said that a major artist makes maybe one, two or three major statements in his lifetime, and the rest is infill, something to do merely to occupy time. In effect, garbage. How close are you?
>
> Matta-Clark: It's difficult to assess what is and what is not important. I am not as much a Frenchman as was Duchamp. He had the advantage of being a perfectly tutored rational being. I haven't been so carefully trained. Where he can define his problem in terms of a few discrete, well-maneuvered jestures [sic] ... which I think is true, that there are just so many new works one can do at any given time. . . . I see the process for my own work as being much more diffuse, much more unrational.[31]

These statements are recorded in a redacted typescript on file in the Matta-Clark archives. In the substantially different published version, which appeared under the title "Gordon Matta-Clark's Building Dissections" in *Arts Magazine* in May, 1976, the passage has been shortened.[32] An equally telling exchange has been added. Wall again begins, "This brings up the placement of your work historically. Does it lie more within Dadaist or Land Art concerns?" Matta-Clark first explains that unlike Robert Smithson, Michael Heizer, et al., he has "chosen not isolation from the social conditions but to deal directly with social conditions whether by physical implication ... or through more direct community involvement." Taking up Wall's other proposition, he continues,

I should mention my feelings about Dada since its influence has been a great source of energy. Its challenge to the rigidity of language both formal and popular, as well as our perception of things, is now a basic part of art. Dada's devotion to the imaginative disruption of convention is an essential liberation force. I can't imagine how Dada relates stylistically to my work, but its spirit is fundamental.[35]

With Duchamp in effect as a *silent force*, it is not, in fact, difficult to imagine how the stylistic relation as well as the energetic liberation can be read into Gordon Matta-Clark's art. Fittingly, though, the pivot point of the insight just might be a mistake. It is not clear who typed the archived transcript of the Wall conversation, though edits appear on every page in Matta-Clark's hand. So arguably not too much should be made of the typo "jestures." It is hard to resist, however. As a pun, "jestures" is on the order of "anarchitecture" or *anartist* as an inspired portmanteau word that names the "disruption of convention" through a "challenge to the rigidity of language both formal and popular." As a label encapsulating a wide variety of artistic practices and an attitude toward the reception and categorization of art objects, "jestures" is itself singularly "discrete" and "well-maneuvered," poised in the infrathin zone where rational and irrational, perfect tutoring and tongue-in-cheek throwaway meet. It is a word Marcel Duchamp might have made up.

NOTES

1. Throughout this essay, unless otherwise noted, phrases and terms in italics are by Marcel Duchamp and are quoted from: Michel Sanouillet and Elmer Peterson, eds., *The Writings of Marcel Duchamp* (New York: Da Capo Press, 1973), and from: Paul Matisse, ed. and trans., *Marcel Duchamp: Notes* (Boston: G. K. Hall, 1983). Those in quotation marks are from writings by Gordon Matta-Clark, either on deposit in the Gordon Matta-Clark Archive at the Canadian Centre for Architecture in Montréal; cited in: Corinne Diserens, ed., *Gordon Matta-Clark*, (New York: Phaidon, 2003); or gathered in: Gloria Moure, ed., *Gordon Matta-Clark: Selected Writings*, (Barcelona: Ediciones Poligrafa, 2007).

2. Francis Roberts, "Interview with Marcel Duchamp: 'I Propose to Strain the Laws of Physics,'" *Art News* (Dec. 1968): p. 62.

3. Joshua Shannon, *The Disappearance of Objects: New York and the Rise of the Postmodern City* (New Haven, CT: Yale University Press, 2009), p. 206 n. 91. Shannon in turn cites David Joselit, *Infinite Regress: Marcel Duchamp 1910–1941* (Cambridge, MA: MIT Press, 1998).

4. These were *Incendiary Wafers*, a mix of agar agar, sperm oil, V8, chocolate Yoo-Hoo, and other substances that had been cooked and left in shallow pans to rot and dry.

5. Friedemann Malsch and Thomas Crow have remarked, apparently independently, on similarities between *Museum* and *Sixteen Miles of String*; Elizabeth Sussman compares *Door, 11 rue Larrey* to *Bronx Floors*; Joan Simon discusses *50 cc of Paris Air* in connection with *Fresh Air Cart* and the accompanying video *Fresh Air* (1972). For Malsch and Crow, see Diserens, *Gordon Matta-Clark*. For Sussman and Simon, see Elizabeth Sussman, ed., *Gordon Matta-Clark: You Are the Measure*, (New York: Whitney Museum of American Art, and New Haven, CT: Yale University Press, 2007).

6. See Jeffrey Kastner, Frances Richard, and Sina Najafi, *Odd Lots: Revisiting Gordon Matta-Clark's "Fake Estates"* (New York: Cabinet Books, 2005).

7. Pierre Cabanne, *Dialogues with Marcel Duchamp*, trans. Ron Padgett (New York: Viking Press, 1971), p. 63.

8. See Betti Sue Herz, ed., *Transmission: The Art of Matta and Gordon Matta-Clark*, (San Diego Museum of Art, 2006).

9. Ibid., p. 35. Fer does not cite a source. Gwendolyn Owens, Consultant Curator for the Matta-Clark Archive at the Canadian Centre for Architecture, cites corroborating reports from Matta-Clark's Cornell contemporaries for the existence of a graveyard string piece and at least two inflatables. Witnesses agree that Matta-Clark made a memorial to Duchamp, though which piece consituted it and precisely where it was sited remains somewhat unclear.

10. Crow in Diserens, *Gordon Matta-Clark*, p. 22. Lee notes that the Cornell friend was called Serpic Angelini. See Lee, *Object to Be Destroyed* (Cambridge, MA: MIT Press, 2000), p. 269 n.4.

11. Sussman, *You Are the Measure*, p. 170. The caption reads, "The plastic fantastic: Gordon Matta '68 salutes his gigantic new sculpture entitled *Deflation*. The $30 plastic creation, seen here on the site of the new art museum, is being inflated by conventional techniques."

12. Theirry de Duve, *Kant After Duchamp* (Cambridge, MA: MIT Press, 1996), p. 96 n9.

13. See discussion between Jean Souquet and Herbert Molderings in Thierry de Duve, ed., *The Definitively Unfinished Marcel Duchamp* (Cambridge MA: MIT Press, 1992), pp. 128–9.

14. Souquet, "Possible," *The Definitively Unfinished Marcel Duchamp*, p. 99. The italicized words are Duchamp's.

15. Ibid., pp. 104–5.

16. This is the central argument of *Kant After Duchamp*. I am indebted throughout this essay to de Duve's analysis.

17. Mary Jane Jacob, *Gordon Matta-Clark: A Retrospective* (Chicago: Museum of Contemporary Art, 1985), pp. 88–9.

18. Jean-François Lyotard, *Les TRANSformateurs DUCHAMP*, 1977. Translated by Rosalind Krauss, and quoted in her essay "Where's Poppa?" in de Duve, *The Definitively Unfinished Marcel Duchamp*, p. 437.

19. See Lee, *Object to Be Destroyed*, chapter four, "On the Holes of History."

20. Diserens, *Gordon Matta-Clark*, p. 95.

21. This is a longstanding debate in Duchamp scholarship. See for example discussion following Francis M. Naumann, "Marcel Duchamp: A Reconciliation of Opposites," in de Duve, *The Definitively Unfinished Marcel Duchamp*, pp. 69–82, in which puns and *inframince* also appear, without explicit connections being made. The classic text on Duchamp and alchemy is Arturo Schwarz, "The Alchemist Stripped Bare in the Bachelor, Even" in Anne d'Harnoncourt and Kynaston McShine, eds., *Marcel Duchamp* (New York: Museum of Modern Art, 1973).

22. Donald Wall, unpublished transcript, p. 6. Matta-Clark Archive at the Canadian Centre for Architecture, (PHCON2002:0016:001).

23. Rosalind Krauss, "Notes on the Index: Seventies Art in America," *October*, Spring (Part I) and Fall (Part II), 1977.

24. Diserens, *Gordon Matta-Clark*, p. 158. All spellings original.

25. Quoted in Arturo Schwarz, *The Complete Works of Marcel Duchamp* (London: Thames and Hudson, 1969), p.35.

26. Joan Simon, "Motion Pictures: Gordon Matta-Clark" in Sussman, *You Are the Measure*, p. 150.

27. Incomplete parentheses original.

28. For Duchamp as godfather, see for example Crow in Diserens, *Gordon Matta-Clark*, p. 16; for Teeny Duchamp as godmother, see Lee, *Object to be Destroyed*, p. 269 n.4.

29. Carol Goodden, letter to Corinne Diserens, July 5, 1992, Diserens, *Gordon Matta-Clark*, p. 213 n7. Batan Matta committed suicide in 1976.

30. Matta-Clark's library, as inventoried some years after his death, contained two books by Gurdjieff and one by his disciple P. D. Ouspensky. Email to the author from Jane Crawford, September 11, 2006.

31. Wall, transcript, p. 12. Ellipses original.

32. Diserens, *Gordon Matta-Clark*, p. 185.

Donald Wall: To interject for a moment, Duchamp once said that a major artist makes maybe one or two major statements in his lifetime, and the rest is infill, something to be done merely to occupy time; in effect, garbage. How close are you to those statements?

Matta-Clark: Duchamp was a master strategist. Being a perfectly tutored rational human being, he could define his problem in terms of a few discrete, well maneuvered gestures. I see the process of my own work as being much more diffuse.

33. Diserens, *Gordon Matta-Clark*, p. 184.

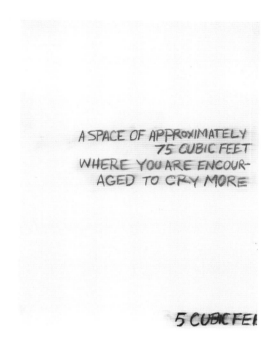

A SPACE OF APPROXIMATELY
75 CUBIC FEET
WHERE YOU ARE ENCOUR-
AGED TO CRY MORE

5 CUBIC FEE

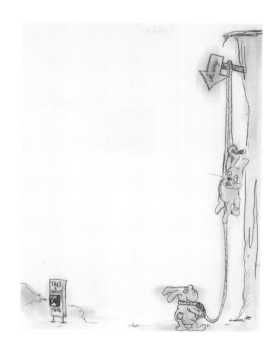

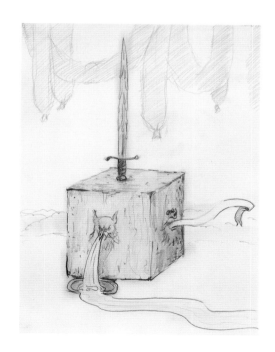

Dailies, 2005
Set of thirty drawings
Graphite and colored pencil on paper
12 x 9 inches (each)
Courtesy Matthew Marks Gallery, New York

"Once upon a time, far up the Mountain of All Toads, during a storm blowing worse than this one, there lived a plump gray boss, ripe for lessons. Yes. His nation's people, he forced to go around bent low to suit his size. They developed big health probs, son. And yet, required to hop like reptiles during his whole gilled reign, they failed to give one peep, complaining ..."

Executive secretary by day—come dark, she consoled her child aloud. She was stretched out on his bedclothes. Under those, at every blot of thunder, the boy clamped hands over his ears. Above this cottage, across black sky, white-hot veins showed then forked then failed. Indoors the son savored his Mom's attention and, throughout, kept close against her.

The boy could not know that—this very midnight—his parents' divorce became final. His father was, his mother hoped, the three promised states away. Tonight she treated her son with such tenderness it looked like pity. Glad, he sensed this would only make her spoken story longer, better. For her, tonight—a storm, a story—all seemed part of one marriage ending. It was all spelled out on her, starting with her husband's four knuckles, ending at her own right eye.

She touched their boy's yellow hair. She touched his blue pajama shoulder. Windowpanes sounded as loose-and-yet-attached as this kid's front-tooth last week.

Came another bold sound. He clutched at her. "Mom, it's not that I'm a*fraid* of thunder. . . . More I just don't *like* it."

To her his explanation sounded very male!

His father, in exiting this house, had grabbed her wrist; kept twisting it (then her) any way he wanted. "You *see*?" he'd said, last thing.

Now, using that same wrist—still braceleted with a memory of his bruise—she soothed the son of one charming hurtful man. She pressed the coolest spot of her own inner arm against a boy-child's thin neck, his nearest ear. He was his father's son. Might not this newt-sized-male contain, far-in, another prince-turned-toad?

Gutters rattled out three hundred gallons. From darkness overhead, thunder sounded like the breaking open of a single planetary egg. And feeling her son jump again, "Once" his Mom half-yelled to push their tale off right, "Once upon a storm, forty times worse than even ours here now tonight, once inside a rock-and-lilypad-palace, there ruled ..."

At "once" he nestled inches deeper under his coverlet's twelve quilted trains. Hall lamps died. A popping, as the dark house creaked itself toward stillness.

"Just a power failure, buddy. Happens. Nothing to worry us, compared with, ONCE ...

In a way-stormier mountain-type time that smelled of maybe pine sap and cold rocks, there lived, let's make it, a King who looked so much like a Toad, he truly *was* one. He'd sprung (or leapt) from a long line of toads. You should have seen his *Moth*er, poisonous.

"Nobody knew how a family of ditch-dwellers with skin-bumps and yellow eyes could've become their Nation's Royalty. But, for generations, none of the country's human-citizens had even bothered questioning this whole set-up. King Toad, the son of one from earlier, he wore a slimy crown. He spoke in deep rivety snaps. He tried deciding everything for everybody. He weighed forty pounds. His legs were so bent to either side, this Toad King did not so much take steps as he got around by..."

"Hopping," the boy contributed. An only child, he pressed his advantage, "All over!"

"*Cor-rect,*" spoke the executive sovereign of tonight's alimony imagination.

Given such bad weather, hearing their neighbors' Siamese cat left out-doors and whining on a nearby deck, recalling the unhappy ending of her *own* romance with the once-fair now-scaley father of this boy here, the mother could—at least within the visiting-privileges of her own story—remain forever a bride, perfectly intact and always right.

"And soon (I did give you the money for your school trip? Oh yes, in the zipped front of your red Thomas the Train bookbag, remember?), soon, because the ugly, warty Toad King was so darn *controlling*, his citizens would rather hurt themselves than risk his yelling at them yet again. (Maybe he, being king, barely noticed all the pain it costs a nation, calming him?) His citizens could still walk on their back-legs perfectly well. But so scared were they of living with the Warty One, they no longer chanced even standing all-the-way-upright in public—imagine. Why, within a few years (since fear keeps always expanding), they'd all forced themselves to ..."

"*Hop!* Most everywheres!"

"Everywhere, no 's'. Otherwise exactly correct. They hopped until folks finally got alone at night, like us here now. Then they could finally taffy-pull themselves up to their full lengths.—Just think how it must hurt, living forever bent, son. Fear'll flatten anyone. Whole countries pancake down because of it. And, after spending a day humped-over from fear? Are you kidding? People's backs must've just been killing them. You know how *mine* gets. There seemed no way for the Toad King's citizens to separate them-selves from how it'd always been being. Not until, one day, there arrived into this mountain-top capital city, a young blond boy, proud in pajamas fashioned of a powdery yet powerful superhero shade of blue ..."

"Like … ?" the boy held up—stared down in the dark—at his own flannel sleeve.

"Exactly. And this clear, straight-standing young boy, fresh in from the country, did not yet know *how* to stoop or grovel or scuddle everywhere like his new town's weakened grown-ups. They all lived so terrified of the executive Toad, they'd made themselves sound simpler than they felt. In the Market Square they no longer *spoke*, more *croaked*. They thumped along in muddy water at their Toad King's swampy level. They could not even make their marriages work. (Though all the moms and dads, however peevish they might've sounded through thin walls late at night, basically loved their boys and girls very very much.) This new farm kid looked down on the others. But just because they *were* lower, limping along, sitting all day in the market or at school. You know it must hurt a wife to go around squatting for twelve hours at a stretch, son! The world is not some basement. But that was how it felt, that's why … That's why they *had* to change.

"First the new boy really tried their way of bumping over cobblestones. He got down on his knees and hands. He later swore this somehow mainly hurt his *neck*. So, rising to his natural height, he plainly told whoever asked, 'There is nothing wrong with hopping—if you happen to get born a toad! Makes perfect sense then. But I feel like, for us others, it's also okay to just walk around letting your spine stay straight as it was made. I have my own farm-type way of moving. Guess I learned to walk out in fields where they don't yet know to be ashamed of getting up mornings then staying on their feet all day un-hunched, unlike here. My dad and mom, they're both six-footers. And I will *nev*er grow up to be healthy and tall as them if I twist myself pretzel-doubled every day! Thank you. But I shall probably just walk on my own. Whichever way feels best. Not being from the Toad King's capital, I'm probably simpler.'

"Having said that, the boy strolled upright everyplace. Towering over the worming-around adults in Market Square, this youngster wandered many a city street. He was as full of questions as of answers. No hiding for him, no hiding him, no hiding anything *from* him. He did not set out to teach or shame others. No, son. This was simply who he was. Always a natural lesson of strength came out of him. Seeing the tall blond boy helped certain bullied older ladies believe there *must* be more to life than living like some curtsey trapped in a basement.

"… And he began to be copied. First, only other little boys dared walk a bit straighter. (But they were still too short to draw many glances in busy squares.) Soon though, there rose up young husbands and brave wives. The vertical got fashionable by inches, then seemed—on Monday Market Day—to shoot up overnight. The power of fashion hemlines' lengths … it has a tidal pull on our emotions. That one sunny Monday others suddenly felt willing to all go about treelike in their natural unlocked and upright positions. It almost became a health fad! And soon the smartest of the

locals—people who'd grown tired of nightly charlie horses and knotted calf muscles, after days spent hopping hunched in their low-level buying and selling—they too rose against their Toad King, son. And how … ?"

"By just … *standing up* to their Toad King? Just by standing *up*, Mom!?"

The mother of the boy must have suddenly needed a break. She rushed out for a glass of water. His mom could get so involved with her own stories that she had to take recesses. Once back, she stated, "*You were just 100% correct, you.* Hey, be honest: did you tell me this story before? Because you seem to know it better than *I*. Can't understand how *any*body was ever any smarter or finer than you seem to me tonight, son—plus during an electrical storm! I don't hear the neighbor's cat anymore, do you? Means she's hidden safe inside their tool shed. There's not a lamp lit in this whole town and yet it feels so cozy here, right? —But wait, you keep wiggling…are you picking your nose again? In the dark, and after all the times I've asked you not to?"

His answer, it assembled slowly. "Well, but I'm not really so much *picking my nose*? It's more I'm … *searching* my nose."

"Whatever you call it, storyteller, having a knuckle clear up your snoot looks awful. 'Searching!' You are always so much, *you*. Give your mom lessons in how she too might manage that? —Meanwhile, back in the knee-level land of the Toad King, someone's simply walking around at a person's full proud height was becoming known. Known by the very name of that fine and searching farm-boy himself, which was …"

"'Jeffery'? Yeah, *Jeff*ery. Did they say, 'I want to go for a jeffery?'"

"Silly. Of course. But while the boy only liked to jeffery around the kingdom having fun and seeing friends whose imaginations were at last coming up to *his* level (which we know was high because his parents had already had him tested), wouldn't you know that dreadful Toad King summoned him? Jeffery's pals all seemed to have been dreading this. Some even started crying. You see, they understood: *You stand up, you stick out.*"

"Seven hopping khaki-colored lizard soldiers soon surrounded Jeffery's home. They made their voices drop toad-low, hoping to imitate his Royal Amphibiousness. Seven guards ordered Jeffery toward the palace. Guards grabbed Jeff's hands and, flopping at all sides, yanked him straight uphill toward the steep, gray, warty castle of the squat, gray, warty king.

"Our Jeffery soon found himself led through chambers paved in round rubber shields painted the green of lily pads. He entered rooms splashing with sixty fountains, overflowing, dripping all over the floor. Guards shoved the boy through one chamber buzzing with a million flies that could only please a …"

"Frog!"

"Toad *or* frog. (We will accept that answer.) Finally the rooms grew taller and damper till our Jeffery knew this must be the biggest and greenest and drippiest of all royal halls. Like a certain boy with that head cold he had six

weeks ago and remember how it all came out at once and you laughed?"

"Yeah. Like one *thing*."

"And there, settled on a lilypad set atop a dragonfly throne, formed of gold then covered with wet blankets and furry gray-green mold, rested the King of Warts and the Nation.

"Croaks he, 'How *dare* you not bow before me, oh Yellow-Haired Upstart! How cruu-el of you to become popular, to make me feel still more hunched and little and spotted? Being the son of one, I am, am I not, *King*? (Plus I have a Master's in Business Administration.) Therefore when I call, "Hop!" you're to respond, "How High a Hop, Sire?" Understand? You, tall young man, are the beginning of an uprising.'

"But our straight-standing boy acted oddly patient. He did not sound mad. Nor did he bow. He just explained that the Toad King ruled a land of toads plus others. Toads hopped. Only natural, being right there in the master plan. But others got around in different ways. Each progressed via its own manner inborn. To make one group bend to the will of another, that is strange, that means a kind of strangling."

"'I don't want anybody copying *me*,' Jeffery told his king. 'I just see where I plan to go and I get there. The best looking distance between two choice points is my favorite daily walk. I hate repeats. So, you're slowing me down, you're lowering my very head on purpose? That only makes me sad. O, Over-Toad of Under-Tow,' Jeffery continued, though the guards were giving him mouth and head-sagging signals not to. 'Half your country feels glum from crouching in a daily squat. That pinches everybody's middles. People must take pills. No picker-up is strong enough for how low you keep bringing your own folks down, Sire. Have you never *guess*ed you're knot-tying their stomachs? You didn't mean it, right? And yet, your country—living on its knees—is in one sad state. And *sad* countries, they mope. And mopey countries produce less. And un-producing-type-countries? tend to sleep and borrow more and grow hateful toward others. Some hitting soon goes on, Sire. Eventually "biters" appear. Your citizens *want* to like you. Since you were born so lucky, tell Jeffery why you stay so mad?'

"The Toad King sat as silent as any major asthma sufferer ever can. He wheezed but felt his every snapping gasp sounded regal, even wise. Did I say his eyes shone yellow with black ropey veins? Watching the Toad King's frown, his guards grew very stiff. You could see they feared him. They'd never heard their boss corrected. He hadn't ever sat still for criticism, certainly not from some out-of-family non-toad!

"Jeffery stood throne-side maximizing both his long hind legs! Just a creature's standing upright in this palace had cost others their lives! But here the brave boy was, vertical and righteous as noontime. Here he was wearing blue pajamas, the white feet-pads stitched right in.

"'No one addresses me thusly, peasant cub! You'd look better bent. Do as I say. Show me how *you'd* look hopping toward me from that far door there.

Afterwards, just to prove that my mind is open, you may demonstrate how you would *like* to approach your Ruler, Source, and Sun-King.'

"So Jeffery, saying 'Oh boy!' jogged to the throne room's far end. He dropped, let himself look silly, sloppy, floppily bent coming forward. Spastic, he hippety-hopped toward the Royal's yellow eyes. These squinted, that eager to feel enchanted. But soon they narrowed, wondering if a joke were being played.

"Jeffery next rose, rushed once more to the far door, and stated, 'Or maybe a li'l of a-*this*?' He was so far from the throne, he looked tiny at first but soon grew big with ease. He strode forward, just smiling the king's way. Jeffery's arms were swinging free. He came simply walking with good posture and a certain chesty force. With that grin, and his scuff pads' tifty-tifty sounds, Jeffery did make locomotion seem pure Thomas the Train fun.

"But the king yet sulked, lowering his butter-yellow pop-eyes. Finally even he admitted, 'It did look a *lit*-tle better. If only because you got to return to me and my royal throne faster than any Olympic-trained hopper. I will say *that*.'

"Jeffery added, 'Probably it's wonderful for kings to hop. Gives you all more land-level thinking-time. But certain taller citizens have jobs like fetching bread or keeping things swept—tasks easier done standing up. When did you, Sire, last try sweeping from the sitting position?' Then Jeffery heard himself, 'Forget I asked that last part.'

"The Toad King pretty much sulked. They tend to, both toads and kings. He bounced a few times, squishing his throne's drippy cushion. Finally, the ruler snapped, 'I suppose you must always have everything your own way?'

"'Don't you? I certainly *try*,' came Jeffery's answer. You sensed the shuddering guards felt pleased, if fighting to hide it.

"At last the First Toad nodded, his mouth tightening along its pale green sticky seam. And, next day, an edict was loudly read in all the public markets:

> *The Toad King now considers it acceptable,*
> *during mere ordinary life,*
> *esp. while fetching bread or simply*
> *getting from the buying into the selling*
> *positions, for His subjects to henceforth*
> *simply*
> *Jeffery.*
> *—That is all*

"So ends our tale. It has tried showing how a single word came to honor the last truthful boy alive. He must have been the only person left in the Toad's vast kingdom who ..." and here she, the mother, glanced down and whispered, "who ... fell totally asleep. That trusting, even during a storm

the very night his parents' trainwreck marriage legally ends. Even while his own name is being made into the noblest of all verbs, a word that his mom, his Toad King and even his lost dad, could all feel proud of."

As the Mother praised her dozing son, the lamps came on: lights down the cottage hall and all over this city of two hundred thousand souls.

"—Look at him sleep," she told herself with a fondness most often reserved for him. "—Somehow, through everything, we still have one very secure child here. —How, on earth, when no one was looking, did *this* particular miracle happen *once upon a time?*"

Malia Jensen

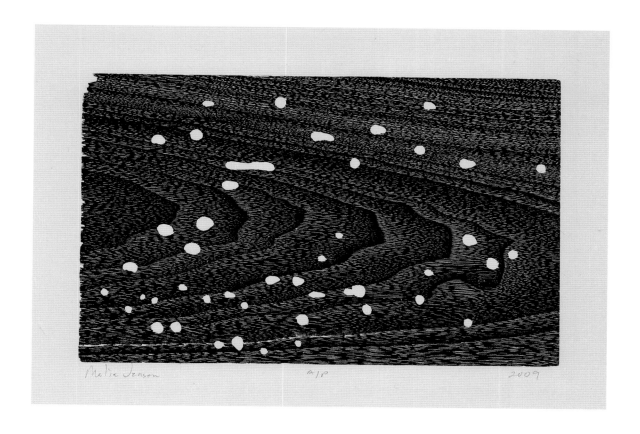

Wormcut #1, 2009
Woodcut on vintage paper
10 1/2 x 14 inches
Printed by The Grenfell Press, New York
All images courtesy Richard Gray Gallery, Chicago and New York

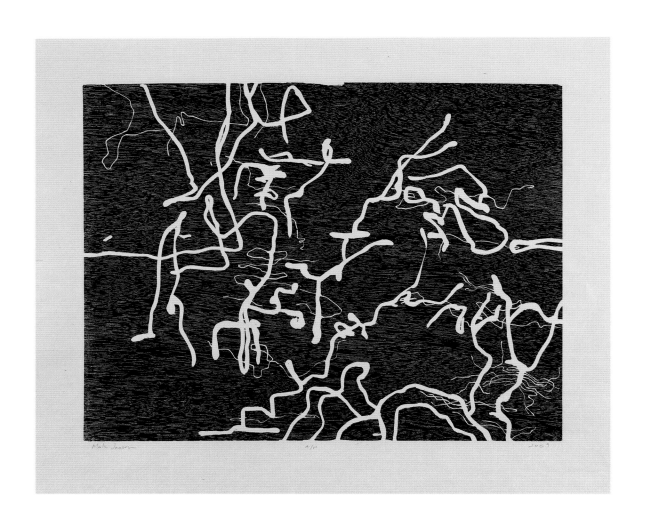

Wormcut #9, 2009
Woodcut on vintage paper
16 x 18 1/2 inches

184

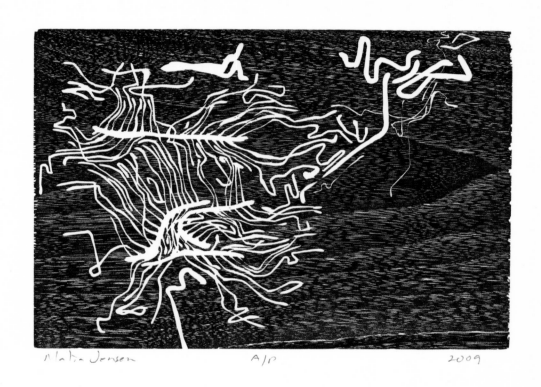

Wormcut #3, 2009
Woodcut on vintage paper
8 1/2 x 10 inches

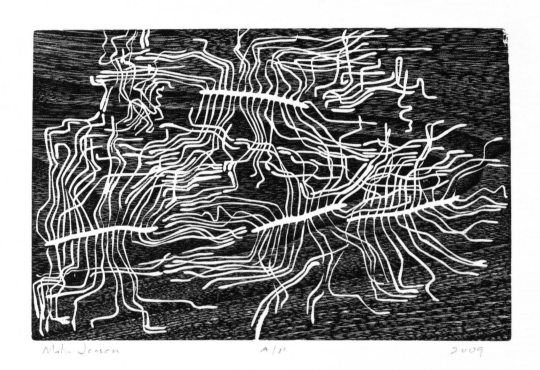

Mike Jensen A/P 2009

Wormcut #6, 2009
Woodcut on vintage paper
8 1/2 x 10 1/2 inches

186

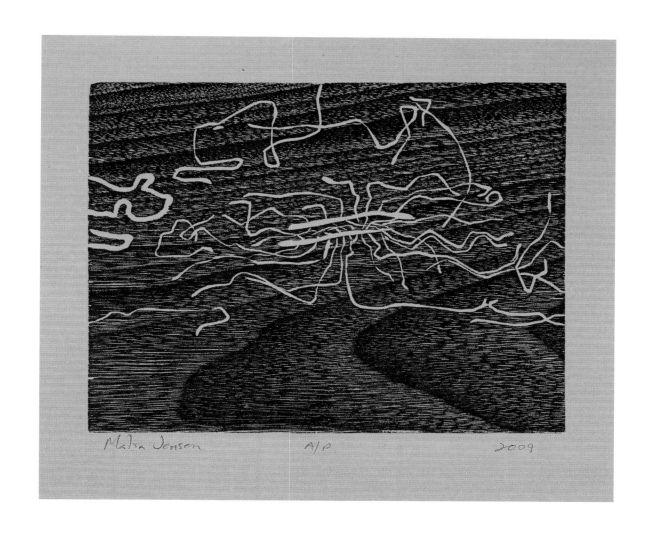

Wormcut #4, 2009
Woodcut on vintage paper
8 1/2 x 10 1/2 inches

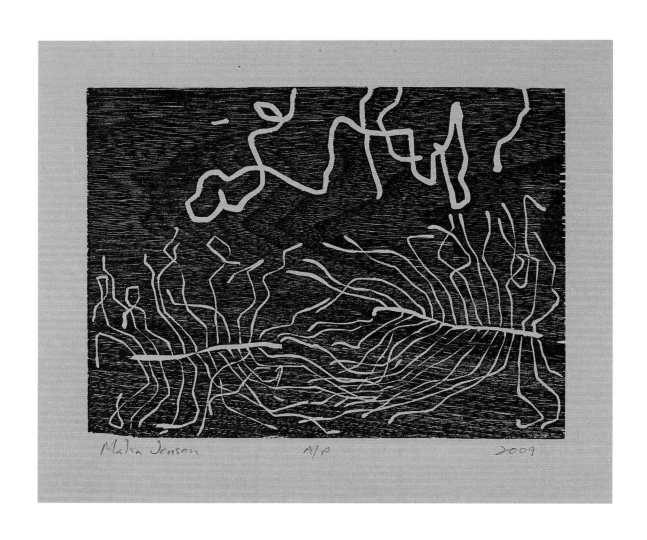

Wormcut #5, 2009
Woodcut on vintage paper
8 1/2 x 10 1/2 inches

188

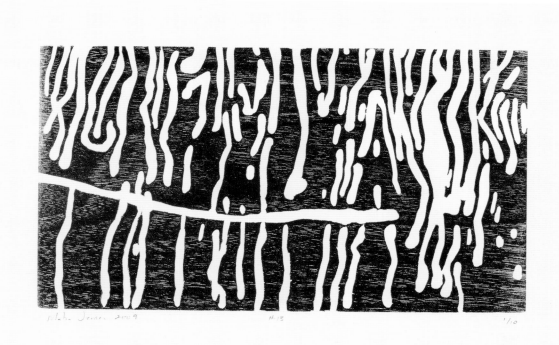

Wormcut #13, 2009
Woodcut on vintage paper
9 3/4 x 13 inches

DEAR DIARY, THE BLAZING

On our charts, wherever they were filed, the hash marks
gleamed like ice chips or diamond dust. They dignified
the black parabola, tried to bridge the yawn between
the asymptote and everything
reachable. And there was a whole world out there, we knew it,
a beyond
filled with people in the
passenger seats of cars, some of them aware of, even dwelling
on the radical trust placed in their drivers, though most were at ease,
unperturbed, fiddling with the air vents and bright dials—
"There's that song I love again" "Oh yeah I love that song"
—and they drove over steam grates, past okay restaurants, and stacks
of last week's Voice that were drowned in
snowmelt, waiting
for the men in green hissing trucks. On the far side
of our table is a half-eaten pastry
deckled cross its top with chocolate lines that
—let's be honest—
are not without their quotient of allure. It's a fine day
for strolling, but just brisk enough that we might prefer
and could hardly be blamed for choosing
to stay in this
warm shop at our table by the window, and one
of us might write Dear Diary, the brightness
of light on water sticks in me and makes it so
I can't tell science from art, business from pleasure,
God's love from these broken-ass chairs, my everything
bagel from the hummus it comes with, the daily-changing
access codes from what is accessed thereby. I'm ready,
one of us writes, maybe, to forfeit the difference
between the circumstantial evidence and
the blazing facts: oceans, women, trees.

SIX OPEN LETTERS

Dear demarcation, save it.
Nobody dances to your song
except the zany financiers.

Our name is the Devil & I'm
rambunctious. Kenneth Patchen
in the wild light—sad laughter. Hey,

if that's how you really feel
about it, next time you can
be the investor. Let's play

stocks and robbers. No, seriously.
Let's tell ugly, demanding jokes
to the pretty girls in the dead park.

It's Wednesday, or will be
Wednesday again. Dear
Wednesday, is this the end

of linear causality? I bought
a paperback book for a dollar
at the junk shop and

it asked me, which is why I'm
asking you. Dear Friday, how
about now? Dear Thursday, Dear August—

ANARCHISM

Some of us have realized this is a gambler's
stake. Let us say a word
and keep it. Let mercy
intervene where justice will not. The vine
is in the world
to bloom. Hundreds, thousands
of whom we have never heard. A restlessness.

Everywhere the generation's ruined strength—
a mass of condemned people enduring a farce
that sweeps the message farther than any
living voice could have carried. A miracle
not wholly to be condemned. The colossal
secret forgotten, men wade
through bazaars of wheels and teeth.

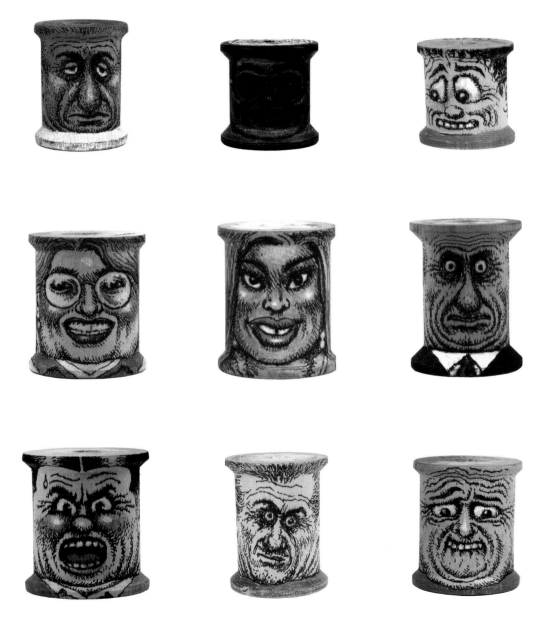

Images courtesy private collection, New York

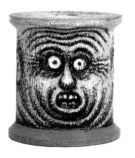
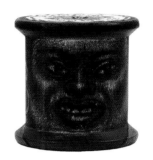
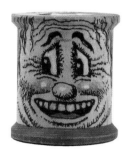
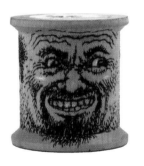
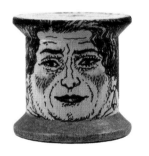
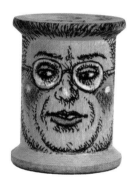
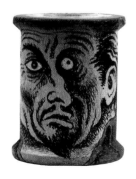

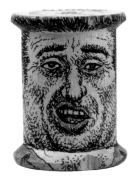
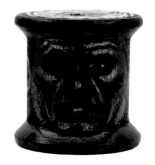
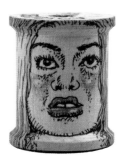

Jiří Kolář
Mona Lisa Environment, 1964
Collage on panel and found objects
Dimensions variable
Courtesy Pavel Zoubok Gallery, New York

Brice Brown ON COLLAGE
 WITH PAVEL ZOUBOK

Brice Brown: Let's begin with the obvious question. How do you define collage?

Pavel Zoubok: Well, for me collage has always been more significant as an idea, a mode of perception if you will, than as a medium for making pictures. From this perspective, collage encompasses a broader and more inclusive creative spectrum, one that tells the story of the modernist century and of the present century in a more accurate and compelling way. Really, the language of collage is rooted in the associative nature of the written word. It's essentially a poetic medium insofar as the collagist, to borrow from the Czech poet/collagist Jiří Kolář, "uses images in the manner that a poet uses words, which is to say that he puts them into a context." The bringing together of disparate or separate realities to produce a meaningful new whole is an idea whose impact has changed the very nature of all of the arts: literature, music, cinema. If you think about it, even contemporary criticism has evolved into a kind of theoretical collage.

BB: I find it interesting that you root your definition of collage in language, and am intrigued by your connection of contemporary criticism to collage. Can you elaborate on these ideas for me, especially the source of these connections—their history?

PZ: Throughout the twentieth century there was a profound connection between collage and poetry. Looking back to collage's official Modernist roots in the *papier colles* of Braque and Picasso, there are important ties to writers such as Getrude Stein and Guillaume Apollinaire that informed, and were informed by, the aesthetics of numerous artists in the avant-garde. In addition to the important friendships between writers and artists, there were numerous collagist/poets like Kurt Schwitters, Jacques Prévert, Jiří Kolář, Georges Hugnet, and Joe Brainard, who frequently moved between visual and verbal poetics. In terms of criticism itself, it seems natural these kinds of relationships would eventually impact the critical discourse, as the idea of bringing together the disparate, or fragmentary, has proven extremely fruitful in other media.

BB: Why do you think a collage-based aesthetic has become such a dominant, or at least very persuasive, approach in contemporary art?

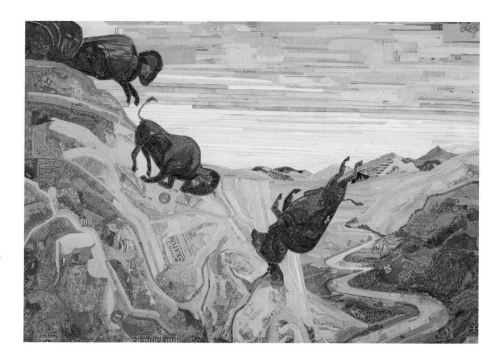

CK Wilde
Empire Falls (for David Wojnarowicz), 2006
Currency collage on panel
16 x 22 inches
Courtesy Pavel Zoubok
Gallery, New York

PZ: I think there are several reasons why collage-based aesthetics have made their way into the mainstream of contemporary art. The emergence of collage as a popular visual strategy for artists during the last decade or so has coincided with an increased interest in and appreciation for drawing and other work on and of paper, as well as a reevaluation of several key figures in the history of collage. When I first began mounting exhibitions, artists like Ray Johnson, Al Hansen, even Joseph Cornell were considered somewhat esoteric, hard to place. These artists enjoyed a cult status and their historical significance was only understood by a select group of adventurous curators, critics and collectors. In the past ten years, I have seen this change dramatically, with important retrospectives of collage artists in museums and major galleries.

BB: Well, as you know, the New Museum inaugurated its new space with a show about collage, perhaps signaling the ascendancy across the board of this collage-based aesthetic you are talking about. What do you make of this?

PZ: I think it's great that more people are looking at collage with renewed interest, but what I find somewhat disappointing about so much of the "new" collage is how little has changed in the way artists employ the conceptual and material aspects of the medium. The exhibition at the New Museum is a perfect example of what I mean. On the one hand, I was delighted that the museum decided to open its impressive new building

with an exhibition of collage. Yet much of the work in both installments looked almost identical to the kind of collage work that artists were producing throughout the 1960s and 1970s, an observation that my partner, who is not in the art world, made upon entering. It's not clear how consciously some of the artists were borrowing or quoting from the past, and I found little or no acknowledgement of the artists who make so much contemporary collage possible. The point is not for artists to reinvent the wheel and find new ways of gluing paper, but to understand that all of these works belong to a larger tradition. I think some of this is generational. You know, each new crop of artists and curators thinking that is inventing or identifying something new. In our aggressively ahistorical and youth-obsessed society, this is just the way it is.

BB: I agree, and see this most glaringly in the work of an artist like Mark Bradford, especially when considered in relation to the work of Raymond Hains or Jacques Villeglé, or even Schwitters for that matter. Speaking of Hains and Villeglé, I've noticed a trend in the contemporary collage we are talking about that favors renegade, low-cost materials and an off-hand, almost disinterested combination of elements. Have you noticed this, and if so can you address why this seems to be the case?

PZ: I certainly have noticed this, and I must admit that much of this kind of work leaves me cold. It's not the use of humble materials that I object to, for there are numerous artists whose work incorporates humble materials in innovative and thought-provoking ways. Look at historical figures like Robert Rauschenberg, May Wilson, and Bruce Conner or more contemporary artists such as Thomas Lanigan-Schmidt and Judy Pfaff, to name a few. All of these artists use the relics of our throw-away culture in their art, but they do so with a formal and conceptual rigor that continues to assert its relevance. What I object to isn't the naïf quality that has become so fashionable, but the fact that so much of this work fails to add anything new to the discourse of collage. There is an absence of refinement—poetic, political, material and otherwise.

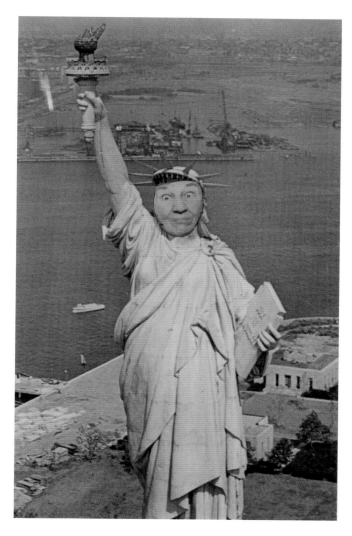

May Wilson
Ridiculous Portrait (Statue of Liberty), 1965–1972
Collage
7 7/8 x 4 1/8 inches
Courtesy the estate of May Wilson and Pavel Zoubok Gallery, New York

Kurt Schwitters
Untitled (For Piet Zwart), 1926
Collage on paper
5 x 4 inches

BB: Ok, one last question. I find it interesting when artists working more traditionally try to reconcile new technologies and media within their practice. It doesn't always work, but sometimes it produces nice surprises. How do you see collage in relation to digital media, and do you see this as a potential avenue for collage to explore?

PZ: I must admit that I have yet to find much digital collage that excites me. I'm not closed to this kind of work in principal. The computer, after all, is just another tool that artists now have at their disposal. But, I do think that there is an inherent challenge in digital work to communicate the kinds of visceral qualities one senses in an artist's physical participation with other materials and processes. A lot of digital collage ends up looking like advertising because of the complete absence of the artist's hand and the materiality of the collage. I'm not sure how one resolves this but artists are creative beings—someone will figure it out. And I am very excited to see where it all goes!

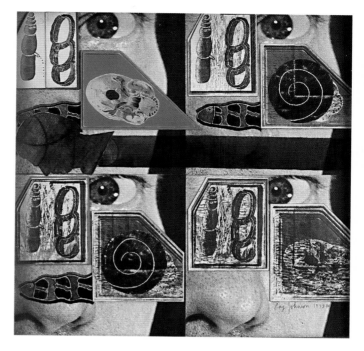

Ray Johnson
Untitled (Portrait of Ray),
1979-80
Collage on masonite
15 x 15 inches
© Ray Johnson Estate
Collection Pavel Zoubok
Gallery, New York

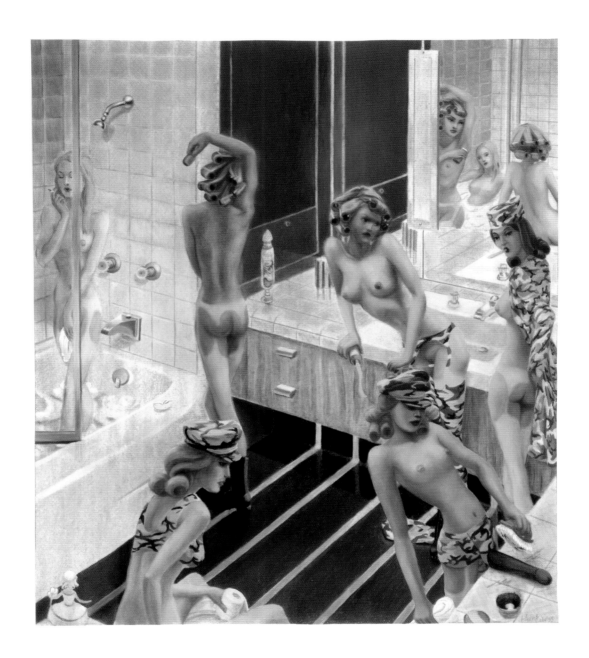

Crack of Dawn, 2005
Graphite, watercolor, and oil on paper
10 x 8 3/4 inches
All images courtesy Mary Boone Gallery, New York

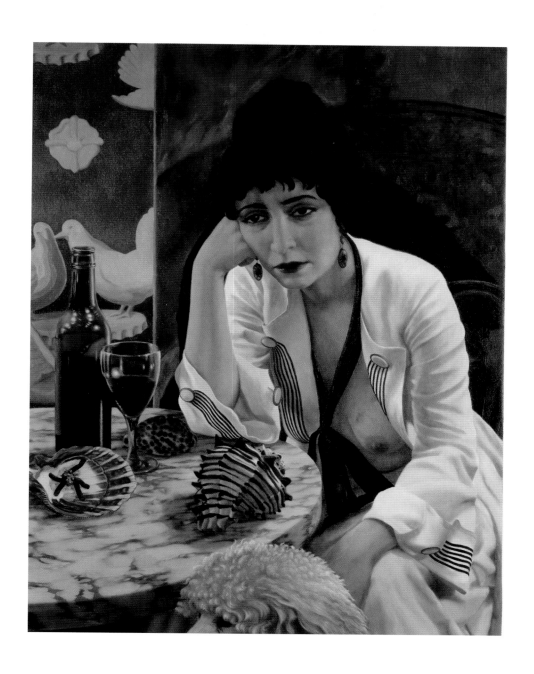

Alice at Loggerheads, 2009
Oil on aluminum
12 1/4 x 9 1/2 inches

Fred Mann

John Mark Ainsley
Photo: Johnny Dredge

Ainsley as Emilio in the
English National Opera's
production of Handel's
Partenope, 2008

Ever since English tenor John Mark Ainsley made his debut in 1987—singing in Stravinsky's Mass *under Simon Rattle——he has been a prolific and in-demand artist who has made some key early music tenor roles his own. Below, Fred Mann, owner of noted UK gallery FRED [London], warmly recalls his recent talk with Ainsley about Monteverdi, Mozart, and Handel, and how he is now tackling twentieth-century and contemporary music on the world stage.*

Sitting down for a cup of tea with John Mark Ainsley is a real pleasure. In his company you feel that this cheerful, funny, bright, and highly engaging man is giving you 150 percent of himself; however, you can immediately sense that beneath the warm and friendly exterior a very serious mind is at work.

Ainsley describes his early education as a "very ordinary middle class affair." His first, rather liberal school had no sixth form so he transferred to a grammar school. That came as a shock, and he felt like an outsider in a school system where being good at sport was what counted. He was saved and supported by the school's isolated music department. Ainsley recalls with wry humor being told by his tutors and peers that he would never make prefect (something about which he didn't care a hoot) or in fact very much of himself. He is now a celebrated "old boy" and up held as an example of a high achiever alongside fellow student Imran Khan (the cricketer and politician).

J. M. Ainsley warmly remembers the impact of the developments that were taking place at the time in recordings of early music. Period instruments were beginning to be used or recreated and new discoveries in how period orchestras played were being made. Of particular affect on the young singer was his exposure to the work of Nikolas Harnoncourt, Christopher Hogwood, and The Academy of Ancient Music.

At Oxford University's Magdalen College, where Ainsley went on to study music, he remembers the sense of revelation he felt at hearing Harnoncourt's now legendary recording of Handel's Messiah (performed by Emma Kirkby) and how it struck him as something new and exciting. Ainsley felt the way the music sounded had quite suddenly, "moved away from that of the symphonic orchestra, as now you could hear all the parts and instruments distinctly, but they held together united by softer grains

and tones that were part of an overall sound." This created an effect that was altogether "much sweeter."

It was also at Oxford that he was able to perform regularly in small groups, which suited the repertoire of Handel, Dowland, and Purcell. Ainsley has always been attracted to Purcell, whose music he describes as "perverse" due to the composer's constant rule breaking, "wrong notes," and "delicious dissonance." He has sung much Purcell, including a ravishing *Dido and Æneas* recording with Catherine Bott and Emma Kirkby for Christopher Hogwood (L'Oiseau-Lyre, 1995).

To the shock of his fellow students, after passing his first year at Oxford, Ainsley left to become a lay clerk at Christ Church. His family, however, were supportive of his move away from Magdalen College, his degree, and of his coming out of the closet, all around the same time. His mother was more concerned about his happiness in life than his academic qualifications.

It is ironic that in later life Ainsley has been critically allied and compared to other so called Oxbridge Tenors, Mark Padmore and Ian Bostridge. All three have been highly successful and have sometimes performed the same roles. However, each has personally marked out diverse repertoire, remaining contemporary, highly distinctive, and individual.

Ainsley as Emilio in *Partenope*, 2008

During his time at Christ Church, Ainsley became acquainted with—and the pupil of—the great tenor of the previous generation, Anthony Rolfe Johnson. A lasting friendship ensued and it was through Rolfe Johnson that he met his longest-standing teacher, Diane Forlano. Forlano had correctly diagnosed a polyp on Rolfe Johnson's vocal chord (which had been plaguing the singer) and earned his lifelong gratitude for her help. It was through this event that she was introduced to the young John Mark Ainsley.

It is clear that Ainsley and Forlano have a special bond. She has taught him throughout his career and has helped him greatly to push his voice to encompass differing roles, at different stages of his career. Ainsley remembers joining Gothic Voices while at Oxford and singing the works of Guillaume de Machaut, the French fourteenth-century composer and the most significant representative of the musical movement known as the Ars Nova.

When discussing the developments that have been possible with his voice, Ainsley observes, "You simply can't sing Marchaut and Peter Grimes. However, as you get older, you can sing Judas Maccabeus and Peter Grimes if you are careful and have the right training."

It is to Ainsley's benefit that Diane Forlano has moved to London. Previously he was only able to visit her during his American engagements, such as his trip to Chicago with Sir George Sholti. Forlano has continued to help him widen his repertoire to include Britten and Hans Werner Henze, without losing Purcell, Handel, and Mozart. These developments create an exciting prospect as Ainsley moves into the second great stage of his career.

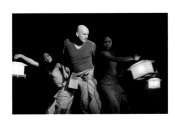

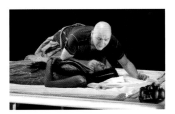

Ainsley as Orfeo in the
English National Opera's
production of Monteverdi's
Orfeo, 2006

His opera stage debut was singing Monteverdi at the English National Opera, in the role of Eurimaco in *Il Ritorno d'Ulisse in Patria* (The Return of Ulysses), directed by David Freeman. At the time, Freeman was at the vanguard of experimental opera productions, when on-stage nudity and avant-garde theatrical direction was not the norm. Ainsley found working with Freeman very exciting, for, even playing a small tenor role, he was able to experiment with his stagecraft as a performer, since his character remained on the stage during most of the opera.

Now Ainsley is a master of his craft and acknowledges that opera, when truly successful is "the perfect balance between the music, the singing, and acting, which needs to be a happy marriage." It is about how to *perform* well. Ainsley feels that the successes he has had with his signature roles are due to the personal bonds he feels with his characters, allowing him to successfully interpret them on stage.

This is especially true of Monteverdi's Orfeo, a role he has made his own, and on which he is considered the world authority. He first performed the title role with The Netherlands Opera, directed by Pierre Audi. He "somehow feels a bond with who this person is" and over the years of performing the role "feels a relationship to his failings." At the end of the more commonly performed 1609 version, Apollo comments that Orfeo is "too emotional," a state that Ainsley interprets as "emotionally indulgent," observing, "He can be a bit like me!"

To Ainsley, Orfeo is "a phlegmatic and reactionary man, who explodes with frustration when he does not get what he wants." Ainsley recognizes and understands this introspection, using it to portray Orfeo with real feeling. It's not often you hear Orfeo described as a "deeply self-centered anti-hero," but Ainsley interprets the moment he turns round, breaking the conditions set by Pluto for his love's release, to check that Eurydice is following him, as an act that only serves to satisfy Orfeo's paranoia. His actions leave us, Ainsley states, "with a final act that is marked by Orfeo's grief-stricken indulgence."

Another major role for Ainsley is that of Don Ottavio in Mozart's *Don Giovanni*. His stagecraft and characterization have become the gold standard during his one hundred or so performances of the role. He comments that Ottavio is the opposite of Don Giovanni, who "through his sexual charisma opens forbidden doors to women, that are wrong to society but clearly attractive." By comparison, Don Ottavio, who is "by no means a wimp," has a problem expressing his feelings, described by Ainsley as an "emotional disability." We only find out Don Ottavio's true feelings in his soliloquy, where in his "formal but tender language he tells of his impassioned feelings towards Donna Anna and betrays a deep emotional character, which the audience has access to, but nobody on stage hears as he can't say it out loud."

Ainsley is especially pleased to be performing the title role in Mozart's *Ideomeneo* this year at the Beyerishe Staatsoper, Munich. Previously, he had

always appeared in the role of Idamante, so he is thrilled to be playing a more substantial and fully developed character he can really get his teeth into.

Another great role for Ainsley has been that of Jupiter in Handel's *Sëmele*, a secular oratorio of which the singer is very fond, for the part is very suited to Ainsley's light, supple voice. Robert Carsen's witty production at The English National Opera in 1999 was a good example of how performance, direction, music, and staging can come together harmoniously and to great effect. Unlike many Handel operas, commonly focusing on counter tenor and soprano roles, *Sëmele's* Jupiter is one of Handel's great tenor roles, and in act two's "Where'er you walk" Ainsley's voice conveys passionate, warm, and rich emotion.

Ainsley as Emilio in *Partenope*, 2008

Sëmele is by no means Ainsley's only association with Handel, a composer with whom he has had an enduring love affair throughout his career. He remains drawn to the "philosophical composer" he has come to know intimately through his music. The "depth of human feeling" possible in Handel's music became most apparent to Ainsley when performing Jeptha, and feels that Handel manages to get "emotion to enter his audience through the solar plexus before the brain." As he has gotten older, Ainsley's appreciation of what Handel can do with emotional states has increased, giving him ever more and more to work with.

Since 2000, Ainsley has also worked extensively with the celebrated left-wing composer Hans Werner Henze. In 2003 he performed at the world premier of *L'Upupa und der Triumph der Sohnesliebe*, widely thought to be Henze's last work. Ainsley played the role of the Demon, which he will revive this year at the Dresden Semperoper.

He has also appeared in the more recent Henze opera *Phaedra*, in the role of Hipolyte, which was written for him. He comments, "You can't say, though it was widely thought, that *L'Upupa* was Henze's last work; he simply had more to say." Ainsley remembers that composer Berthold Goldschmidt (1903–1996) had a twenty-year break from writing after his experiences as a gay Jewish man during the Holocaust. Goldschmidt returned to writing "as truly creative people must do." This return to music prompted a revival of interest in his work in the last decade of his life. It is in this way that Ainsley sees the creative drive: if you have something to say as an artist you must provide a platform for it, and this is how he sees his work with Henze: "more to say, more to do."

In a recent interview with Ainsley, Rupert Christiansen predicts he will become the next great interpreter of Britten's *Peter Grimes*. Grimes, a deeply conflicted character, is left to be either condemned or championed as the individual against the masses. Ainsley feels there are new and exciting ways to present Grimes. And at forty-five, having shown such dexterity and passion in his past performances, this is a very exciting prospect.

David Coggins
Rudolf Ruegg

**"scientific examinations have proven that your body emits infrared
and ultraviolet rays, subsonic waves, gamma rays and magnetic forces,
and a bombardment of neutrons at levels 80 to 170 times superior to a
normal person. congratulations. happy birthday rudi, d."**
postcard from pavello alemany, barcelona. dc 07/99

**"as i was unpacking the camera
my spy eyes took notice of the expiration date
 : 03 / 1998
sending me outdated material to work with...
my photogenius ego is crushed.
 please pamper me. ®"**
post-it note on disposable funsaver camera. rr 01/03

sudden service cleaners. dc 10/03

almost empty correspondence box. rr 03/09
the black horse card. dc 05/01

birthday card. rr 11/08

The Spruce Grouse (left) protected by law is often times mistaken for the much sought after Ruffed Grouse (right). The coloration varies among both species, the most distinguishing features are the Red Eye Patch and the obvious darker feather of the Spruce Grouse.
"musicians must remember :
grouses (of all types) are your friends.
oh yes they are."
the two grants. dc 06/03

collection 1996-2008. rr 03/09

teach your duck some manners. rr 02/02

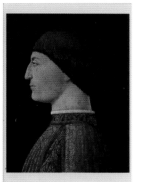
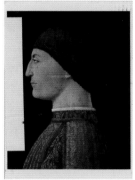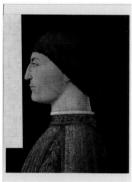

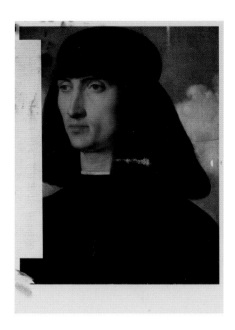

m.s. malatesta; chapter 8
"gaming in the land of the von trapps"
sigismond malatesta series. dc 01/02

kasparov's revenge. rr 09/99

"a large used bookstore that is extremly well-considered
without being too precious. they have large sections of
art, particularly fluxus, but also swedish naval history.
they seem to care about design - there are old exhibition
posters framed on the wall. there are well placed chairs near
the stacks to sit while you read. they even let you use the loo.
they were selling one or two cd's but it wasn't clear what the
connection was. two nice older men worked there, at least
one of whom had a typewriter. that is all we know."
please consider the enclosed from stockholm. dc 06/06

no relation. dc 06/03

hot dog
(rubber)
"oh boy !
wait til he
bites into it"

fool your friends

DIRECTIONS
place the hot dog in a frankfurter
roll, spread mustard, then hand to
victim and watch results.

FOR FUN
IT'S FRANCO

**"after the birthday party food, there
were games and lots of prizes for
everyone. then suddenly it was time
for everyone to go home."**
fool your friends. rr 02/99

note: this horse was rejected. dc 07/00

**Part of living Room of
new cabin.
Everything is done in
Knotty Pine. Table is cherry lot
Pine legs. Beds are norway
Pine. no furniture bought. only
4 chairs + large lazy chair.
1948 - harry**
captain hudgins coot. dc 04/04

PARTY
6way
 Moustache
Completely
 changes
your
appearance
Will make you
look more
distinguished

**shape
it
any
way
you
like**

made in japan

**"wear the disguise
before they arrive..."**
6way moustache. rr 11/99

hello ! "i'm pole." the local butcher had only one thing in mind when he planned to furnish his stables with only the finest thoroughbreds **hello ! "i'm simon."** when the horses finally arrived, he welcomed them with cubes of sugar and a big smile on his face **hello ! "i'm nancy."** the portrait photographer must not have worn his warmest gloves. as she dropped her hankerchief, noone in the room bothered in the least to pick it up **hello ! "i'm jane."** at night, the townsmen united to engage themselves in playing 'gypsy fixtures', a popular social game of that time and space **hello ! "i'm hector."** i can reek something's foul. did you clean out the stables, master, or do i have to do EVERYTHING for you ?! **hello ! "i'm gertrud."** upon entering the stables, he found his horses meditating infront of their selfmade shrine. his hunch was correct **hello ! "i'm francesca."** at the tavern, the complimentary steaks didn't quite taste the way they used to. it called for an internal affair. they sent only their best scouts **hello ! "i'm randolph."** the rough riders were a bit too ambitious in applying the saddle soap. when the horses took off, they got ejected right out of their well-waxed seats **hello ! "i'm conrad."** surprisingly enough, after accumulating the points on all the scoresheets, butcher got graced with the prestigious 'best horse in town' award **hello ! "I'm elmer."** suddenly the real intellectuals marched in and taught the estate agents their final lesson about the do's and don'ts **hello ! "i'm wally."** it didn't seem to help. eventually, they confiscated everything and everyone. ever since, nothing has been heard of them. we keep investigating. eleven prancing horses for david's newest birthday. rr 11/01

jane's beauty bar. dc 08/01

gerold, barrik, sevi, nils, nero, isis, and otto. rr 06/02

les animaux de la ferme. dc 03/02

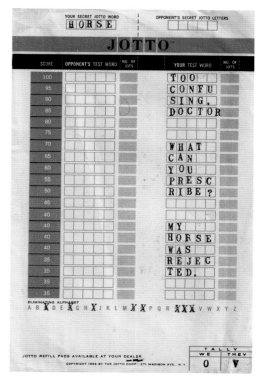

your secret jotto word. dc 07/00

gentlemen officials. rr 07/99

broken button. dc 09/00

set of instructions. rr 03/99

```
agent d. 3o5.538.1ooo3
important documents are
on their way.
do not leave your apartment.
unfortunately, the operation
has taken on new proportions.
abide by its set of rules
and procedures.
we will keep you posted.
footsteps will eventually
lead to the oasis.
beating around the bush di-
verts from real intents.
don't give in to their demands.
we are counting on you.

agents h.w 79.83o3
it's a privilege
```

"attention : when you
see this bearded man,
hide all your stockings
immediately"
saint nicholas. rr 12/99

"this color space map shows how test prints
look when the density is correct and the color
balance is varied. to evaluate your test print,
try to match it to one of the examples here."
the guildsmen of print. rr 02/02

note from the principal. dc 03/02

world patents pending. dc 07/03

awareness is a good fisher. rr 02/03

three classy burlington route - colorado &
southern diesels are on train 77 at cheyenne,
Wyo. on september 1, 1969. the lead unit is
a GE U30C and the rear two units are EMD
SD40's. photo by howard fogg.
**"howard fogg knows all
 but tells only some.
 - the ranchhands."**
burlington 892 postcard. dc 06/02

top secret from pine lake, wisconsin. dc 03/00

note from the taxman. dc 10/99

I never knew that my first boyfriend was Jewish. Not, as I've since learned, that you can always tell from a name. But the very idea of a typical Jewish name was a foreign concept to me, maybe because I'd grown up the Midwest. Even so, Mom laughed at me when I eventually told her about him. "Benjamin Edelstein?" she said. "Come on!"

But neither one of us ever lived up to the label of boyfriend, all things considered. I met him the second day of college. I'd flown in to the Sarasota airport—at the time little more than a tin shack and a couple of runways—to find an older boy with a scraggly beard and a cowboy hat waiting for me at the gate. He held a hand-made sign that read, simply, "New College." His tie-dyed t-shirt and cracked flip-flops irritated me. We wandered around the tin shack from gate to gate, picking up nervous freshmen along the way. Outside at the curb we threw our bags into a van. As our guide revved the engine he pointed across the parking lot.

"That's New College," he said. The campus, shimmering in the heat, was less than a hundred yards away, a distance we could have walked had it not been for our luggage. Later I'd learn that nobody in Sarasota walked anywhere. The city was known for its beautiful keys and golf courses, but New College sat along an eclectic stretch of U.S. 41—the Tamiami Trail—near a string of supermarkets, gas stations, and cheap motels. The school's main dormitories had been designed by I. M. Pei. Considered one of his minor works, they looked to me like three clumps of cement boxes scattered along the edge of the highway, but then I'd never heard of Modernism, either.

My new roommate was nowhere to be found, but he'd already covered his entire half of the room with posters of Jim Morrison, Jimi Hendrix, and Janis Joplin. More hippie crap. On my short walk across campus I'd seen more than a few tie-dye t-shirts. Avoiding Morrison's sultry gaze, I wandered out onto the balcony (a rare luxury for first-year students, I was told) that looked out upon the dormitories' central court. Giant palm trees, arranged in geometric rows, stretched nearly fifty feet into the air. I was watching the first-years move in, some with the help of their parents, when the skies suddenly opened and a torrential rain pounded the campus, sending everyone shrieking across Palm Court.

I'd applied to seven colleges. Two were local, in Minnesota: merely back-ups. Reason and practicality had nothing to do with my master plan. I wanted one thing above all: distance between me and home. The other five schools fulfilled that wish: two in upstate New York, one in Florida, and two in California. Besides distance I wanted eccentricity. I did not dwell on

the Ivies or large state schools, only tiny liberal arts schools populated by eccentrics. Instead of Berkeley I applied to UC Santa Cruz, whose mascot was the banana slug. And I was done with winters, done with shivering on street corners waiting for late buses, done with wind chill, cabin fever, and long johns. Done with the shivery, stoic climate of wrapped-tight Scandinavians—blonde, red-cheeked, and surface-nice.

Dad had invited me out to dinner at Pearson's, a "family" restaurant staffed by stiff-jointed waitresses where every dish came with brown gravy, and where he'd unveiled a complicated spreadsheet financially comparing UC Santa Cruz, my first choice, and the New College of Florida, my second. New College had offered me a scholarship waiving the out-of-state tuition fee. The money that my parents had saved for my college fund would more than likely cover the full four years at New College, with a little scrimping and saving. But it wouldn't make a dent at Santa Cruz, leaving me with more than a little debt that, Dad informed me, would be my responsibility alone. Naturally I resented this turn of affairs, and resented Dad for bursting my little collegiate fantasy. Hadn't he heard? Follow your heart, damn the checkbook! But Dad had missed out on the fantastical gene. I was headed to Florida.

"A public school with a private school feel" is how New College's catalogue described itself. U.S. News and World Report consistently ranked it as one of the country's top "Best Buy," a major selling point, no doubt, for Dad. But little of that mattered to me. New College satisfied my own special requirements. It was seventeen hundred miles away from home, in a tropical climate. It had an unusual curriculum (no grades, massive amounts of critical paperwork, an emphasis on the "self-designed" education, and a required undergraduate thesis). But the other reason I kept to myself. A dog-eared page in the middle of the catalogue featured a black and white photograph of a student, a young man, shirtless, bent over a notebook in the school cafeteria. The image of his bare chest had burrowed within me and taken root. The black-and-white shot, and the young man's short haircut, gave both him and the photograph a timelessness; he could have been anywhere between twenty and thirty, the shot taken any time in the last three decades. No doubt he had long ago graduated. No doubt he liked girls. But he'd crept up on me whenever I imagined the Sarasota campus. I heard the sweep of his dusty heels as he ambled beneath palm trees, the air echoing with tropical birdcalls. The thought of a college where men sat shirtless in the cafeteria—nursing bad coffee, lost in liberal-educated thoughts— seduced me. The thought of meeting him, or men like him, the thought of my own seat in that cafeteria, surrounded by brooding, bare-chested men, soon consumed all other reasons for attending New College. A most impractical reason—hidden down deep within me, feeding off dim-lit dreams, as my last year of high school came to an end.

But there were many things I didn't know about the school that I'd never once visited: that it was known for its post-hippie culture; that there was little to do in Sarasota unless you were retired; that August was the end of the rainy season and that every late afternoon, like clockwork, rain flooded the campus. Nor could I know what a sordid soap opera my life was about to become. I looked around for the young man in the college catalogue, but I never found him.

The next day I sat on a ledge outside the dorm, looking across the back lawn. Near the swimming pool, beside a clump of brush pines, stood a small group of students clad in long cloaks, velvet dresses, and suede boots. I'd been to the Renaissance Festival in Minnesota, and had the group pegged. They appeared to act out some kind of scripted ceremony; a boy in a loose shirt, laced up at the neck, knelt before a girl sweating in a floor-length velvet dress. She smirked, placed her hands at her waist, thrust out her ample bosom, and spoke words that I couldn't quite hear from my perch. Every so often one of the other boys, sweating in the heat, hoisted an authentic-looking sword in the air, and made some kind of proclamation, the words distorted by the constant drone of traffic on the Tamiami Trail, but I caught the distinct musicality of Olde English, spoken with more earnestness than precision. They pranced about under a perfect blue sky. Fresh grass clippings clung to the girl's velvet hem as the group bowed and glided over the lawn. Surely they'd fall lower than me on the school's food chain.

But like them I'd overdressed for the climate. I sat there sweating in a British Knights tracksuit that I'd purchased on layaway from a gangsta wear store in downtown Minneapolis. My last year of high school I'd befriended a girl who'd sat next to me in Mr. Delgado's Spanish class. Later I met her brother, the first white boy ever initiated into the Disciples street gang, who affected a tough, sullen demeanor, smoked Newports, and combed his hair with Jherri Curl. A sect of the Disciples had migrated north from Chicago a few years back, and rented a house behind the McDonald's on East Lake Street. My friend had taken me there two or three times over the last months of high school. I always went with high hopes. My first visit there, a black boy a few years older than me, dressed in a tracksuit, rushed into the house gripping a pistol and said the cops were looking for him. The other men there called an emergency meeting in the back bedroom for "folks" only. A few minutes later they emerged again, the boy complaining that he'd only just bought the tracksuit, and now he'd have to get rid of it. I'd been immediately hooked by the adrenaline. That year all of the white kids from my high school knew the words to Public Enemy, Ice-T, and Niggaz With Attitude. We congratulated ourselves on electing the first ever black student council president, and the first black Homecoming Queen. But unlike my peers, I'd been in the Disciple's house. I'd had a brush with drugs, guns, and testosterone. Pretty soon I was taking stories I'd overheard at the house, of police raids and drug busts, and putting myself at their

center, guilty and high school glamorous by association. College offered me a fresh start, a place for self-reinvention, which was every freshman's right. The hicks in Florida would no doubt be impressed—intimidated even—by my hard stare, my streetwise stroll, and my small but growing collection of hip hop vinyl.

Which is how I ended up sitting anxiously in a white tracksuit on the edge of Palm Court, realizing, less than 48 hours into my new life, how poorly my performance had been received. The lines that I'd had the barber back home so carefully buzz into the back of my scalp, as further proof of my urban roots, had been mistaken for a punk rock look by a boy wearing a Suicidal Tendencies t-shirt. Adding insult to injury, the boy looked disappointed when I replied, weakly, "I like hip hop."

The volleyball smacked the ledge beside me, breaking my reverie. I hopped off the ledge and picked up the ball, already self-conscious (how should I throw the ball: overhand? upperhand? just kick the damn thing?) when one of the players, a boy in cut-off camos and a Throwing Muses t-shirt, ran up to me. I handed the ball to him. "Wanna play?" he said.

"I'm not very good," I offered.

"None of us are," he said. "It's just for fun."

I joined his team, and quick introductions were thrown my way. He told me his name was Benjamin, then scurried to the front line as the ball sailed towards us. He leapt up in the air and struck it back, his thick calves flexing as he landed again on the sand. He had strong arms, and when he leapt up to block the ball, his t-shirt rode up his back, revealing a flash of the waistband of his Hanes briefs. Tight blonde curls fell over his forehead. He had brown eyes and a sweet smile and sometimes, when going for the ball, we'd knock against each other and he'd put a warm hand on my lower back, to steady me.

We were all first-years, joking between points, some of us far from home, none of us settled, each of us staving off the threat of loneliness. An hour back I'd thrown off the jacket of my tracksuit. Underneath I wore a t-shirt, and the track pants clung damply to my legs as I hustled after the ball. The sun fell behind the trees, lighting up the gorgeous masses of clouds overhead. They curled tall and majestic, pink and tangerine, pushing the very boundaries of the sky. I'd never seen such clouds, such colors in the sky. The air around us cooled. A few people ducked out of the game. The light faded, and the ball sailed, pale and ghostly, back and forth across the net. Benjamin—his t-shirt damp with exertion—brushed against me, and I brought my wrist to my nose and inhaled his sweat, which smelled of soap, grass, and sand.

Eight years before, back home, Mom and Dad had sat me down in the living room and told me that they were both gay. Down the hall, my little brother had played in his bedroom alone. He wasn't old enough, they'd said, to understand what gay meant. But then I didn't quite understand either. I

was ten years old. It was 1981, we lived in a small suburb outside Saint Paul, a stone's throw from the State Fairgrounds, and I'd only ever heard the word hurled across the school playground. A year earlier I'd fallen prey to my first crush, on a grown man, a friend of my father's, but I hadn't known it was a crush, what a crush meant, much less a crush on a man. When I'd grown older, and the crushes on other men had continued, I'd kept them to myself, despite, or maybe because of, my parents' examples. Sure, I knew my parents, and their partners, and their circles of friends. But I knew nobody my age, nobody like me in that one way. And so I couldn't imagine a life for myself. Who would I hang out with? My parents? I could only picture a miserable loneliness, and I'd clung to the slender idea that I might turn out straight. Had there been a surgery to turn myself normal, I would have saved up all of my allowance

Benjamin's dorm room, a stone's throw from the volleyball court, was a shrine to obscure musicians: Love and Rockets, Front 242, The Sugarcubes. He'd decorated his walls with album covers and posters he'd collected from the record store in Atlanta where he'd worked during high school; the colorful foliage of a Talk Talk album cover, an enormous poster of Peter Murphy gazing down, gloomy, erotic. I resolved to hide from Benjamin my record collection, should he ever stop by.

For an hour he played me music, watching and grinning at me during each song. I'd never heard of any of them; bands and the singers that had grown out of punk, playing in the years after I'd stopped listening to the Smiths. The songs were moody, more complicated than the dance beats I'd grown accustomed to, and there was little about them that immediately grabbed me. Still, I faked enthusiasm, wanting him to like me. He had broken me out of my awkward solitude, and he was adorable. He moved about with a boyish enthusiasm, as if his legs couldn't quite keep up with the rest of him. He trampled over piles of clothing on the ground, fetched us soda from his mini-fridge, and rifled through his CDs. I'd stare at the sturdy muscles of his calves when he wasn't looking, and when he was, I'd look around his room.

"What are those?" I asked.

"Lacrosse sticks," he said, snatching one up. "Ever played?" I shook my head. "It's easy," he said, and spun the stick deftly in his hands. "I'll show you. Maybe tomorrow we can play."

Several thoughts crossed my mind: his affinity for sports meant he was straight; I'd look clumsy and stupid playing lacrosse; and he wanted to be my friend. "Sounds good," I said.

Later that week we ended up in a girl's dorm room, sipping spiked punch. Gregarious Benjamin had already gathered up a few friends, including Mary, who had a matching set of glasses from Wal-Mart. She also had a miniature ironing board, a crockpot, and her own telephone. I'd arrived with little more than clothes, a single set of sheets for my twin bed, and a

Hudson's Bay blanket that Dick, my father's partner, had loaned me.

Mary's roommate was off studying somewhere. She rolled her eyes at the horse posters hanging on the wall above the girl's bed. Mary was a tiny, saturnine girl with a messy red bob, dark at the roots, that hung over one eye. She wore a thrift-store baby doll dress and spoke in a monotone that only grew flatter as she drank. She and Benjamin lay slouched together on her bed. I sat on the floor. They both bummed cigarettes from me, but neither of them held the Camels convincingly, and Benjamin, I was touched to see, didn't even inhale. He sucked in the smoke and then blew it out, the smoke just as blue as before. After two drinks Mary's face grew shiny, her eye grew bluer and unfocused, and she slid her little hand under Benjamin's. He took it without changing his impish, dreamy smile, and I felt the familiar dark weight of disappointment as I feigned a conspiratorial grin at them both.

After a few drinks we staggered outside, down the walkway to the orientation-week pool party. Our walk felt disjointed, as if frames had been spliced from our film—the glittering blue water of the pool, and the sounds of the party, swam up towards us in sudden jumps. Benjamin and Mary laughed at something, and I, drunk and delirious with a sense of power, laughed with them. I was far from home, buzzed and free, and I belonged here already.

The pool flashed with light and noise; the water frothed with swimmers. Half-naked people danced and weaved on the patio, shouting the lyrics to Grandmaster Flash, a throwback song for a throwback school. Silhouettes along the edge of the pool: couples leaning into each other; four girls with bottles of Rolling Rock balanced on their knees; a long-haired boy shaking water from his ear, his thick wet ponytail like a snake down his back. Clusters of people on deck chairs, under boughs of pine trees and scrub palms. Everywhere the soft glint of glass bottles—in hands, under chairs. The sudden shriek of a girl tossed into the water.

Rum bold and goofy, I stripped down to my boxer shorts and plunged into the pool. My shorts were yanked down to my knees; I laughed bubbles underwater and pulled them up around my waist, surfacing, looking to Benjamin and Mary, who'd already turned away, still holding hands, and I could feel the damp warmth caught between their fingers. I ducked under the water again and kicked, relishing the cool water, its chemical sting dulled by my drunken nerves. I surfaced at the deep end and held onto the tiled edge. A sturdy boy with a beard, in a Hawaiian shirt and flip-flops, danced to "Could You Be Loved?" He had his eyes closed, like the others around him, everyone dancing alone. A dark-haired, gnomish woman of indeterminate age, cigarette in hand, shuffled unsteadily to the music. I watched the ember's trail and thought how stupid I'd been, to pick a school I'd never seen, where I'd spend the next four years of my life. How stupid, to have thought I'd reinvent myself as a college-bound gang banger, here, where nobody cared. Cool air against the wet skin of my shoulders. I'd already dis-

carded that reinvention. But now what? Could I cast my lot with Benjamin? I looked around the pool, straining to focus as the rum caught up with me in waves. No sign of him or Mary. That feeling of power faded, stranding me in the middle of the party. I glared at the clusters of people. How had they met each other so quickly?

"Are you a first year?"

I swung my head back. A boy treaded water a few inches away. Yeah, I told him.

"Me too." He looked mulatto, light-skinned, with a smooth chest and a short afro on which clung perfect beads of water. His arms and legs worked back and forth hypnotically. "Are you alone?" he asked.

"No," I said. "I have friends. They're around."

His had gentle eyes. "Friends are good," he said.

A few minutes later we'd worked our way to shallower water. He retrieved an enormous plastic tumbler from the edge of the pool, and shared his drink with me. It tasted like Kool-Aid and gasoline, and it got us talking. He was an English major, and his mother had driven him down from Philly last week. His skin, like mine, looked paler under water, and sometimes our shoulders touched as we talked. I felt his desire, and, boldened again by his drink, I smiled at him. Had he pegged me right from the start? Or had he just taken a chance? The party spun more wildly around our quiet circle. The laughter grew raucous, and a dangerous game of chicken churned the water a few feet away. Time slid and sped by in patches; the film spliced again as I faced him. The light and the noise and the smell of chlorine all rose up as I pushed through the slow inches between us, closed my eyes, and kissed him. His tongue was cool and sweet, and I felt his hands grip my waist. We broke apart. I smiled at him, dunked my head, surfaced again. Nobody yelled, no cries of disgust. The gnome still shuffled back and forth with her cigarette. He asked if I wanted to go back to his dorm. "I have my own room," he said.

Long trek on bare feet, my tennis shoes in hand. He lived on the other side of the Trail, over at B-dorm, which I'd heard was full of freaks, and at this school that was saying something. The night carried me warm and strong and young. A beautiful ache in my groin, cool water dripping from my boxers. The people we passed on the warm cement walkway, dark shapes full of giddy noise, didn't know what we were about to do. Cars—confusions of light and sound—roared beneath us as we took the footbridge over the Trail. The pale library bathed in warm sodium lights, cooler tile underfoot, a narrow asphalt road, then a soft blanket of pine needles as we walked, shoulders brushing, the dorm lurching up towards us, over a dirt path through dark shadows of pine trees, then the bright lights of the dorm. Cement steps leading up to a cluttered common kitchen, secondhand pots and mismatched forks in the sink, a startled girlish boy in Buddy Holly glasses on a threadbare couch—Hey!—a hall lined with thin carpet, the

slick erotic sound of his key sliding home, a room no bigger than a twin bed in white sheets, a desk by the window.

Nothing on his walls, no sign of who he was or what he wanted you to think of him. Then the door swung shut behind us, the dark room, the window, outside the pine trees waving in a warm wind. I could feel him a foot away, a source of heat and held breath. I could step towards him now, but I took an extra second, to enjoy the dark, the soft sound of us.

A knock at the door, hesitant and cruel. He sighed, flicked on the light over his desk, and cracked the door. Buddy Holly peered in expectantly. I wanted to kill him, but sat on the mattress instead, waiting for the English major to get rid of him. But instead he invited him in. Buddy Holly, skinny and fey, took up the room. Pulled the desk chair over near the bed, and sat down. After a minute, my new friend sat beside me.

Buddy Holly held out a delicate hand. He told me his name, which I promptly forgot, then asked me what I planned to major in. The delicious golden fluid in my head cooled and congealed. I didn't want to talk about my class schedule, or why I hadn't registered for any Lit classes. I didn't want to explain, at that moment, with a half-naked boy next to me, that I was fearful, unable to commit myself to literature, to something so impractical. Or why, through some strange reasoning, I had instead signed up for anthropology courses, and a sociology course on deviants. "Still figuring out my schedule," I said.

My hand, obeying a primal urge, ran lightly over my friend's smooth back. He took my hand. Buddy Holly, perched like a cartoon bird, legs folded, hands clasped, smiled, as if our hint were an invitation to stay. He kept his eyes on me, even as my answers to his questions grew monosyllabic. He launched into some convoluted story about two boys, who may have also lived in B-dorm, who most definitely were both gay, and whose blossoming romance seemed to have not just Buddy Holly, but every residents of B-Dorm, in a tizzy of rumor and intrigue. I could only focus on my friend's hand in mine, and the slow dance they created together in constant, slow movement, his fingertips tracing the lines of my palm, my hand collapsing around his fingers, then opening, tracing his in response, our hands following their own logic, intertwining fingers, knuckles, one set of calluses against another, our desire sublimated, narrowed into this single point of contact. They moved together for what felt like hours, as Buddy droned on, and my drunk darkened and thickened and turned stupid, and I wavered on the edge of sleep.

Suddenly Buddy was gone, and the room was dark again. The English major rolled over on top of me, and we kissed, almost tenderly, and pulled at each other's shorts. We did not fuck. I remember the pressure of his body against mine, his slow, gentle movements. The dark room and the waning rum and our rhythm combined, as if we rolled together on waves. And how badly, and for how long, I'd wanted to feel such a thing. And how

both strange and inevitable it felt. And how little I knew, but how little that seemed to matter. And the quick intake of his breath as he came across my stomach, and then, before I could do the same, he had fallen asleep. And I listened to his breath, unbelieving at first, then merely resigned, until a terrible pain gripped me, someplace low, between stomach and groin and, thinking I had to shit, I grabbed my clothes, slid from his room, and hurried down the hall to the common bathroom. I sat there in a stall, gripped by a sharp, unfamiliar pain. I did not have to shit, I did not have to puke. I sat doubled over and confused, in the bathroom at B-dorm, my eyes blinking against the ugly light buzzing overhead.

The door opened, and someone shuffled in. They took the stall next to mine. I glanced over and saw small, pale feet, with blue nail polish, wearing pink flip-flops. A distinctly male voice coughed, then:

"Who's that over there?" the voice asked.

I hesitated. "Um, you mean me?"

"Yes, dear, you." The voice drawled like Blanche DuBois.

"My name is Mike."

"Mike? Do you live in B-dorm?"

"No, I'm just … visiting."

"Well, that's kind of you. Who are you visiting, dear?"

I couldn't remember my new friend's name, and the man with blue nail polish must have taken my silence for reluctance.

"My name is Ansel, dear. Many call me Queen Ansel. Perhaps you've heard of me?"

"Yes, I think I have," I lied. I played with the toilet paper for a second, flushed, and pulled up my pants. "It was very nice meeting you," I said to the pink flip-flops.

"Oh, likewise dear. Likewise. I hope you'll come back to visit us again. We're like one big family over here."

I avoided my pale reflection in the mirror, and slid out, down the stairs, out through the shadows of the pine trees. Suffering my first ever case of blue balls, I took the path back over the Trail, back to my own room. The night had cooled, and the way back felt much longer than the way there.

When I woke the next morning I wasn't hung over enough to have forgotten the night before. I had wanted Benjamin, but settled for someone else, a turn of events that I vowed would never happen again. So I avoided the English major. But at a school of six hundred students, one couldn't hide from anyone for very long, a fact that became more apparent to me over the next few weeks.

Benjamin and I never discussed where we had each wound up that night. He only told me that Mary was a "really nice girl." We spent most of our evenings together, after class, during dinner and in various dorm rooms afterwards, wherever the fickle social current carried us that night. There wasn't much else to do in Sarasota, even less if you were underage

and without wheels. We ended up every night sitting on the floor of some-one's dorm room, smoking cigarettes. They were nearly always girls' rooms: Mary's and others, nearly all of them friends of Benjamin. Walls plastered with kisses: Klimt posters, or the Doisneau black-and-white shot of the two young Parisians on the sidewalk. Excessive Francophilia. Photographs of a young boy and a baguette on the back of a bicycle, gliding down a tree-lined street. I remember pink touch-tone telephones, sea foam throw rugs, teddy bears, stacks of CDs, and a carton of Virginia Slims. I remember Mary's poor roommate rearing up from sleep, squinting through the cigarette haze, and yelling at everybody to get out of the fucking room, now, for the love of God. Bathrooms with coordinated towels and heaps of lotions, lipsticks, hair brushes and tampons. Rows of white plastic clothes hangers, t-shirts and underwear drying on a shower rod. I remember every girl's name, and most of their hometowns. Long permed tresses, acne, majors that changed by the month. I remember stories of boyfriends: alcoholics; the erudite; and the painfully shy. I remember Benjamin on the floor beside me, in baggy cut-offs, his hairy calves jittering from too much caffeine. I took pride in our friendship, in our reputation, Benjamin and Mike, joined at the hip, knocking at a girl's door, bringing nothing but good will and a pack of smokes.

Surely there was homework, massive volumes of reading for Cultural Anthropology, a paper to write for Social Deviance, the glowing screens of Mac II's in the school's computer lab. Few details of my academic life from that first year remain; I only remember the people I met, how quickly I fell in with, and fell out of, certain friendships, my optimism for a new life, far from the quagmire of my family, with whom I'd already grown distant. I still feared that I had chosen the wrong place, a sun-kissed, throwback school in a dead-end tropical paradise. The frustration of my infatuation with Benjamin, a blonde, fresh-faced boy with such innocent, enthusias-tic regard for life that it seemed impossible he could harbor a secret like mine.

Martin Wilner

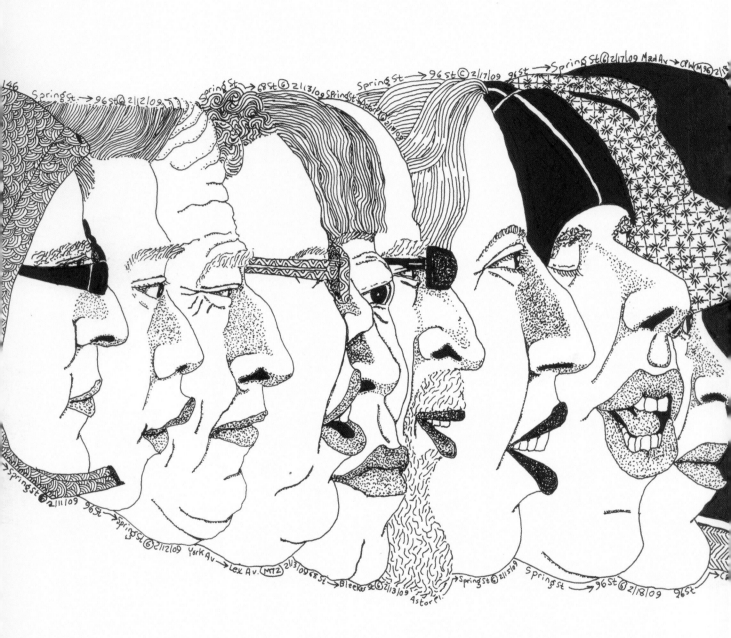

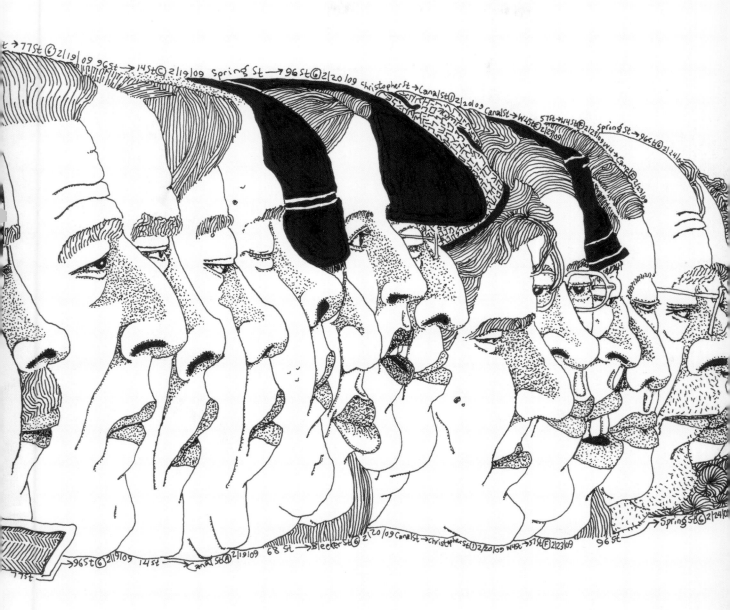

51.147

THE NEXT STOP IS 51st STREET. 'n I never got to SCHVARTZE gonna do: on the next stop. SOME

h, boy... It scared me. IT'S LIKE AN ADULT DISCUSSION... SO SHE REALLY LAID THE GROUNDWORK. read about it. So good. I HAVE A FRIEND THERE WHEN THE TRAIN STOPS

t WORRY ABOUT IT. STRENGTHENS. snff... ARE YOU MANAGING? Lecture. TRANSFER IS A snort! OK. Excuse me, please!

not worried. VISUALIZES... You gotta think... Tonight or in general. Computer... TO THE Ⓑ Ⓕ AND Ⓥ TRAINS. That's what I mean. THIS IS

DID AN EXCELLENT JOB. GREAT JOB... Sienta... ...TONGUE IN CHEEK WAY. 'n I'm lookin' at this... BETWEEN... Like DO YOU THINK when I go home to my parents.

feel a lot closer GREAT JOB. keeps me out of trouble. I don't want all these like... like... EVE SOMETHING. I know

with the kids. SO TELL ME ABOUT ISRAEL. WEAR IT AS SHOULDER PADS 'n I know... Hurting so much... Sorry. Ok, no, I take this always. We need some.

ONE THING YOU Not that it... THIS IS A PELHAM BAY Don't you dare! I bought this brace. MUCH BETTER THAN TAKIN' A CAB.

OULD DO... TIME FLIES. PARK Ⓒ LOCAL TRAIN. Cool. Privacy. THREE TIMES As soon as I put it on, it Good for my THE NEXT STOP IS 42nd ST

e learned a lot. Umm, más I feel like that's all Somebody. As big as... all the pressure Posture PORT AUTHORITY BUS TERMINA

TENTION PASSENGERS. YOU STAYIN' ON THIS they focus on. ...easier. Whatever. off my shoulder.

NEXT STOP ON THIS TO 14th STREET? MY EYES... I MIGHT POP IN LATER. I'M mumble... mmbl... TRAIN IN total. I'M WAIT. you wan

AIN IS 125th STREET. MY, UH, EX... HIS SHIT WUZ HAZEL. GOING TO THE RITZ TONIGHT. ONT OF US... SQUW...

SHE GOT SOME IT'S NOT WHAT YOU Good luck with your HIS MUSIC IS THIS IS A QUEENS-BOUND Ⓔ TRAIN.

R-BA-RA NICE EYES. DO. ITS HOW YOU DO IT shoulder pads AMAZING. AWESOME.

-AH-AN you knew I that. Educate IN FEBRERO... This is a gay train I'M IN LOVE Un.on Square. THAT'S THE WORST I'm looking

H-BAH-BRA was going She's so THE CHO ECKARD You'll love it. The WITH HIM. WE WERE SITTING SO CLOSE. at it.

INN. That's why it's GULLIBLE. IS GREAT. dancing in it is ROOSEVELT I HAVE THIS PICTURE OF MY MOTHER

so stupid. That's another thing. So-o latin. AVENUE LOOKING RIGHT UP AT CHER.

THEY DON'T TRAVEL MUCH. I don't know but That's right. THINKING LA GUARDIA. DOS BACKSTAGE PASSES. HUH HUH HUH HUH

YEAH, NICE JUST THAT ONE How was the Claro. WAS GOOD.

BLEEKER STREET uh...? Spring st Ⓒ 3/3/09 Spring st → 42 st Ⓔ 3/4/09

Canal st.

PROTECT YOURSELF. WHEN YOU COME OFF MY BLOCK, YOU I'm pretty Spring st → 96 st Ⓒ 3/6 Stri

HAVE TO GO DOWN THIS HILL. positive... DOH SAMO... No. No. LA CIENTA. STAND

STREET. SO MUCH More, More, You said you were doing YAWN! DVA LA BLANCA. HE'S FUNN

STRESS. More, More pretty well there... RAHZE. VENTO UNO HE'S CRAZY.

JOB WITH NO STRESS. THE NEXT STOP IS ZOWE AUTOBUS? ROZHUMIESZC+1? Gracias. You'd like him.

I'm your mail order bride. 68th STREET- you may not get THIS IS 14th STREET Goot?! YOU GOTTA

Peek-a-boo! HUNTER COLLEGE. out of it. -UNION SQUARE. METROPOLITAN. MEET HIM.

I see you! IT JUST FELT YES. SKRR... SKKR... SSKRRR

HE'S THE HAPPIEST LITTLE I JUST CAN'T I want to have these. did I say... THIS TRAIN IS MAKING

SO WHA' HAPPENED TO YOU? KID IN THE WORLD. ACCEPT IT. HE HAS HIS HAND OVER HIS MOUTH. ALL LOCAL STOPS.

She wakes up now and AND THEN, AFTER Covered... PRINCE STREET IS NEXT.

PROBABLY ABOUT SEPARATION seems to have nightmares. SIX TO EIGHT MONTHS... CHECK THE...

ANXIETY AT THAT STAGE. I had a really snap! Ⓒ TRAIN TA BROOKLYN. THE ONLY PROBLEM IS

tough night! AFTER GIVING HER $1000 A MONTH... HOW FAR IT IS...

SPRING STREET. CANAL IS NEXT. THEN THE ATTORNEY SAYS... UNDER THE BRIDGE. FUCKING CONTINUE.

8 MONTHS?! EIGHTEEN. tellin' people they ain't doin' anything. Quatro... LISTEN.

90% chance to change my life. ...AND THEN SHE CALLS ME. 34th STREET...

In this business, you don't get a 90% chance. SHE CALLED MY BROTHER LEAVE ROOM FOR Obviously... Even...

DEY GOT CORNED BEEF. LAST NIGHT. PASSENGERS. MY CALVES ARE HUNGRY.

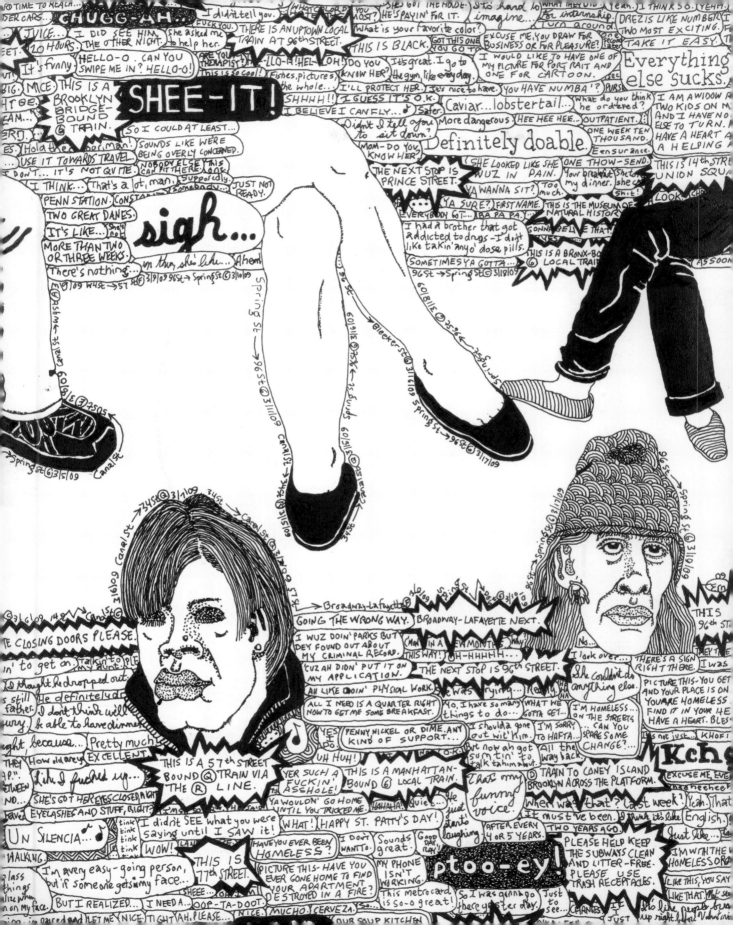

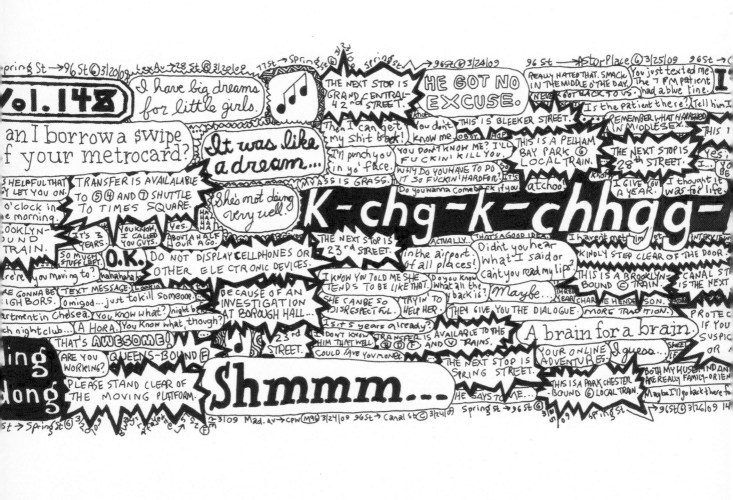

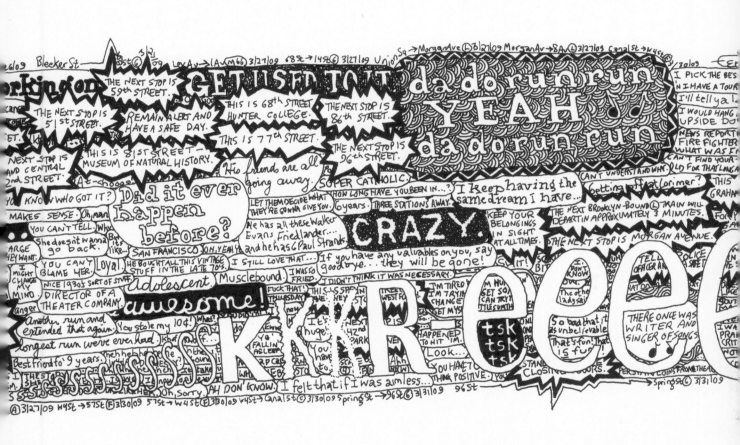

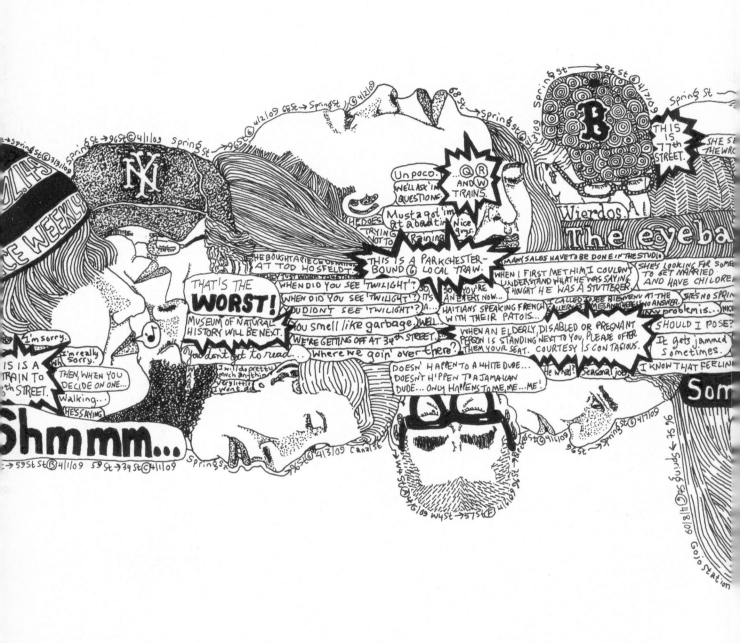

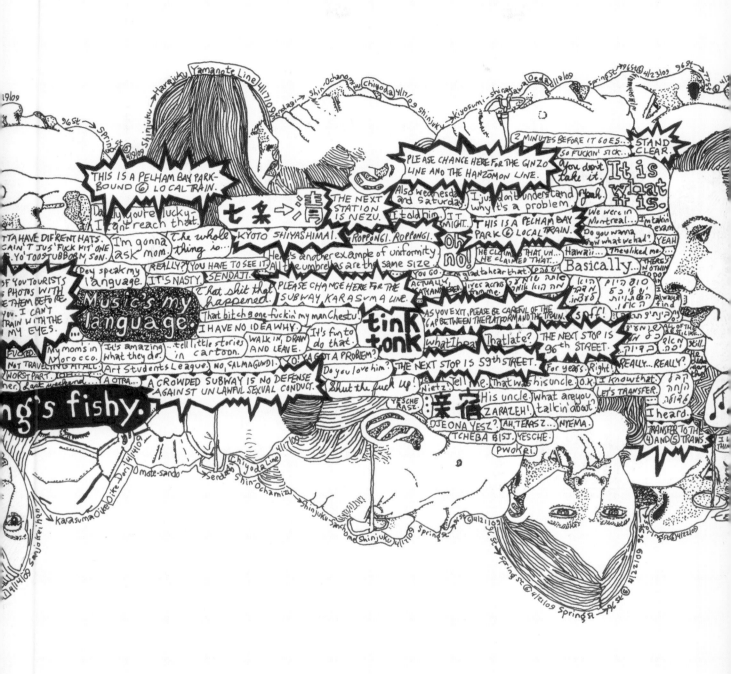

David Park Curry

CABINETS OF CURIOSITY: THE REVERSE GLASS PAINTINGS OF RICHARD LEE

Be not afeard; the isle is full of noises,
Sounds, and sweet airs, that give delight and hurt not.
Sometimes a thousand twangling instruments
Will hum about mine ears; and sometime voices
That, if I then had waked after long sleep,
Will make me sleep again; and then in dreaming,
the clouds methought would open, and show riches
Ready to drop upon me, that when I waked
I cried to dream again.
Caliban, *The Tempest*, 3:2

Sinking and Burning is the latest in an almost-complete series of thirteen large cabinets with inset reverse glass paintings by the Martha's Vineyard-based artist Richard Lee. It is a curious cabinet indeed—dreamlike, filled with visualized noises, humming with life despite the rather dire title drawn from the Italianate composite towers at the bottom of the composition. As one tower subsides into azure waters, the other's foundation is ablaze. The process of reverse glass painting dates back to thirteenth-century Italy,[1] but Lee's recondite mixture of motifs, culled across centuries and cultures, is distilled into a unique dream world populated by all manner of mythological, hieratical, and chimerical beings, a world that leaves much to the contemporary viewer's own imagination. With highly detailed but runic images, the artist seeks to achieve what he calls "specific ambiguity."[2]

In *Sinking and Burning*, a mask inspired by Oceanic art dominates the top of each arched panel. An oculus pierced through the forehead of the purple mask reveals a glimpse of a distant island in a watery expanse. A muscular kahuna, endowed with magical powers, emerges from a ring of fire atop the blue mask. He, like fire itself, is a purifier. And water not only drowns, it gives life. Luxuriant downward trailing vines and flowers bracket the masks. Chief among them are strange blossoms echoing beach rose, morning glory, and trumpet vine, all known for indefatigable, even invasive growth habits. A golden nimbus sets off the pale visage of a male saint borne up by flying fish, while a female flower spirit emerges from a vigorous stalk that miraculously produces hybrid parrot fish as well as somewhat noxious blooms. Assorted grotesques occupy heaven and earth. Meanwhile,

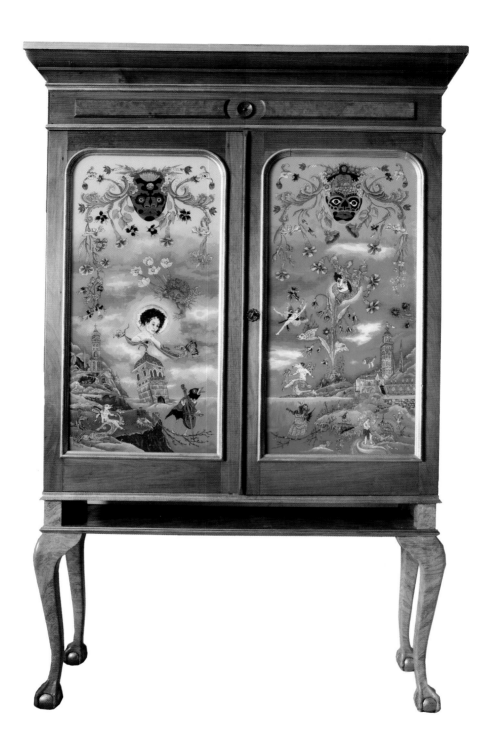

Sinking and Burning, 2005
Reverse glass painted panels in walnut cabinet with parcel gilt, faux grain paint
69 x 44 x 14 inches
Unless otherwise noted, all works are by Richard Lee

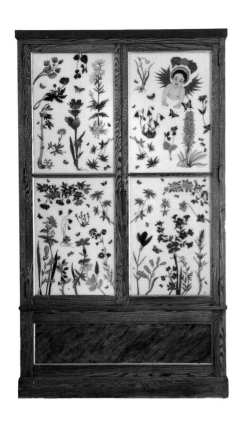

Cigar Cabinet with Angel, 1987
Reverse glass painted panels
in oak cabinet with parcel gilt,
faux marble paint
96 x 52 x 8 inches

a blackbird in a red coat with white collar and cuffs has gone out on a limb with his lute. He sings earnestly across the waters to his lady bird. A threnody? Cool jazz? "O Solo Mio"? Perched precariously in her pink gown, she, too, warbles the song we cannot hear. In duet, the birds look upward through the clouds to the colorful riches ready to drop upon them.

Despite its vivid palette, the image is a chilly one. The artist's technique provides an eerie, even gloss—the pigments have been applied to the back of a glass panel, through which the viewer looks as if peering through a sheet of ice. That the picture was created quite literally backwards—with details applied to the glass before the main figures and then the background were added—reifies the surreal subject matter.[3]

Like Lee's imagery, the case piece housing the twinned glass panels marries old and new. The boxy walnut Eastlake-style storage unit is a thrift-shop find that has likely been on-island since the 1880s. Poised on claw-and-ball feet, new faux-grained Chippendale cabriole legs lift the bulky case aloft, countering the downward movement of the panels with their heady imagery. Striking a balance between painting and furniture, Lee makes formal choices mitigating against the sense of incipient chaos. Episodic painted elements balance one another in intricacy and scale while sidestepping rigid symmetries. Touches of gold in the painting are repeated in the restrained parcel gilding of the woodwork. The jewel-like colors are carefully distributed over—well, under really—the glittering surface of the glass. Somehow, the Renaissance-inspired baptism taking place in the lower right-hand corner seems reassuring, even if the devotee's hair is on fire and he is closely observed by a squatting Caliban-esque monster.

Lee's concept for a limited series of painted furniture with reverse glass panels evolved from his discovery of specially made curio cabinets that stored small treasures in royal households. This royal history, coupled with a long-standing interest in numerology and playing cards, led to his decision to limit the series to thirteen case pieces: thirteen is the king's number. Layers of paint obscure the contents stored in these completely functional cabinets, yet, like little keepsakes, motifs collected on the glass retain a discrete integrity. Lee notes that each cabinet, like each keepsake, "has its eccentricities." For example, *Sinking and Burning*, the penultimate work in the series, includes a shelf just below the closed glass-painted doors, offering convenient storage for precious albums, folios, or prints.

Already an accomplished practitioner of reverse glass painting and a decade-long resident of Martha's Vineyard, Lee didn't work with furniture until 1987. His initial piece, *Cigar Cabinet with Angel*, includes four large panels of flowers and butterflies on a white ground, a grand continuation of

his earlier painting. Lee first exhibited some of his reverse glass paintings in Beverly Hills in 1965.[4] Shows in Munich, Paris, and Los Angeles followed. By then Lee's obsessive technique and his imaginative visual vocabulary were well established, and his twelve-year journey from California to Martha's Vineyard—via Europe, Hawaii, and Colorado—was underway.

A corresponding sense of time travel pervades some of the approximately 150 pictures he made before settling on the island. Among these early images is *The Last Acorn*, 1967, painted in California. Spangled in spades—a powerful symbol of death and taxes—a woman with a full head of (doubtless organically raised) carrots seems to be coming in for a landing.[5] With her knife-wielding familiar on her knee, she sits astride a fecund peapod powered by a rose the size of an outboard motor. An enormous pink gerbera daisy hangs, radiant, in the icy heavens. Hovering attendants with black bumbershoots herald her arrival. On the ground, someone clad in a bear suit holds aloft the eponymous nut, trailing a delicate network of roots. Like a signal flag, the acorn guides the peapod and its passengers to shore. Appropriately, the furniture selected for *Cigar Cabinet with Angel*, the first to be transformed on Martha's Vineyard through the alchemy of Lee's reverse glass panels, is made of oak. It had been custom built for a tobacco shop in Montpelier, Vermont. The artist later rescued the extremely shallow oak carcass from a junk store and shipped it to the island on which he seems finally to have taken root himself.

Lee says of his eclectic imagery, "Some see Persian, some see Chinese, some see Bosch. For years, I told people Bosch was my grandfather."[6] Facetious or not, the acorn picture evidences Lee's contribution to a long artistic continuum. It quickly entered Mildred Lee Ward's collection of reverse glass painting.[7] Now dispersed, her significant historical collection, amassed in the 1960s and '70s, covered a range of some five hundred years, representing artists from much of Europe, North America, and Asia, situating Lee's oeuvre in an extended global context.

The cabinets Lee refurbishes add further art-historical resonance. All are American (and for the most part late nineteenth or early twentieth century); this gives his furniture series a particular affinity with case pieces, clocks, and mirrors of the Federal era, when reverse glass painted panels were a popular decorative embellishment up and down the eastern seaboard. Lee likes to picture rescued cabinets, "some mail-order, factory made, going up-island in a buckboard in the 1800s."[8] Refurbished and fitted up with reverse glass painted panels, the cabinets are transfigured into resplendent works of art, however humble their origins.

Some of their most elegant American predecessors were made in Baltimore, Maryland, as the eighteenth century gave way to the nineteenth. The overall form of this little mahogany *Bonheur de jour* (lady's writing desk) was inspired by designs published by English tastemakers Thomas Sheraton (1751–1806) and George Hepplewhite (circa 1727–1786). Its deli-

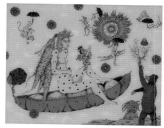

The Last Acorn, 1967
Reverse glass painting
16 x 20 inches
Collection Dean and Ginny
Graves

Lady's writing desk, circa 1800
Mahogany, mahogany veneers,
satinwood inlay, reverse glass
painted panels, brass
50 3/4 x 30 3/4 x 18 3/4 inches
Baltimore Museum of Art

Lady's writing desk, detail

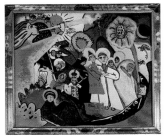

Wassily Kandinsky
Alleheiligen I, 1911
Reverse glass painted panel in
original painted frame
13 3/8 x 16 inches
Lenbachhaus, Munich

Jakob Fröhlich
Beaker with interior sundial,
circa 1560
Enameled silver-gilt with
reverse glass painted panels
Height: 6 3/8 inches
Walters Art Museum,
Baltimore

cately inlaid mahogany surface serves as a foil for a number of reverse glass panels, probably made in Baltimore as well. Graceful if cautionary images of Temperance and Justice flank a compartment fitted with cubbyholes and drawers where a woman of fashion might have secreted her personal correspondence. The compartment is masked by a drop-down inlaid panel that supports a romantic reverse glass glimpse of two figures near a rock by the sea. Diana, goddess of the hunt, wears her signature crescent moon in her hair. But she has put armaments aside to cradle the head of a recumbent shepherd in her lap. He is Endymion, whom the gods granted eternal sleep to preserve his youth and beauty.

If a shared sense of symbolic, open-ended allegory ties Lee's work to early American decorative arts, perhaps of even greater interest to the contemporary reader is the sudden adoption of reverse glass painting as a playful component of twentieth-century modernism, particularly in the work of The Blue Rider, a group of influential avant-garde artists based in Munich. Gabrielle Münter was the first to discover and admire Bavarian religious reverse glass painted images of the eighteenth and nineteenth centuries. During the summer of 1908 she began collecting them and imitating their reduced forms, schematic drawing, and brilliant passages of flat color.[9] Other members of The Blue Rider, including Wassily Kandinsky, Heinrich Campendonk, Alexi Jawlensky, Paul Klee, August Macke, and Franz Marc soon followed her lead.[10]

Kandinsky's *Allerheiligen I*, painted in 1911, incorporates St. George with lance and shield, riding the blue horse that was so frequent and arresting a motif that it gave the group its name.[11] By dividing the composition into light and dark, Kandinsky contrasts life and death, but ultimately his picture inspires hope. The bright colors dominate the dark ones, while a tiny butterfly and a phoenix both fly toward a colossal angel with an uplifted golden trumpet. Neither a sense of proportion nor of logical connection governs this gathering of saints and angels still in its original frame, painted by the artist.

Lee, who looked carefully at reverse glass paintings by both German folk artists and Blue Rider members, also selects and decorates his own frames, as practitioners of reverse glass painting often do.[12] And while Lee's work stands out stylistically from the international array of saints, seasons, biblical tales, genre scenes, hunting scenes, exotic landscapes, seascapes, stylized portraits, folksy floral pieces, and even abstract images created by various artists using reverse glass painting techniques over the centuries, a reassuring presence of the past functions as a significant building block in Lee's version of modernism, as it has done for so many artists before him.[13]

Black Heraldry Cabinet, second in his furniture series, explores some of these layered histories, albeit irreverently. Addorsed stags' heads with magnificent racks of antlers might conjure aristocratic coats of arms engraved on silver flagons or chargers, but Lee's—hardly monarchs of the glen—

peep out with sly expressions and lolling tongues from behind generously swagged purple and maroon draperies. Odder still are vividly painted heads of hungry-looking lizards. Armorial bearings for an upwardly mobile family? Cartoonish demons, glamour girls, ballerinas, a technicolor frog, and prim Fu dogs jockey for available space. With their intricately twisted and ornamented handles, the cabinet's bold knives and forks emblazoned in bright golden yellow resonate with an elaborate sixteenth-century covered cup that is actually a sundial, adding savor to our appreciation of Lee's delicious assemblage of impossibilities.[14] The sides of Jakob Fröhlich's silver-gilt beaker bear reverse glass painted figures of the days of the week, each represented by a planetary god. These cosmic personifications echo prints by Vergil Solis (1514–1562), a Nuremberg engraver.[15]

Lee's far-flung sources are less specific, but beings from his own vast cosmos populate the black void of two

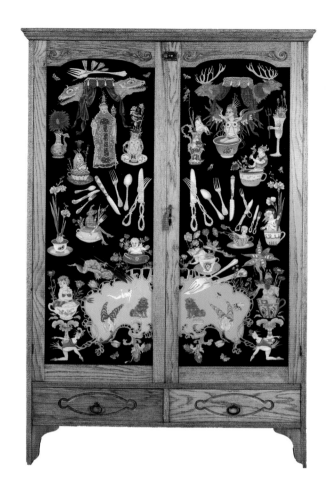

Black Heraldry Cabinet, 1988
Reverse glass painted panels
in oak cabinet
64 x 39 x 41 inches

huge glass panels set into a late nineteenth-century oak cabinet, found, like all but the first in the series, somewhere on Martha's Vineyard. Flying cups, with or without saucers, are piloted by bizarre, sometimes mongrel figures. As often as not, the cups have eyes.

Cloaked in silk and stars, edged in fire, an arhat-like figure with a compelling stare proffers a handful of purifying flames. His staff is topped with a burning building. He represents the official guardian of the linga, a phallic Hindu symbol of regeneration, his promise made manifest in the teeming floral life scattered across the panels. Opposite him, a fat woman wearing only striped socks and a tricorne hat occupies the spout of a small ceramic pitcher with ormolu mounts that, again, recall sixteenth-century gold work. There is just enough room for a stem of orchids to squeeze past her pink amplitude, thrusting magenta blossoms into the air. The heraldic heads at the top of each panel are balanced by a frigid blue ovoid form at the bottom. Rather like a lake, it also recalls a mirrored surtout-de-table—an elaborate dining room centerpiece popular in noble residences in centuries past. Judicial balancing of colors and elements, with attention to

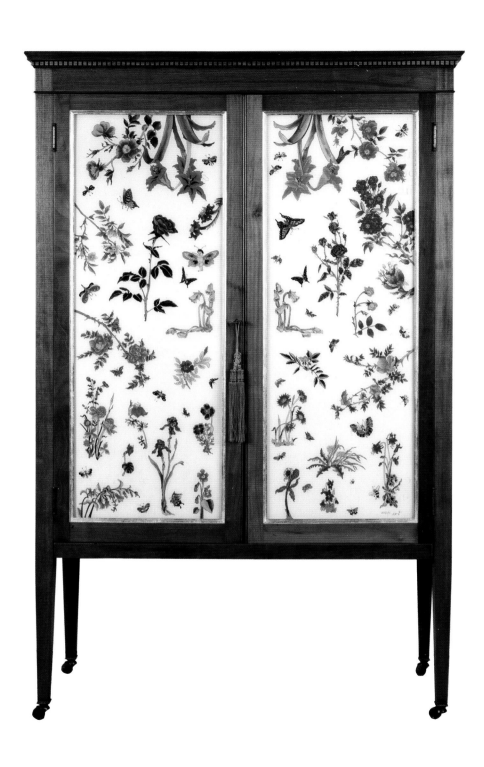

Edgartown Flower Cabinet, 1988
Reverse glass painted panels in mahogany cabinet with parcel gilt
62 x 39 x 14 inches

found patterns extant in the rescued and refurbished woodwork, keeps Lee's compositional universe from sinking into entropy.

One might turn with some relief to the third piece in the series, the aesthetically restful *Edgartown Flower Cabinet*, 1988, named after the old whaling port on Martha's Vineyard where the carcass was discovered. Closely related to *Cigar Cabinet with Angel*, this piece stands like an enormous book of simples. Individual flowers, most of them easily recognized, are isolated as if pulled from a book page and carefully distributed over cool white panels set into the front and sides of a spare federal revival case on tall, slim legs.[16]

To be sure, the *Edgartown Flower Cabinet*'s seemingly straightforward florilegium has its disconcerting moments—along with the beach rose, iris, and tea rose we find flowers that do not exist in nature. On a side panel, an elephant appropriated from a Persian miniature is one of several somewhat alarming animal amalgams sprouting vegetal tails. And on the front panels, large red amaryllis are growing upside down, while two clumps of anemic pink digitalis with partially collapsed pale-blue stems seem to be in the first stages of cardiac arrest. In contrast, tiny carefree butterflies—symbols of eternity in the artist's visual lexicon—flit through the frosted white atmosphere. At least one has metamorphosed into a putto with colorful butterfly wings of variegated yellow, pink, red, and orange. Each wing is centered with a large eye that looks forward to subsequent developments in the series.

On *Butterfly Cabinet*, number five in the series, Lee's beautiful insects seem to have gone forth and multiplied, covering a single large plate-glass panel. Fifty-two butterflies (the same number as playing cards in a deck) hover in a white vortex, accompanied by a single butterfly-winged putto. Separated by a wreath of roses and ferns, another five dozen butterflies flutter across a black background toward the edges of the panel.[17] The effect is that of an enormous chaplet frozen in a block of ice, like the outlandish fruit and floral garnitures that were standard decor at European court banquets during the Renaissance and Baroque eras.[18] Meanwhile, on subsequent cabinets, Lee's flowers take on ever more impossible colorings, or change into surreal personages, whether exotically costumed or nude, with grotesque flowers where their heads ought to be. Again, one recalls sixteenth-century herbals filled with descriptions and illustrations of plants, along with notes for their medicinal or culinary use. These books also include images of fantastic figures and discourses on the magical powers of herbs.[19] Their illustrations are as painstakingly precise as some of Lee's birds, beasts, blossoms, and bugs.

Individual flowers set against stark white backgrounds bring to mind one of Lee's most famous American predecessors in the medium of reverse glass painting, Rebecca James (1891–1968). Like Lee, who has been a dancer and mask maker as well as a painter, James came from a theatrical background.

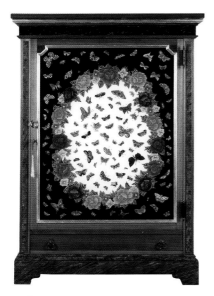

Butterfly Cabinet, 1988
Reverse glass painted panel in walnut cabinet
with parcel gilt, faux paint
53 x 36 x 17 1/2 inches

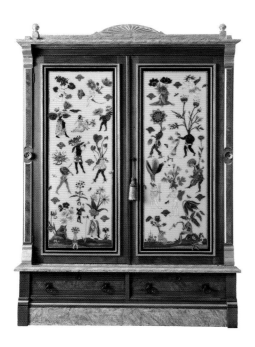

Zoomorphic Garden Pink Cabinet, 1991
Reverse glass painted panels in mahogany
cabinet with parcel gilt, faux paint, carving
67 x 46 x 16 inches

She was the daughter of a touring operatic soprano and the accomplished impresario who created the Buffalo Bill Wild West Show to spread the myth of the American West around the globe. The show debuted in 1884, during the decade when some of the cabinets later rescued by Lee were made. Born while the show was playing in London, James traveled with it until she was eleven. The rest of her upbringing was equally unconventional.

Married for a time to photographer Paul Strand, James was part of the circle of modernists gathered around Alfred Stieglitz in New York.[20] Through Stietglitz's European connections, James and her colleagues, including Arthur Dove, Marsden Hartley, Georgia O'Keeffe, Rockwell Kent, and Joseph Stella, were well aware of developments in Munich. Stieglitz even published translated excerpts from Kandinsky's treatise "Concerning the Spiritual in Art" in the pages of *Camera Work*.[21]

The religious fervor expressed in the folk arts of rural Germany and Austria that so engaged members of The Blue Rider found its New World counterpart in the Hispanic Southwest, where numerous American modernists sought inspiration.[22] With Strand, James learned to take close, intimate, severely discriminating views of ordinary objects in order to transform them into abstract compositions. Moving to Taos, New Mexico, in 1933, she became interested in the religious art and *colcha* (indigenous embroideries) she found there. She learned from O'Keeffe how to use a piece of glass as a palette, but her reverse glass painting technique, like Lee's, was largely self taught.[23] In *New England Still Life* she gathered a posy of old-fashioned flowers—roses, lilies, pansies (symbolic of thoughts or *pensées*), forget-me-nots. Despite their nostalgic associations with contemplative memories, her image is distanced by the slick glass surface that overlays it. The conical vase, not unlike those filled with artificial bouquets in New Mexican cemeteries, casts a surreal, unexplained shadow, but the flowers are the more remote and ghostly because they do not.

In contrast, Lee's bouquet for his *Empire Style Cabinet* is an energized burst of roses real and unreal,[24] guarded by winged unicorn monopods armed with forks. The flowers are arranged in a footed cup made of almost animate individual bits, from the jolly green-capped circle of friar faces at the bottom, past the open-mouthed arabesque, up the stem hung with peapods filled with staring eyes, past the single somewhat daunting all-seeing eye emblazoned on the cup to the pair of ditzy yellow birds perched atop bearded masks to conduct an

aviary gossip over the cup's rim. Butterflies, putti, and even—perhaps over-looked by the all-seeing eye—a couple of sets of winged male genitalia impersonating Lepidoptera drift over the roseate coral background. Like some others in the series, this cabinet features not only judicious parcel gilding but also faux finishing that creates the effect of marble on parts, powerfully framing and enhancing the magnificent tableau.

Along with *Sinking and Burning, Magenta Convex Cabinet* of 1992 comes about as close as the artist gets to an overarching narrative in his series. The cabinet's imagery, delivered in Lee's usual episodic, emblematic manner, obliquely addresses African American history. Typically, it is up to the viewer to string the narrative elements together. Most of the people depicted on the cabinet are black. They include Adam and Eve—perhaps acknowledging the theory that the entire human race can be ultimately traced to African progenitors. Presented front and center under a gaudy chandelier, suspended from the top of the panel as if it were theatre light-ing, the first couple holds a pair of golden forks bolt upright, like the gilded staffs carried by high-ranking Akan officials of the west coast of Africa. Carved figures and symbols on Akan staffs embody symbolic stories that are spoken over and over in a culture that had no written language. Likewise, Lee's visual images spin many an unwritten tale.

Adam and Eve are flanked by a pair of fey-looking major domos wear-ing pink silk knee breeches and white stockings terminating in cloven hooves. A correspondingly sinister gentleman (albeit sans hooves) stands at the bottom right of the central panel, turned out in his eighteenthth-century frock coat and powdered wig. Although leaning upon his walk-ing stick with a proprietary air, he is on tenuous ground—or no ground at all—only a flowering branch lies under foot. He is more than counter-balanced by a shaman, powdered white all over and sprinkled with red diamonds, who twirls a colossal wire whisk like a swizzle stick, stirring up a flaming cosmic cocktail of pure energy. At their feet, a figure holding a gun lies dead, the victim of his own resistance to change.

The colonialist and the shaman are separated by a cloisonné vase placed directly above the corpse and decorated with the image of a black baptism, but Lee discounts any direct connection to Oak Bluffs, a town on Martha's Vineyard long associ-ated with the Methodist movement whose liberal views towards race relations that made it a mecca for vacationing African Americans. The town still

Rebecca Salsbury James
New England Still Life, circa 1940
Reverse glass painting
27 x 22 inches

Empire Style Cabinet, 1988
Reverse glass painted panel in walnut cabinet with parcel gilt and faux marble painting
48 x 39 x 13 inches

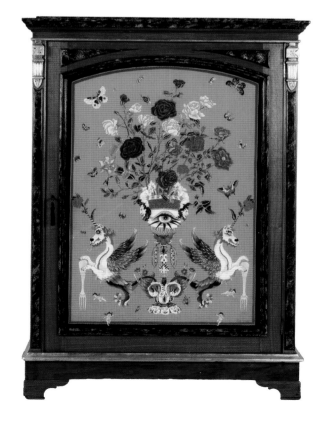

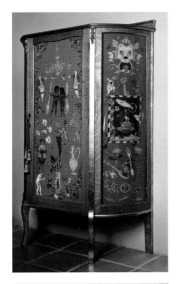

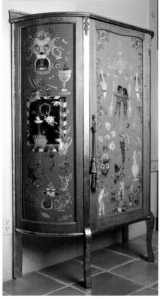

Magenta Convex Cabinet,
1992
Reverse glass painted panels
in oak cabinet with parcel gilt
62 x 40 x 16 inches

is dominated by late nineteenth-century "Gingerbread Cottages," decorated in colors as bright as those found on Lee's reverse glass painted panels.

On its curved side panels, *Magenta Convex Cabinet* features two performances staged in teacups. One honors the Buffalo Soldiers, originally members of the U.S. 10th Cavalry Regiment of the United States Army. Formed in 1866 at Fort Leavenworth, Kansas, they played a significant role in settling the American West, first as soldiers, then as cowboys.[25] Lee's bronco buster, in lime green jeans and pink cowboy boots, coaxes not fiery steeds but shining fish to leap through his blazing hoop. Near him, another black male figure, bound upside down to the handle of a knife, offers a sharp reminder that the path to freedom was not always an easy one. In the other teacup, a black ballerina in a pink tutu goes en pointe while holding out another fiery hoop, through which a white figure reminiscent of multibreasted Artemais does an obedient back flip. The temple of Artemais at Ephesus may have been one of the wonders of the ancient world, but here the ballet dancer is in control. She was inspired by Carmen de Lavellade, whose long and distinguished career as an actor, prima ballerina, modern dancer, choreographer, and teacher has broken many social and cultural barriers. Early on, Lee saw the accomplished dancer perform at Jacob's Pillow in the 1950s.

Distilled in the motifs generously scattered over his cabinets, then, Lee's memories extend back for more than half a century. When evaluating these unusual pieces of decorated furniture, perhaps the ever-present sense of performance they create most clearly spotlights the power they contain. Lee's cabinets can be at once engaging, repellant, majestic, mundane, amusing, disturbing, inspiring, mystifying, inclusive, and self-referential. On a remote island like Martha's Vineyard, anything useful is unlikely to be thrown away. The artist's act of salvage (unwanted cabinetry rescued from the thrift shop) becomes his message of salvation—trash transformed by the hand of the painter. Lee doesn't take the basics for granted. Earth, air, water, and fire—the four archetypal elements of the ancient world—are celebrated here. On one side of *Magenta Convex Cabinet*, a strong black hand is, as often seems to be the case with Lee's imagery, aflame. But what a lovely way to burn.

NOTES

1. Rudy Eswarin, ed. and trans., *Reverse Paintings on Glass, the Ryser Collection* (exh. cat.: Corning, NY, Corning Museum of Glass, 1992). Text based on Frieder Ryser, *Verzauberte Bilder: Die Kunst der Malerei hinter Glas von der Antike bis zum 18. Jahrundert* (1991)

2. Richard Lee, conversation with the author.

3. Lee's paintings, whether independent or intended for a cabinet, begin as sketches on the cell vinyl used in cartooning. These are traced onto the glass. The artist uses a fine-tip pen, usually a crow's quill. He uses a brace laid horizontally across the back of the picture frame to steady his hand. One might argue that the difficulty of the technique itself adds a tension to the finished image.

4. Setay Gallery, Beverly Hills, CA, February 15–March 13, 1965. The artist reports that he discovered the medium by chance when he had to make a birthday card for a friend and had no paper to hand. He tried working on a sheet of glass and was instantaneously engaged by the method he has since perfected. Heather Curtis, "Art: Richard Lee: Through a Looking Glass," *Martha's Vineyard Times*, August 2, 2007.

5. The ace of spades is often interpreted as a "death card" in folklore. Starting in the early eighteenth century, duties were levied on decks of cards in England. Initially, one card in the pack—usually the ace of spades, was hand stamped to indicate that the duty had been paid. Various systems using the ace of spades were subsequently employed until the tax was finally abolished in 1960. See Ben Schott, "Card Tax & The Ace of Spades," *Schott's Sporting, Gaming & Idling Miscellany* (London: Bloomsbury Publishing, 2004), p. 62.

6. Lee, quoted in Elaine Louie and Solvi dos Santos, *Living in New England.* (New York: Simon and Schuster, 2000), p. 151.

7. Mildred Lee Ward, *Reverse Paintings on Glass* (exh. cat.: Lawrence, KS: Helen Foresman Spencer Museum of Art, University of Kansas, 1978), fig. 39; cat. no. 77.

8. Lee, letter to the author, April 6, 2009.

9. Helmut Friedel and Annegret Hoberg, *The Blue Rider in the Lenbachhaus, Munich* (Munich, London and New York: Prestel, 2000), no. 71. Unlike many artists who taught themselves this technique, Münter studied briefly with a professional glass painter, Heinrich Rambold. Many examples of Bavarian reverse glass paintings were published in *The Blue Rider Almanac*.

10. For examples, see Friedel and Hoberg, The Blue Rider.

11. Now in the collection of the Lehnbachhaus, Munich, Kandinsky's small square reverse glass painting of St. George on a blue horse evolved into the actual signature image of the group. (See ibid., pl. 41.) First impressions last. Lee recalls, in conversation with the author, encountering The Blue Rider as a fifth-grader when a print of a blue horse was given to his school as a memorial to a dead student; "My imagination was struck with wonder that someone would paint a horse blue. I still remember the picture."

12. Lee studied reverse glass paintings, almost all religious, but had little formal training as an artist.

13. I have long been interested in this topic. For further discussion, see David Park Curry, "Slouching Toward Abstraction," *Smithsonian Studies in American Art* 3 (Winter 1989): 49–72. See also "Rose Colored Glasses: Looking for 'Good Design' in American Folk Art" and "Time Line," in *An American Sampler: Folk Art from the Shelburne Museum* (exh. cat.: Washington, D.C.: National Gallery of Art, 1987).

14. Lee's interest in food, apparent on a number of the cabinets, relates directly to some of his paintings, for example the Who Ordered the Avocado series. Not surprisingly, Lee's résumé includes a short stint at Richard's Dessert Gallerie and Restaurant in West Tisbury on Martha's Vineyard.

15. Eswarin, *Reverse Paintings on Glass*, p. 19. Made over a period of about thirty years (1562–1592), reverse painted panels from Nuremberg were often either mounted in metal or fitted into small pieces of furniture.

16. Like variations on a theme, the first, third, sixth, and eleventh cabinets in the series explore isolated flowers on white backgrounds, interspersed with butterflies and other—to my mind increasingly unsettling—creatures. As each cabinet is unique, so is each glass panel, made to conform to the idiosyncratic shapes of the cabinets they adorn.

17. The woodwork is actually the salvaged center portion of a walnut storage piece. "I never saw the other two sections," the artist reports. Lee's colleague Simon Hickman made the base from two by fours to help support the weight of the heavy plate glass door. This is the only cabinet to bear an original maker's signature: "April 10th 1903. D. O. Willmond, Ipswich, Mass." Like the majority of the cabinets, it was found on Martha's Vineyard.

18. Elizabeth David, *Harvest of the Cold Months: The Social History of Ice and Ices* (New York: Viking, 1998).

19. Sixteenth-century herbals by Gaspard Bauhin, Otto Brunfels, Hieronymus Bock, and Leonhard Fuchs were popular in Germany and England.

20. Suzan Campbell, "In the Shadow of the Sun: The Life and Art of Rebecca Salsbury James" (Ph.d. diss., University of New Mexico, 2002). Rebecca James' mother was Rachael Samuels, her father Nate Salsbury. James studied at Felix Adler's progressive Ethical Culture School in New York, but as an artist had little formal training. Her association with members of the Stieglitz group was, of course invaluable.

21. Quotations from Kandinsky's text appeared in *Camera Work*, no. 39, July 1912.

22. For an overview see Charles Eldredge et al., *Art in New Mexico, 1900–1945: Paths to Taos and Santa Fe* (New York: Abbeville Press, 1986).

23. Colleagues from the Stieglitz circle who tried reverse glass painting include Arthur Dove, Marsden Hartley, Rockwell Kent, and Joseph Stella. James described the technique as "extremely difficult," commenting in her notes for a 1954 radio broadcast about reverse glass painting, "Often the images have to be reversed mentally, and in the larger paintings the glass often has to be turned upside down to make certain areas accessible to the brush." The work requires infinite patience, and of course, once the paint is dry, no changes are possible, so that there can be no slip between idea and execution. "Notes for a Radio Broadcast about Painter on Glass," art festival NY, 1954," Campbell, *Shadow of the Sun*.

24. Lee's roses are blue now and then—*Empire Style Cabinet* prominently features a large blue rose on the left side of the composition, recalling a short-lived Russian association of Symbolist artists called *Blaue Rose*. The group was active only during the first decade of the twentieth century, but its fascination with the music of color and line coincided with Kandinsky's theoretical interests. Kandinsky was an associate member, contributing works to *Blaue Rose* exhibitions in Moscow between 1906 and 1910.

25. For further information on Buffalo Soldiers, see Lonn Taylor and Ingrid Maar, *The American Cowboy* (New York: Harper and Row, 1983).

San Francisco, California, 2007
C-print
30 x 37 1/2 inches

Desk and Tree, University Place, New York, NY, 2007
C-print
30 x 45 inches

NOTES ON CONTRIBUTORS

MITCHELL ALGUS opened the Mitchell Algus Gallery in 1992.

CHRISTIANE ANDERSSON is the Samuel H. Kress Professor of Art History at Bucknell University. She is an authority on the work of Urs Graf, as well as German and Swiss drawings and prints, with additional focuses on images of women in the Renaissance, the censorship of art, and the drawings of Albrecht Dürer. She recently contributed to *The Language of the Nude: Four Centuries of Drawing the Human Body* (with William Breazeale, 2008).

WILSON BENTLEY (1865–1931) photographed his first snowflake in 1885. He went on to photograph over five thousand "tiny miracles of beauty" over the course of his life. He was the first known photographer of snowflakes, renowned in technical and artistic communities alike.

NAYLAND BLAKE is an artist, writer, and educator. His work is represented by Matthew Marks Gallery, New York; FRED [London] Ltd., London; and Gallery Paule Anglim, San Francisco. His work is in the Museum of Modern Art, the Whitney Museum of American Art, The Studio Museum in Harlem, and the San Francisco Museum of Modern Art, among many others. He is chair of the International Center of Photography/Bard masters program in advanced photographic studies. He lives in Brooklyn.

BRICE BROWN exhibits his work at Schroeder Romero Gallery, New York, where he will have a one-person show in early 2010. He writes a monthly column in *City Arts* newspaper on decorative arts and design. More information at www.bricebrown.com.

GARY CARDOT lives in northwestern Pennsylvania, where he teaches photography and art history. He received an M.F.A. in visual art from the California Institute of the Arts in 1990. His work has been exhibited in galleries and museums throughout the country. He is currently working on a series of portraits of people in masquerade. More information at www.garycardot.com.

SUSANNA COFFEY is the F. H. Sellers Professor in Painting at The School of The Art Institute of Chicago. Her work has been exhibited in galleries and museums throughout the United States, Asia, and Europe. Awards include those from The John Simon Guggenheim Foundation, and The Louis Comfort Tiffany Foundation and The National Endowment for the Arts. She lives in New York and Chicago. More information at www.susannacoffey.com.

DAVID COGGINS is a writer and contributor to Art in America. His work appears in *Interview, Artnet* and *The Wall Street Journal*. He has written catalogue essays about Wes Lang, Enoc Perez, and Ridley Howard. He lives in New York.

R. CRUMB recently published *The Book of Genesis*, a graphic novel including the entire original text, in 2009. A founder of the underground comix movement, and a distinctive illustrator, he has published comics and books since the late 1960s, collaborating often with beat writers and musicians. He lives in Southern France. More information at www.crumbproducts.com.

DAVID PARK CURRY is senior curator of decorative arts, American painting and sculpture at the Baltimore Museum of Art, specializing in American and European art

of the late nineteenth and early twentieth centuries. He has has lectured widely in the United States and England. His most recent monograph, *James McNeill Whistler: Uneasy Pieces*, was published in 2004. He is currently working on a contextual study of the Hayes presidential china as well as a short book on William Merritt Chase's fish pictures.

MARK DOTY won the National Book Award for Poetry in 2008 for *Fire to Fire: New and Selected Poems*. He has published numerous collections of poetry and prose for which he has received honors including: the National Book Critics Circle Award, the Los Angeles Times Book Prize, a Whiting Writers Award, two Lambda Literary Awards, and the PEN/Martha Albrand Award for First Nonfiction. He is the only American poet to have received the T. S. Eliot Prize.

JON GREGG founded the Vermont Studio Center in 1984, the largest international artists' and writers' residency program in the United States. His artwork has been reviewed in *Art in America* and *The Brooklyn Rail*. Gregg is a forty-year practitioner of Tibetan Buddhism and an avid cyclist; he rode across the country in 2006.

ALLAN GURGANUS writes fiction because he was read to nightly as a child. Nothing since has ever been quite so stimulating and reassuring. He wants to thank the Brothers Grimm, plus Mom.

ROCHELLE GURSTEIN is the author of *The Repeal of Reticence: A History of America's Cultural and Legal Struggles over Free Speech, Obscenity, Sexual Liberation, and Modern Art*. She is currently writing a book tentatively titled *Of Time and Beauty: A History of Aesthetic Experience*.

HILARY HARKNESS was born in Detroit in 1971. She received an M.F.A. from Yale University and shows at Mary Boone Gallery, New York.

HANNAH HÖCH (1889–1978) was a German Dada artist best known as the originator of the photomontage. She studied art during World War I and became acquainted with Raoul Haussman in 1915, a relationship through which she developed her ideas of photomontage and their strong connection to feminism—challenging gender roles between the wars within the Dada ranks.

VALENTINE HUGO (1887–1968) was an illustrator and set designer. A murcurial muse to the Surrealists—including André Breton, Paul Éluard, and Jean Cocteau—she was married to Jean Hugo, great-grandson of Victor Hugo.

JAMES JAFFE is the owner of James S. Jaffe Rare Books LLC, New York, a firm specializing in rare books, manuscripts, and literary archives. He publishes books at random and at whim under the imprint Green Shade. Born in Virginia, after decades of displacement he makes his home in Salisbury, Connecticut.

MALIA JENSEN was born in Hawaii in 1966 and raised by wolves in the woods of Oregon. She currently lives in Brooklyn. Principally a sculptor engaged in testing the limits of faith and pestering animals, she enjoys asking, "What would a worm do?" This series of woodcuts was printed on vintage papers at The Grenfell Press, New York. Jensen is represented by Richard Gray Gallery, New York and Chicago, and by Elizabeth Leach Gallery, Portland, Oregon. More information at www.maliajensen.com.

KIM KEEVER is a photographer living and working in New York. He is represented by Kinz + Tillou Fine Art, New York, and Carrie Secrist Gallery, Chicago. His work

is included in museum collections, including those of The Metropolitan Museum of Art, The Museum of Modern Art, and the Brooklyn Museum of Art, New York; the Hirshhorn Museum, Washington, D.C.; among others.

TIM KNOX is the director of Sir John Soane's Museum, London. He was head curator of the National Trust from 2002–2005. He is a trustee of the Pilgrim Trust, the Stowe House Preservation Trust, and the Friends of Prehen, and a member of the United Kingdom's Reviewing Committee on the Export of Works of Art and the Comité Scientifique of the Palace of Versailles, France. He lives in London.

GUY KLUCEVSEK has been composing for accordion(s), chamber ensembles, bands, modern dance, theater, and film since 1972. He has released twenty-two recordings as soloist/leader since 1985, many of which are still in print on the Winter & Winter, Tzadik, Starkland, Review, XI, and CRI labels. He lives in Staten Island, New York. More information at www.guyklucevsek.com.

LOUISE KRUGER apprenticed with shipbuilders in Italy and bronze artisans in Ghana. Her work has been shown at The Museum of Modern Art, the Whitney Museum of American Art and The Metropolitan Museum of Art, New York. She is represented by Lori Bookstein Fine Art, New York, where her embroideries will be the subject of a solo exhibition in 2010.

GERARD MALANGA is the author of twelve books of poetry, four photography monographs, and one book of nonfiction. His most recent publication is a collection of lost-found snapshots, *Someone's Life* (Morel Books, 2009). For nearly nine years now he has been working on a series of poems, *Who's There?* He lives with his four cats in upstate New York. More information at www.gerardmalanga.com.

FRED MANN has had a mixed and colourful career that has included everything from DJing at Glastonbury, running illegal nightclubs and raising money for arts education in East London schools. He is the owner of FRED [London] Ltd, London. More information at www.fred-london.com

MICHAEL MCALLISTER received an M.F.A. from Columbia University, New York, and lives in San Francisco. The excerpt published here is from his memoir-in-progress, *My Nuclear Family*. More information at www.dogpoet.com

JOAN MITCHELL (1925–1992) was an Abstract Expressionist painter. One of the few women of the New York School, she rose to acclaim in the early 1950s. Known for the materiality of her work and its visual sentiments of nature, she continues to be celebrated for her large, luscious, and honest works.

MICHAEL NEFF is an artist working in photography, printmaking and sculpture. He heads the design firm Specimen and is a partner at Marginal Editions. His work will be included in the upcoming Philagrafika 2010. He lives in Brooklyn. More information at www.michaelneff.com.

CARL PLANSKY (1951–2009) was a painter, teacher, and paint maker. He moved to New York in 1970 to attend Hans Hofmann's New York Studio School. He also studied with his close friend Joan Mitchell. In the early 1980s he began to make small batches of handmade oil paints, which later became Williamsburg Oil Paint, widely regarded as one of the finest oil paints in the world. More information at www.carlplansky.com

FRANCES RICHARD has published *See Through* (Four Way Books, 2003), *Anarch.* (Woodland Editions, 2008), and *Shaved Code* (Portable Press at YoYo Labs, 2008). She has been a member of the editorial teams at *Cabinet Magazine* and *Fence*. She organized an exhibition and accompanying monograph *Odd Lots: Revisiting Gordon Matta-Clark's "Fake Estates"* with Jeffrey Kastner and Sina Najafi in 2005. She teaches at Barnard College, New York, and the Rhode Island School of Design and lives in Brooklyn.

RUDOLPH RUEGG is a Swiss designer. He and his brother Roman write and produce studio albums for their record label Sevensleeper, independent music and collaboration featuring recordings by The Throstles, Cheong Hee Cheong, and Los Hombres De La Tierra Roja.

KURT SCHWITTERS (1887–1948) is most widely recognized for his collages, which he called Merz. These were created from the everyday detritus of the street, because, as he said, "Everything had broken down and new things had to be made out of the fragments." In addidition these collages, he also known for his large collaged interior installations, called The Merzbau, and early experiments with sound poems, called Ursonate.

MARK SHORTLIFFE is an artist and editor living and working in New York. He has built tree huts with Tadashi Kawamata, managed publications for Matthew Marks Gallery, New York, and coördinated other fly-by-night operations. He is currently pursuing a career in architecture. His identical twin lives too far away.

ARNE SVENSON has had solo exhibitions at White Columns, New York, the Grey Art Gallery at New York University, and the Laband Art Gallery, Los Angeles. He has shown at San Francisco Museum of Modern Art; The Andy Warhol Museum, Pittsburg; and The National Museum of Photography, Copenhagen. He received the Nancy Graves Foundation for Visual Arts Grant in 2008. He is represented by Julie Saul Gallery, New York, and Western Project, Los Angeles. He lives and works in New York City.

BARBARA TAKENAGA is an abstract painter who lives and works in New York. She is represented by DC Moore Gallery, New York, and Gregory Lind Gallery, San Francisco. She also teaches at Williams College, Williamstown, Massachusetts. More information at www.barbaratakenaga.com.

JUSTIN TAYLOR is the author of a collection of short stories, *Everything Here Is the Best Thing Ever* (Harper Perennial, 2010) and a chapbook of poems, *More Perfect Depictions of Noise* (X-ing Books, 2008). He lives in Brooklyn. More information at www.justintaylor.net

CHARLES VALLELY (1953–2008) was the sixth of eight children, and an aspiring actor who earned an M.A. in literature from Middlebury College, Vermont. Boston Irish, handsome, and alcoholic, Charles was a man of modest independent means and a favorite son of the Boston antiquarian book trade. Although he contributed editorial commentary and introductory essays to the rare book catalogues of his friends, his poems remained unpublished until after his death.

LAWRENCE WESCHLER was a staff writer at *The New Yorker* (1981–2001) before becoming director of the New York Institute for the Humanities at New York University and artistic director of the Chicago Humanities Festival. His recent books include *Vermeer in Bosnia, Everything that Rises: A Book of Convergences* (winner of the

National Book Critics Circle Award for Criticism, 2007), *True to Life: Twenty-Five Years of Conversations with Robert Irwin*, and a newly expanded edition of *Seeing is Forgetting the Name of the Thing One Sees: Over Thirty Years of Conversations with Robert Irwin*.

MARTIN WILNER is an artist living and working in New York. He is represented by Pierogi, Brooklyn, Hales Gallery, London, and MEM Gallery, Osaka. His work is included in the collections of the Los Angeles County Museum of Art, The Jewish Musem, New York, and the Vassar Art Library, Poughkeepsie, New York. His work is featured in Jennifer New's *Drawing From Life: The Journal as Art* (Princeton Architectural Press, 2005), and Steven Holmes' *Festschrift: Selections from the Cartin Collection* (Leo Press, 2008) and has appeared on the cover of Bomb Magazine's *First Proof* literary journal.

PAVEL ZOUBOK is owner and director of Pavel Zoubok Gallery, New York, which exhibits the work of contemporary and modern artists with a focus in the field of collage, assemblage and mixed media installation. The gallery's program combines modern and contemporary works in an effort to create a cohesive art historical and commercial context for collage and its related forms. More information at www.pavelzoubok.com.

ACKNOWLEDGEMENTS

This volume would not have been possible without the assistance of many people who provided help securing images and other materials. Special thanks to Elaine Lustig Cohen, Kari Morris, the Library of Congress, Jane Crawford, and Gwendolyn Owens of the Centre for Canadian Architecture.

We are greatly indebted to the musicians and labels for their generous contributions to *Guy Klucevsek: MUSIC (1986–1994)*:

SCENES FROM A MIRAGE,1986
Guy Klucevsek, accordion
Scenes From A Mirage, Review Records, vinyl release, rere 106, 1987; re-released on CD as Review LC 8388, 1992.

FLYING VEGETABLES OF THE APOCALYPSE, 1988
Diane Monroe, violin; Tom Cora, cello; Guy Klucevsek, accordion
Flying Vegetables of the Apocalypse, Experimental Intermedia Foundation, XI 104, 1990

SYLVAN STEPS, 1990
Mary Rowell, violin; Erik Friedlander, cello; Jonathan Storck, doublebass
Citrus, My Love, RecRec Music, ReCDec 54, 1993 (out of print)

ELEVEN LARGE LOBSTERS LOOSE IN THE LOBBY, 1991
Guy Klucevsek, accordion
Transylvanian Softwear, Starkland, ST-207, 1999 (originally released on John Marks Records, JMR 4, 1994)

THE GRASS, IT IS BLUE (Ain't Nothin' But a Polka), 1986
John King, electric guitar/vocals; David Hofstra, Fender bass; Bobby Previte, drums; Guy Klucevsek, accordion/vocals
Flying Vegetables of the Apocalypse, Experimental Intermedia Foundation, XI 104, 1990 (originally released on Klucevsek's very first recording under his name, Blue Window, zOaR cassette, zcs-8, 1986; re-released on Polka Dots and Laser Beams, eva, wwcx 2036, 1992)

ALTERED LANDSCAPES, 1994
Guy Klucevsek, accordion
Altered Landscapes (American Music Bacharach to Cage), evva 33011, 1998 (out of print)

Images on pps. 153–159 by Marcel Duchamp are courtesy Art Resource, New York, p. 160 courtesy the Philadelphia Museum of Art. All works by Marcel Duchamp are copyright estate of Marcel Duchamp, Artist Rights Society (ARS), New York. All works by Gordon Matta-Clark are copyright the Estate of Gordon Matta-Clark. Lady's writing desk, p. 237, courtesy BMA, gift of Maria Groome Tracy. *New England Still Life*, p. 243, courtesy BMA, W. Clagett Emory Bequest Fund, in memory of his parents, William H. Emory and Martha B. Emory; Edward Joseph
Gallagher III Memorial Fund; and purchase with exchange funds from Bequest of Lowell Nesbitt in memory of Adelyn D. Breeskin. Catherine Ashmore contributed performance photography of John Mark Ainsley. Shaun Myles of Eyefull Graphics, New York assisted with additional photography.

Extra thanks to Michael Neff of Specimen for his tireless efforts. Thanks also to Leslie Miller at The Grenfell Press and Trevor Winkfield for their continued support.

A special dedication to our good friend Carl Plansky, who sadly passed away during the making of this volume.

Special thanks to Don Joint.